WATERCOLOR: THE WET TECHNIQUE

WATERCOLOR: THE WET TECHNIQUE

By Arthur J. Barbour

WATSON-GUPTILL PUBLICATIONS, NEW YORK
PITMAN PUBLISHING, LONDON

This book is dedicated to
OUR LADY OF THE ROSES,
MARY, HELP OF MOTHERS
to say "Thank You" to Her
for sending us our lovely
little girl, Pacita Kamla,
and in special memory of
my recently deceased mother,
Alma L. Barbour.

First published 1978 in the United States and Canada by Watson-Guptill Publications,
a division of Billboard Publications, Inc.,
1515 Broadway, New York, N.Y. 10036

Published in Great Britain by Pitman Publishing Ltd.,
39 Parker Street, London WC2B 5PB
ISBN 0-273-01211-8

Library of Congress Cataloging in Publication Data
Barbour, Arthur J 1926–
 Watercolor : the wet technique.
 Bibliography: p.
 Includes index.
 1. Water-color painting—Technique. I. Title.
ND2420.B36 1978 751.4'22 77-27827
ISBN 0-8230-5681-3

Manufactured in Japan

First Printing, 1978

CONTENTS

ACKNOWLEDGMENTS

My sincere thanks and gratitude to the many people who made such a fine contribution toward the production of this book:

First, to my wife, Margie, whose participation in many areas besides typing the manuscript was greatly appreciated. Then to my children, Maureen, Arthur, Gregory, and Peter, for their patience and many errands that helped me greatly.

To Avery Johnson, who patiently fathered my activities in watercolor over a quarter of a century ago and who was gracious enough to write the foreword to this book. To Bernard Guerlain of Special Papers, Inc., West Redding, Connecticut, for his continued interest and knowledge regarding the Arches watercolor papers used in all the demonstrations. To M. Grumbacher, Inc., for supplying the paints and brushes used in this book. To Stanley Hufschmidt of West Milford, New Jersey, for his photographic advice and help in the special mechanics of photography presented in this book. To Alfred Latini of Paterson, New Jersey, for his advice regarding the close-ups of finished paintings. To Robert Gibson of Ringwood, New Jersey, for his photographs of the author on the flap of the jacket and on page 14. To the Ford Motor Company, Dearborn, Michigan, for permission to reproduce *Cape Henelopen Dunes* (demonstrated on pages 110-114), which is in their permanent collection.

To Maria Dulce Prasarn of Clifton, New Jersey, for her assistance in typing portions of the manuscript. Then, at Watson-Guptill Publications, to Donald Holden for his direction in the conception of the book, to Marsha Melnick for her helpful considerations concerning the format of the book, and to Bonnie Silverstein for her skillful editing of the manuscript.

Finally, to my beloved parents, Dr. and Mrs. Peter J. Barbour, for their behind-the-scenes contribution to this book.

FOREWORD

Although a musician generally performs a work that was originated by someone else, one of the most enjoyable things about painting is that one originates as well as performs the work. In fact, depending upon the painter's personal approach and the circumstances of the moment, the originating and the performing often briefly occur simultaneously. This is especially true with a subtle, responsive, and capricious medium like watercolor. Normally, however, the origination and performance are separate functions of the activity.

Any treatment of watercolor painting should illuminate three aspects or areas of this activity. In this, his third book on the subject, Arthur Barbour deals with all three areas with admirable thoroughness, clarity, and balance.

The first area has to do with the technical skills and procedures necessary to perform the work. These are acquired through sound instruction and lots of practice. In short, they are teachable.

The book's main theme is controlled wet-in-wet painting, and Barbour includes a section giving complete descriptions of the brush and wash techniques used in this approach, along with sponge and crumpled paper for textural effects. He also gives us several surprises, such as sprinkling washes with salt and the use of razor blades for applying pigment. Of special interest is his method of transferring pigment to moist paper from lightly textured formica.

The second area deals with originating the work. This includes color relationships, arrangement of shapes and forms, linear rhythms, distribution of dark and light values, and the like. In this area, too, the basic guiding principles are teachable.

Here the book is especially rewarding, offering a double dividend of information. The first lies in the text, where Barbour is unusually frank and explicit in explaining why, as well as how, he does certain things. The second is found through careful analysis of the plates themselves, which are often more revealing than words concerning certain facets of his organizing skill. A case in point is the Cathedral of St. James on page 124, where he plays off warm and cool colors, and subtly shifts the contours of the towers against the sky from light on dark to dark on light.

The St. James painting is a prime example of the importance of organizing cloud patterns. It is no accident that the sky echoes the dramatic vertical design of the cathedral towers. In fact, all of Barbour's skies merit careful study, for they invariably fit the picture in some special way. It may be through dramatic lighting effects, or by repeating the shapes and rhythms of the main subject matter. Often it is by association, as in the use of verticals for grandeur, slanting forms for action, or undulating horizontals for peaceful serenity.

The third area, which can critically affect both of the other two, concerns intangible personal factors such as mood, impulse, imagination, and intuition. It has been said that watercolor is more a state of mind than a matter of technical procedures. Along with freehand sketching, it probably transfers the mood of the artist to the viewer better than almost any other medium. Since this area is on a feeling rather than a thinking level, it cannot be taught. It can, however, be encouraged and inspired. This is exactly what the book does.

We sense that Barbour thoroughly enjoys his work, and has a friendly rapport rather than a domineering attitude toward his paints. This is fortunate, since watercolor resents being pushed around, just as do people. We also note his sensitivity to the feel of his subjects, as shown in the contrast between the cathedral's awe-inspiring majesty and the quiet simplicity of the winter scene on page 138.

Often near the end of a painting, a departure from the game plan is called for. Whether this be due to a poorly painted area, or to seize an unforeseen golden opportunity, Barbour is always alert to these situations, and refreshingly candid in explaining them. A dramatic example is his decision to darken the sky over the rim of the Grand Canyon on page 83.

Thirty years ago Arthur Barbour was one of my most promising students at the Newark School of Fine and Industrial Art. Little did I foresee the extent and variety of his achievements in fulfilling this promise, the latest being this book that offers so much to so many. Anyone will enjoy simply looking at the pictures; the art-oriented lay person will be fascinated with the step-by-step development of the paintings; and the serious student or amateur or would-be painter will find a wealth of useful information, encouragement, and inspiration.

Avery Johnson

MATERIALS AND EQUIPMENT

The following pages contain pictures and a description of the equipment I use for the wet-in-wet watercolor techniques described in this book.

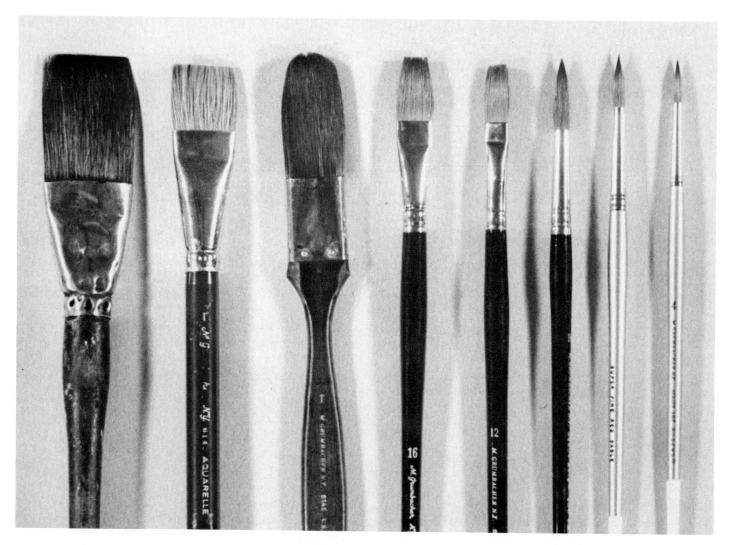

Brushes. A variety of brushes can be used for applying color to watercolor paper. The typical brushes I use, pictured left to right, are 1 1/2" (38 mm) flat sabeline; 1" (25 mm) flat sabeline; 1" (25 mm) oval wash brush; 1/2" (13 mm) flat sable; 1/4" (6 mm) flat sable; No. 10 round sable; No. 6 round sable; and No. 4 round sable. A 3/4" (19 mm) flat sable brush that I use extensively throughout the demonstrations is missing from the photograph, but looks the same as the 1/2" (13 mm) flat sable, only wider. The 1" (25 mm) oval wash brush shown here is referred to as a "flat round brush" in my other books. I often substitute sabeline brushes for the sables because they are less fragile and can take more abuse.

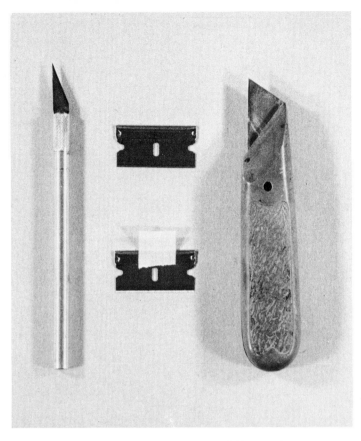

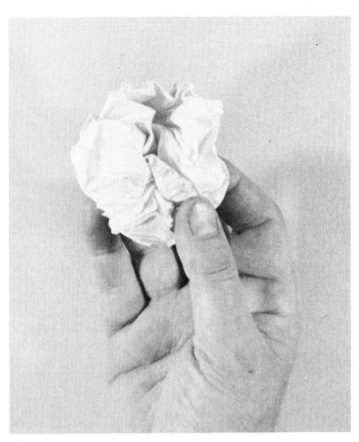

Knives. I use a variety of knives and sharp instruments for special effects. Pictured left to right: X-Acto blade, for scraping out sharp whites; heavy-duty knife, for scraping out whites and cutting mats; razor blades, also for scratching out whites, but mostly a painting tool for squeegeeing or stamping paint onto paper.

Crumpled Paper. I use crumpled paper to stamp pigment onto dry or moist watercolor paper for special effects in handling foliage, stones, and debris. You will find this technique demonstrated on page 27.

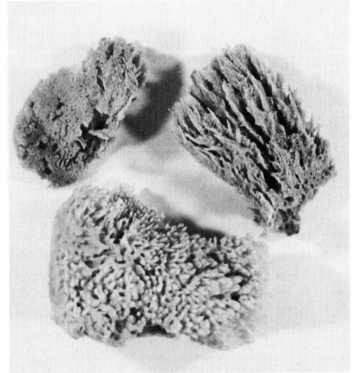

Handles. I use the back ends of paintbrush handles for pressing out moist paint in order to render a line in a moist wash or to scrape or crease the paper so the pigment runs into it and creates a line. The paper must have a real wet wash on it so the pigment can flow into the scored, creased, or scratched area to produce a mark. This is demonstrated on pages 32–34.

Sponges. Here are three large, natural sponges, torn in sections to show the different textural patterns I can get using the natural texture of the sponge to apply paint by stamping, or twisting and stroking. These sponges are also used for wetting the paper surface in preparation for painting wet washes. They can usually be purchased in a hardware store.

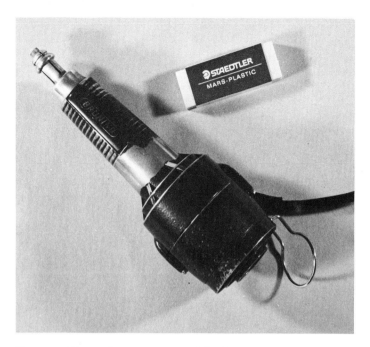

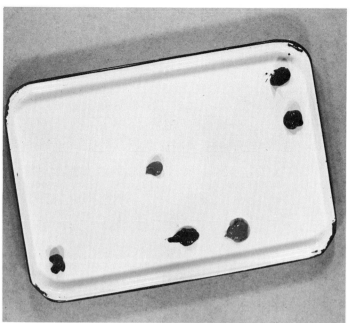

Erasers. The only two erasers I find necessary are the electric eraser and the Staedtler-Mars plastic eraser. I use the electric eraser seldom and then very sparingly to burnish small highlights on the edge of buildings, foliage, and small sections of snow. The Staedtler-Mars plastic eraser removes strong pencil lines with little damage or fracture to the surface of the watercolor paper.

Butcher's Tray. This is a 13″ x 19″ (33 x 48 cm) butcher's tray, the main mixing palette I use for all my watercolors. My arrangement is simple. The tray itself is always situated on my right-hand side, close to the painting board. The blues and browns of my choice used for mixing grays, for example, cobalt blue and burnt sienna, are placed for convenience in the upper left-hand corner near each other. Other colors are placed at random except for a strong dye color such as Thalo blue. This is kept in the lower right-hand corner, as far from other colors as possible, to keep it from invading the other pigments.

Fixative Sprayer. This is a very handy tool for rewetting such areas as skies, trees, and foreground in order to paint back into them without lifting the settled washes. Just place one end in a small jar of water, tilt the sprayer at a right angle (about ninety degrees) and blow, and out comes a fine mist.

Salt. Here is a pile of the coarse, kosher salt I use to make the salt designs shown on page 35 and in many of the demonstrations.

Cold-pressed Paper. You can see that the surface of this sheet of 300-lb cold-pressed Arches paper is not quite as coarse as that of the rough paper. I prefer the cold-pressed paper. The paint slips on more readily, because of its smoother surface and leaves a lovely irregular design as it settles into the valleys of the paper. One of the reasons I prefer Arches paper—both rough and cold-pressed surfaces—is because it's exceptionally strong and durable and holds up well under scrubbing, scraping, and sponging, and, when masking tape is removed, the paper does not tear.

Rough Paper. Here is a sheet of unstretched Arches 300-lb rough paper. Its rough, granular surface is exceptionally good for drybrush. When washes are applied, the granular pigment settles into its moist surface and is enhanced by the irregular rough texture of the paper.

Stretching Watercolor Paper. Many of the demonstrations in this book are painted on stretched watercolor paper. When watercolor paper is soaked, it swells 1/4″ to 3/8″ (6 to 10 mm) larger all around and lies in a flat position. By taping and stapling it at this point, you trap it in its swollen state and prevent it from shrinking. Thus, when it is wet and rewet in the painting process, it cannot swell or buckle. The result is a beautiful flat surface to run washes on.

To stretch a sheet of paper, you will need to assemble the following equipment: A full sheet of watercolor paper, called "imperial size," 22″ x 30″ (56 x 76 cm) (for sheets of any size and paper of weights of 300, 140, or 90 lbs, you would follow the same procedure). A roll of carton-sealing tape (which adheres with water-soluble glue). A plywood board, 1/2″ to 3/4″ (13 to 19 mm) thick, cut 1″ (25 mm) larger than the paper on all sides. I use a 23″ x 31″ (58 x 79 cm) board for a full sheet of paper. Also, a staple gun, a sponge, paper towels, a saucer of water, a long straight edge, and, finally, something to soak the watercolor paper in (usually a bathtub).

This is how to proceed: (1) With the straight edge, draw a line 3/8″ (10 mm) in from the edge of the paper all the way around. (2) Submerge the paper in the bathtub, breaking the sizing (the paper is starched) by sponging it lightly on both sides. Let it soak for fifteen minutes. (3) Cover the watercolor board (an area slightly smaller than the sheet of watercolor paper) with clean paper toweling to keep the other side of the watercolor paper clean, if needed for future use. In stretching paper of weights lighter than 300 lbs, it gives a resilient feel to the working surface. (4) Cut the carton sealing tape into four strips: two the length of the board, and two its width. (5) Lift the watercolor paper gently out of the water by holding two edges, and allow the excess water to run off into the tub. (6) Position the watercolor paper on the paper towels in the center of the board so that the wooden board is visible around all the edges. (7) Dry about 2″ (50 mm) of the outer edge of the watercolor paper with paper towels until very dry to the touch. (8) Wet the water-soluble strips of tape in the saucer of water, then squeeze the excess water off by running the tape once through your fingers. (9) Now place the wet tape along the pencil line on the edge of the watercolor paper. The rest of the tape will extend over and onto the edges of the wooden board and adhere thoroughly. (10) Drive staples all around the perimeter of the paper, about 1 1/2″ to 2″ (38 to 50 mm) apart, right through the tape and watercolor paper, and into the board. (11) Let the paper dry in a flat position for about six to eight hours. Now it's ready for painting. (12) When your painting is finished, let it dry for several hours, then remove the staples. (13) Run a razor blade along the edges of the watercolor paper and cut through the tape to free the painting. Don't worry about the tape left on the painting. It's a good reinforcement for the edges of the paper and can easily be covered by a mat when the painting is framed.

The Razors. Here are two single-edged razor blades. To break one of them, I wrap it in several layers of paper for protection and bend it until it snaps in half. Then I straighten it out and pull out a section of the blade, leaving the other half and the back edge as a handle. I use this broken razor for smaller details.

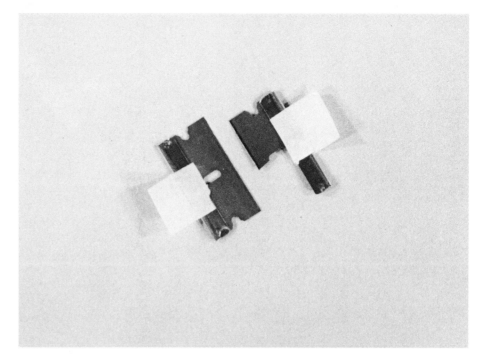

Holding and Loading the Razor. I dip the razor in paint almost as thick as it comes out of the tube. I mix the colors together only slightly on the palette, because I prefer to blend my colors on the painting itself, where the partially mixed colors vibrate visually. By folding a piece of masking tape and placing it on the folded edge of the razor, I can extend the width of the folded edge for a better grip.

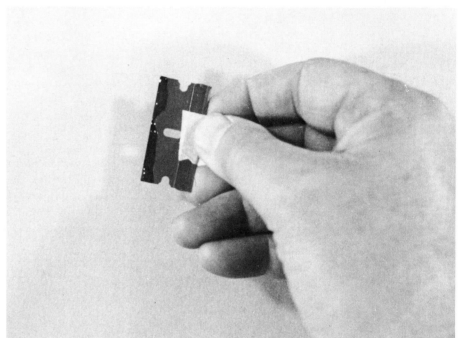

Applying Paint. To squeegee paint off the blade onto the moist watercolor paper, notice how I position the blade so it is nearly flat to the surface of the paper. This allows the paint to slip off more readily. When I do this on a dry sheet of paper, the paint has a dry, sparkling look.

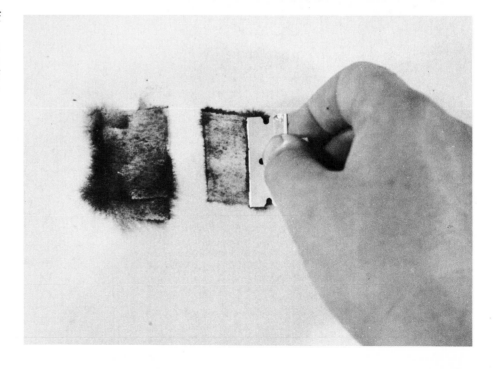

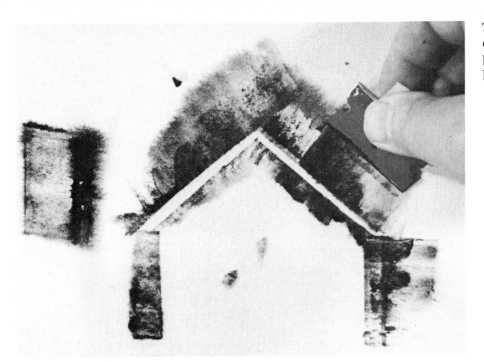

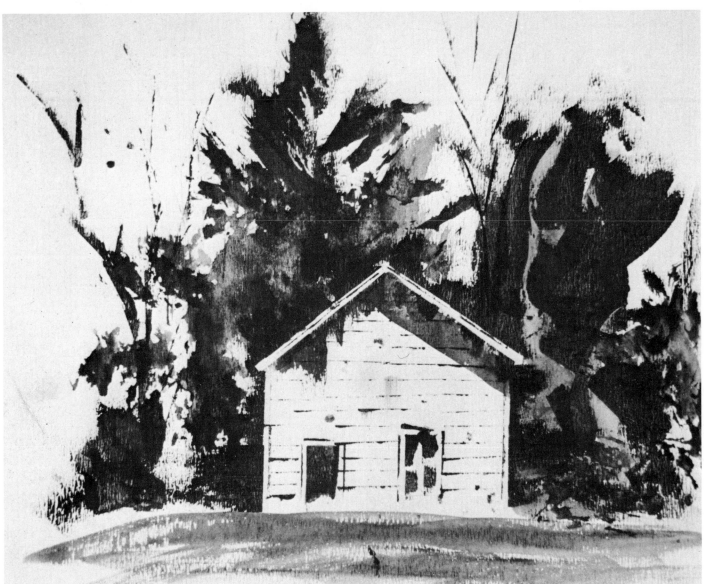

Razor Painting. Here a simple design of building and trees was rendered almost entirely with razor blades. The foreground was the only area painted with a flat sable brush. Notice that most of this work was done on a dry surface, so the edges of the suggested foliage have an elusive, drybrush look. I painted the clapboard with the sharp edge of the razor blade by stamping the blade straight down. The tree branches were printed and stamped in the same manner.

Outdoor Equipment. (Right) When working outdoors in sunlight, I use a French easel and I shade my watercolor paper from glare with an inexpensive and easily constructed umbrella. This is how the setup looks when assembled.

Easel Drawer. (Below) This is some of the equipment I put in the top drawer of my French easel. I keep paper towels and brushes plus an umbrella for shading the paper in the bottom drawer (not shown). This easel is especially helpful for painting outdoors. The legs are adjustable to suit different terrains, and the board can tilt at any angle from zero to ninety degrees.

Umbrella for Outdoor Setup. (Below right) I use the following items, listed from the top down, in constructing the sun umbrella: (1) A folding umbrella, with the handle screwed off and fitted into a 3/4″ (19 mm)-diameter electric coupling. (2) An electrical floodlight clamp with the socket removed and a key ring inserted large enough to let the pipe coupling slip through. (3) A 3/4″ (19 mm)-diameter electrical pipe cut in lengths to fit into the French easel, along with the couplings attached to one end.

To assemble the umbrella, I slip the pipes together and tighten them with a screwdriver. Then I slip the umbrella on the pipes and tighten the screws. I clip the clamp to the board or easel; it can be moved to any section. Finally, I slip the pipe through the key ring in the electrical clamp, and I'm done. The entire device, unassembled, fits into half of the bottom section of my French easel.

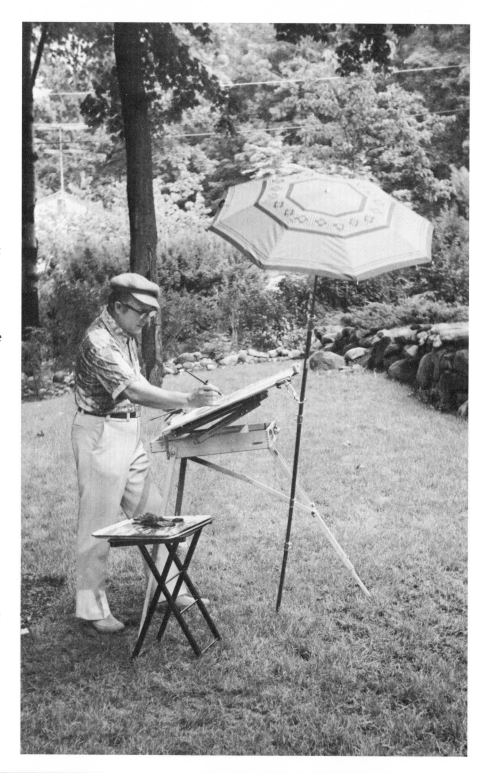

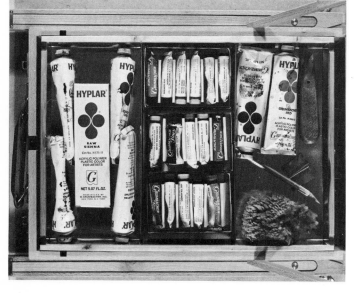

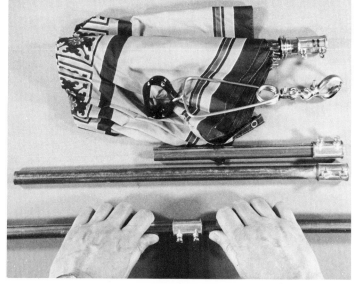

1

WET-IN-WET WITH A BRUSH (BUSH)

In this demonstration I show how to paint wet-in-wet using a simple bush as a subject. When you compare this demonstration with the next, you will see that the brush technique—which gives better control—lacks the explosive quality of the sponge technique. I use it when I need to paint tighter and more carefully. In this demonstration, I use a 3/4" (19 mm) flat sable brush and a No. 6 round brush, and I am working on a stretched section of 300-lb cold-pressed Arches watercolor paper. My palette is burnt sienna, cobalt blue, raw sienna, and sap green.

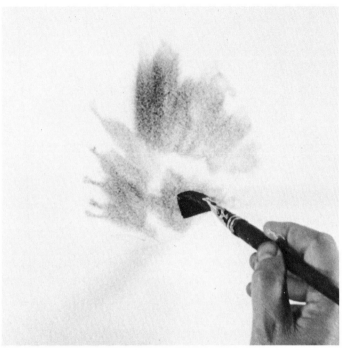

Step 1. I first wet the paper with a damp sponge and clear water. Then I paint the form of a bush into the moist paper, with raw sienna and sap green.

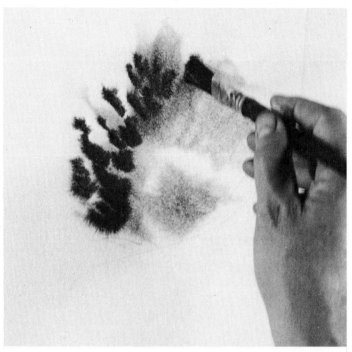

Step 2. I continue to render texture and deepen the value using mixtures of cobalt blue, burnt sienna, and sap green.

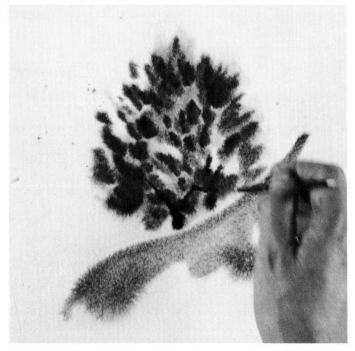

Step 3. When this is complete, I put in the branches with a No. 6 round brush and thick mixtures of burnt sienna and cobalt blue. Then I add light washes in the foreground with a 3/4" (19 mm) flat brush and the same colors to indicate snow.

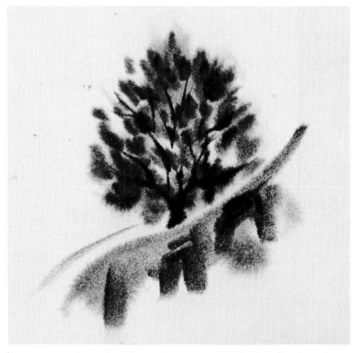

Step 4. I indicate rocks in the snow with the flat brush and cobalt blue and burnt sienna in order to anchor the bush, and I'm finished.

In this demonstration you will see how I use the built-in textural patterns of a natural sponge to achieve a variety of painting textures. I'm working on a section of 300-lb cold-pressed Arches watercolor paper, using a No. 6 round sable brush in addition to a large natural sponge. My palette is raw sienna, sap green, burnt sienna, and cobalt blue.

2
WET-IN-WET
WITH A SPONGE
(BUSH)

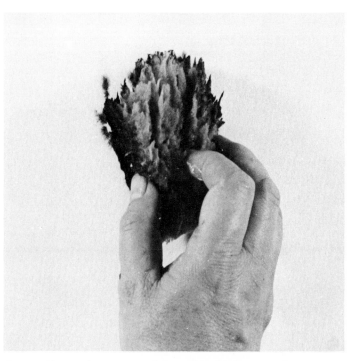

Step 1. I tear the sponge into several pieces and examine it to see the various structures and textural patterns, then I select a section with a texture resembling a bush. I dampen the sponge, squeezing out excess moisture, and pick up several colors on it—raw sienna, sap green, and a touch of burnt sienna and cobalt blue—and mingle them together on the palette. Then I gently press the sponge into the moist surface of the paper.

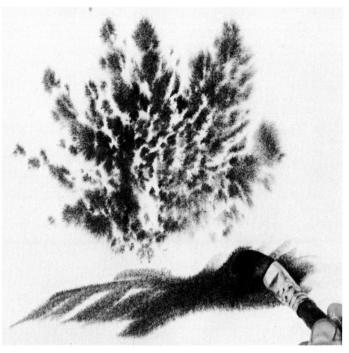

Step 2. Now with the sponge and color, I stamp three overlapping fanned-out impressions on the paper. This is the essence of the bush. Then I paint in a darker mixture of sap green, raw sienna, and cobalt blue to anchor the bush to the ground.

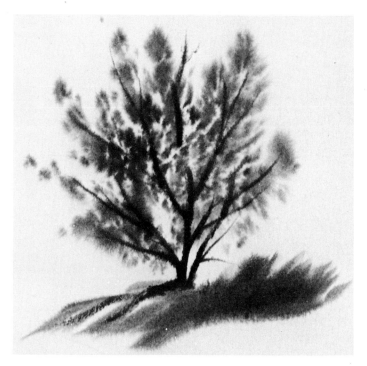

Step 3. Finally I add the tree trunks and branches with a No. 6 round brush and burnt sienna and cobalt blue.

3

LARGE WASHES ON WET PAPER (CLOUDS)

I will demonstrate how to handle large washes on wet paper using puffy white clouds with patches of blue in between as an example. A half sheet, 15" x 22" (38 x 56 cm), of Arches cold-pressed watercolor paper is stretched and ready for use. I use a 1" (25 mm) flat brush and a No. 6 round brush. My palette consists of burnt sienna, cobalt blue, sap green, and French ultramarine blue.

Step 1. I first sponge the entire paper liberally several times with clear water and then sponge it again to remove the excess water, for a proper working surface. Then I swish a warm mixture of burnt sienna and cobalt blue into the moist surface with the flat brush, leaving intermittent areas white.

Step 2. These same colors are deepened and washed down to the horizon. I prefer to mix my colors on the painting rather than the palette so that I can see how they harmonize with the rest of the painting. If the colors are wrong, I quickly adjust them while they are still wet.

Step 3. Still using the same brush, I inject pure cobalt blue for patches of blue sky between the warm gray washes, leaving some areas white for the lighted edges of the clouds.

Step 4. I continue this procedure until the sky seems complete. Then I sponge and brush in mixtures of burnt sienna, French ultramarine blue, and sap green for the trees and the ground.

Step 5. Finally, I paint the tree trunks and branches with thick mixtures of French ultramarine blue and burnt sienna, using a No. 6 round brush. This completes the painting.

4
LONG STROKES ON WET PAPER (CLOUDS)

To show how I paint long strokes on wet paper, I paint a receding sky with the streaky clouds growing thinner as they recede into the distance. I use a sponge and the following brushes: 1 1/2" (38 mm), 3/4" (19 mm), and 1/2" (13 mm) flat brushes and a No. 6 round brush. My colors are burnt sienna and cobalt blue. I am working on a stretched half sheet of 300-lb cold-pressed Arches paper.

Step 1. I wet the paper several times with a sponge and clear water and then mop it with the sponge until its surface is wet evenly. I then paint in a cool gray wash of burnt sienna and cobalt blue with a 1 1/2" (38 mm) flat brush for the sky at the horizon.

Step 2. I then add deeper washes of burnt sienna and cobalt blue at the top of the painting for the darker gray clouds.

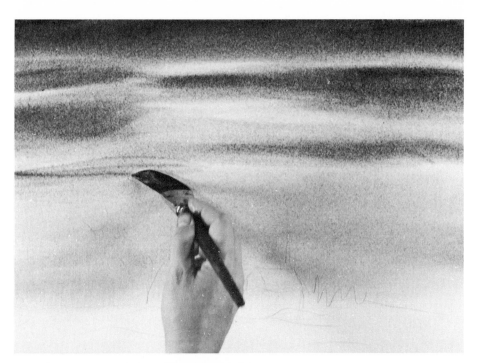

Step 3. To paint the thinner clouds, I use the side of the 1 1/2″ (38 mm) brush and the same colors. I stroke them into the wet sky, carrying them down to the horizon.

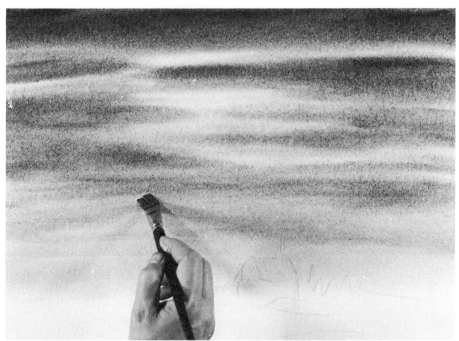

Step 4. Now, switching to a 1/2″ (13 mm) flat brush, I use the same treatment for the receding clouds but make them slightly lighter and thinner.

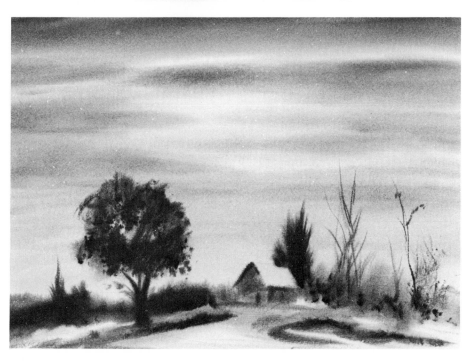

Step 5. I now paint the foreground, house, and trees with a 3/4″ (19 mm) flat brush and the same simple colors, using a sponge for the heavier darker masses. I paint the smaller trees by dragging thick paint through the wet washes with a No. 6 round brush.

5
FANNED-OUT BRUSHSTROKES (GRASS)

Here I will use a fanned-out brush to produce a simple beach scene. I use a No. 10 round brush and a section of 300-lb cold-pressed Arches paper stretched on a drawing board. My colors are French ultramarine blue, Hooker's green, and burnt sienna.

Fanned-out Brush. To fan out a brush, I hold it between my thumb and forefinger and shift the hairs as I squeeze them in order to spread them out, making a series of smaller brush points.

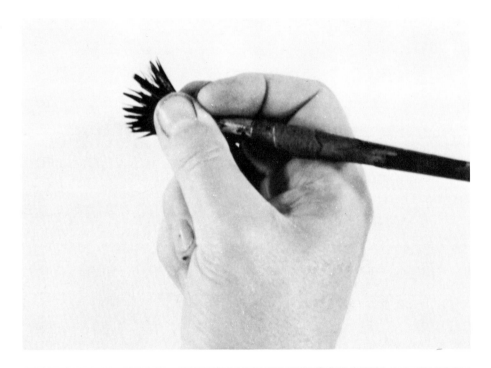

Fanned-out Brushstrokes. Here I use this technique with color. You can see how the paint slides off the brush onto the moist paper.

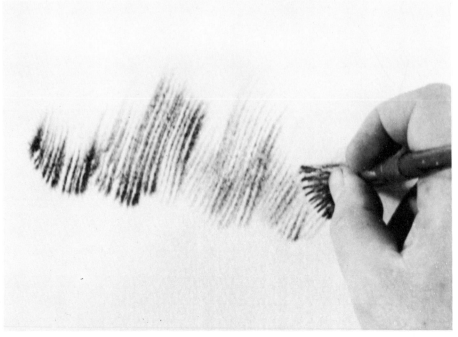

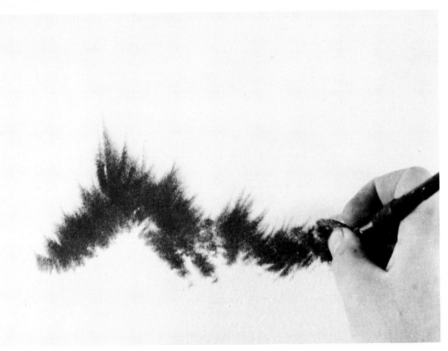

Step 1. Now I begin the painting. First I wet the paper, sponging it with clear water to make a moist surface. Loading a No. 10 round brush with Hooker's green and a touch of burnt sienna, I fan it out to start forming the grass.

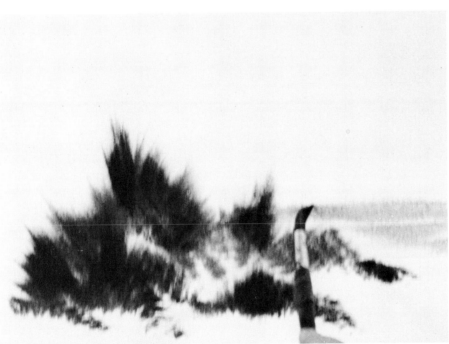

Step 2. With the same fanned-out brush, I paint a warmer mixture of burnt sienna and Hooker's green beneath these first tufts of grass to establish the foreground. Then, repointing the brush, I start forming the horizon of the ocean with French ultramarine blue.

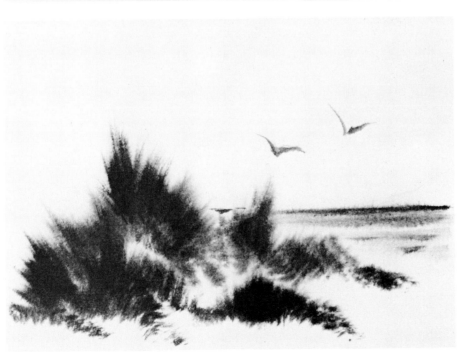

Step 3. Now, with the same brush and color, I bring the ocean into sharper focus. Then I add two birds to convey, in the simplest of terms, the effect of a typical beach and ocean.

6

DRYBRUSH ON DAMP PAPER (TREE TRUNK)

Dragging thick, moist color onto damp paper gives a soft drybrushed effect. The granular marks have a slightly diffused look. In this demonstration, I use drybrush to paint a tree trunk. My brushes are a No. 10 round and a 3/4" (19 mm) flat sable. The paper is a section of 300-lb cold-pressed Arches watercolor paper, which I have previously stretched. My palette is French ultramarine blue and burnt sienna.

Drybrush Technique. Working on a scrap of watercolor paper that has been premoistened with a sponge and clear water, I lay in thick mixtures of paint holding a No. 10 round brush in an almost flat position, as demonstrated. The thick paint wipes off onto the tops of the small bumps of the paper , leaving the valleys white.

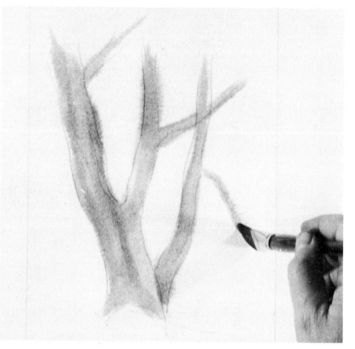

Step 1. I begin painting the tree trunk on a fresh sheet of watercolor paper. First I wet the paper with clear water and a sponge. Then I apply a cool gray mixture of French ultramarine blue and burnt sienna with a 3/4" (19 mm) flat sable brush.

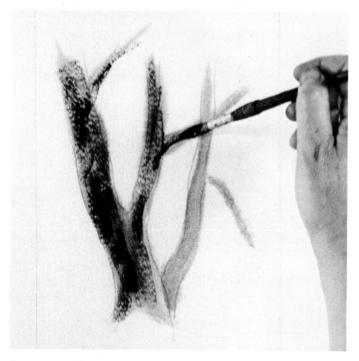

Step 2. As the paper gets slightly drier, I use a No. 10 round brush with thick mixtures of the same colors to drybrush the paint onto the moist surface, as illustrated in the first photograph.

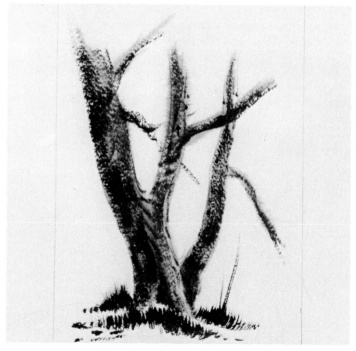

Step 3. I work the same process further, varying warm and cool thick mixtures of French ultramarine blue and burnt sienna for interest. I suggest grass with the fanned-out brush technique.

This demonstration shows how, by stippling on thick color, I can use a simple repetitive pattern to render a group of trees and lend visual interest to them. I use a 3/4" (19 mm) flat sable brush and I'm working on a stretched section of 300-lb cold-pressed paper. My colors are raw sienna and burnt sienna, cobalt blue, French ultramarine blue, and sap green.

7

STIPPLING ON THICK COLOR (TREES)

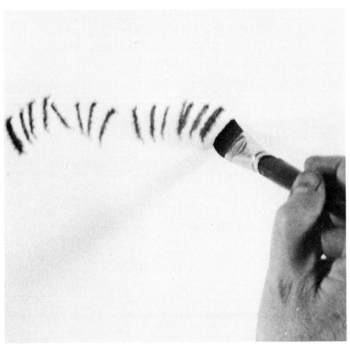

Stippling Technique. I load the brush with paint and, using the chisel-like tip of the brush, as shown, I stipple it onto the moist surface of the paper.

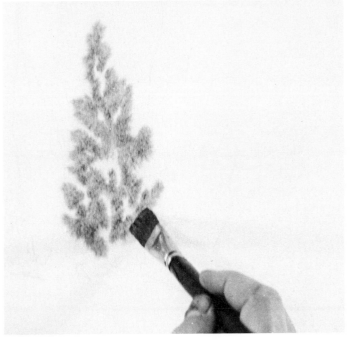

Step 1. I moisten the paper with a sponge and stipple raw sienna with a touch of sap green onto the damp surface with the brush as I start the rendering of a small tree.

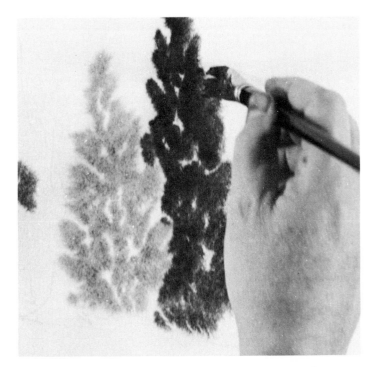

Step 2. Now I pick up thicker, deeper mixtures of sap green, burnt sienna, and cobalt blue on my brush and stipple them in for the larger, darker tree on the right. I let its darker value define the shape of the smaller tree on the left.

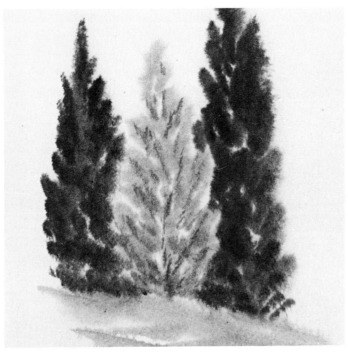

Step 3. I do the same thing on the other side with another tree mass, pushing the lighter tree forward. The tip of the brush is flattened to a chisel point by stroking the paint-loaded brush back and forth on the palette. Then I stipple burnt sienna and cobalt blue onto the middle tree to suggest a trunk and branches. I paint a light wash of cobalt blue into the foreground for snow.

8

WET-IN-WET SPONGE TECHNIQUE (TREES)

Here I paint an impression of a group of leafy trees using a natural sponge. I use a No. 6 round brush and a section of Arches 300-lb cold-pressed paper stretched on a drawing board. My colors are raw sienna, sap green, burnt sienna, cobalt blue, and black India ink.

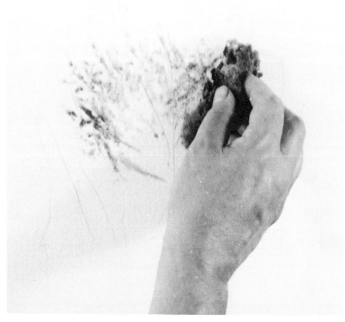

Step 1. I wet the paper with clear water and a sponge several times and leave the surface in a moist state. Now I pick up thick mixtures of raw sienna, sap green, and burnt sienna on a squeezed-out, damp sponge and stamp and twist it into the moist surface of the water-color paper to suggest an irregular foliage pattern.

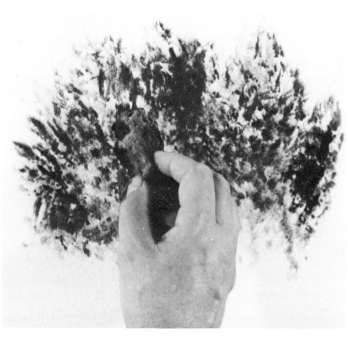

Step 2. I repeat the same technique and colors to further carry out the simple design.

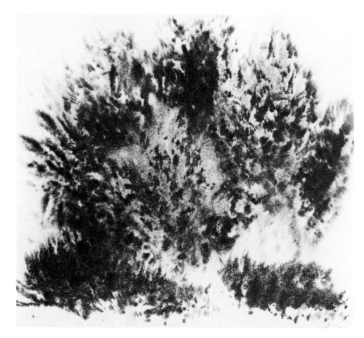

Step 3. Now I deepen the foliage around the edges, leaving the suggestion of a lighter, smaller tree in the center. With the same colors, I sponge in a simple foreground. I use the almost-dry sponge with thick color in a brushing or dragging motion.

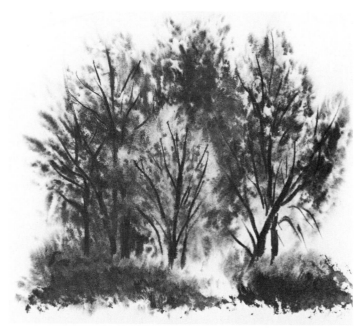

Step 4. Finally, I switch to the brush and paint in the tree trunks with burnt sienna and India ink while the paper is still moist. The results are suggestive and simple.

Here I take a piece of hand-crumpled paper and make use of the irregular pattern that can be printed with it. My brushes are a 3/4" (19 mm) flat and No. 6 round. The paper is a section of 300-lb cold-pressed Arches watercolor paper, stretched on a drawing board. The palette is Grumbacher red, cobalt blue, sap green, raw sienna, and burnt sienna.

9

APPLYING COLOR WITH CRUMPLED PAPER (BLOSSOMS)

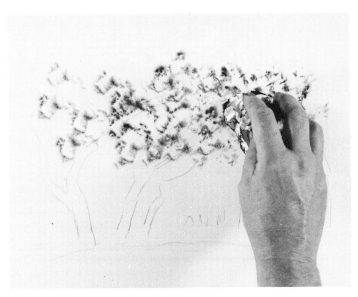

Step 1. After a simplified initial drawing, I wet the paper with clear water and a sponge. I go over the wet surface with the sponge several times, removing the excess moisture but leaving the surface moist. Then I push the crumpled paper into some mixtures of cobalt blue with a touch of Grumbacher red and raw sienna and squish it into the moist surface of the watercolor paper to form a varying pattern for the blossoms.

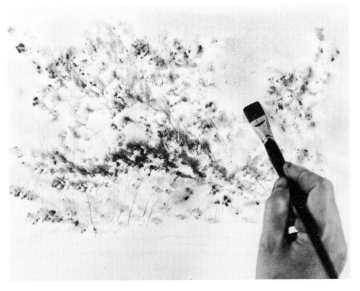

Step 2. With the flat brush and cobalt blue, I paint the sky area around the blossoms a flat, pale color.

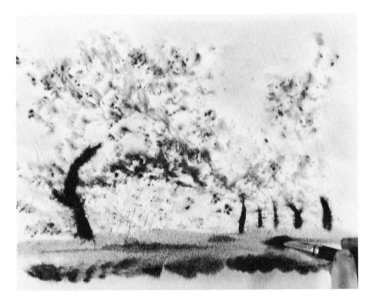

Step 3. Using a No. 6 round brush and painting wet-in-wet in thick, dark mixtures of cobalt blue and burnt sienna, I start the tree trunks. With the flat brush, I first paint on a light wash of raw sienna and sap green for grass, then deepen it with burnt sienna, cobalt blue, and sap green.

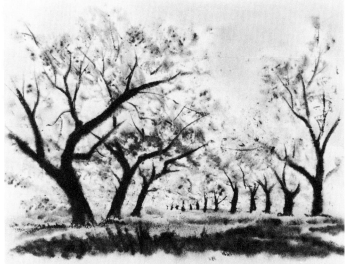

Step 4. The grass is finished using the same colors and brush. Then I complete the tree trunks, applying thick, dark mixtures of burnt sienna and cobalt blue with a No. 6 round brush.

10
SPATTERING
(PEBBLES AND SAND)

This demonstration shows how to achieve texture by spattering a painting with thick color just before the wash dries. My palette is raw sienna, cobalt blue, burnt sienna, cadmium red light, sap green, and black India ink. A 3/4" (19 mm) flat sable, a 1/4" (6 mm) flat sable, and a No. 6 round are my brushes. I work on a section of Arches commercially mounted watercolor board (rough).

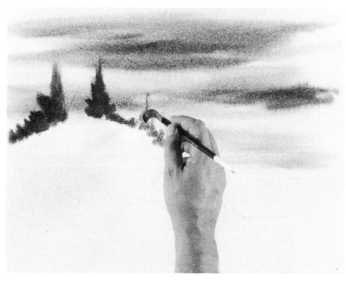

Step 1. I sponge the paper several times with clear water, then sponge it to a moist surface. I mix burnt sienna and cobalt blue to a cool gray and paint in the sky with a 3/4" (19 mm) flat brush. Then I paint into the wet sky with a 1/4" (6 mm) flat sable to start the rendering of pine trees.

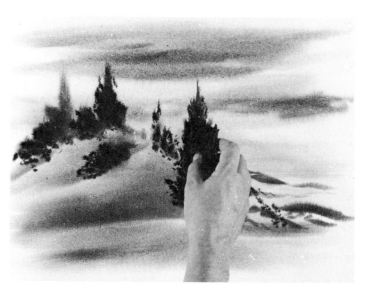

Step 2. Using the same brush and cobalt blue and cadmium red with a touch of raw sienna, I mix a warm purple directly on the paper to start the rendering of the sand. Then I paint in mixtures of raw sienna, cobalt blue, and sap green touched lightly with burnt sienna for additional pine trees. I use a No. 6 round brush and burnt sienna and black India ink to accent the tree trunks and branches. Finally, with cobalt blue and cadmium red and a 1/4" (6 mm) flat sable brush, I indicate the distant terrain on the right-hand side of the painting.

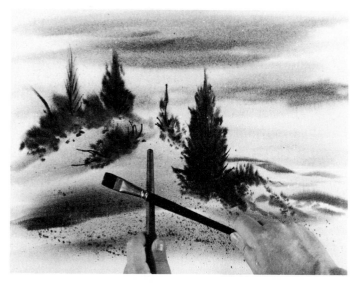

Step 3. When the trees are completed, I pick up thick mixtures of cobalt blue and burnt sienna on a 3/4" (19 mm) flat sable brush. I then hold the handle of this brush across the handle of another brush and smack it in order to spatter paint on the moist foreground and create a rough texture, as illustrated. (I first test the spatter on a blank sheet of paper to make sure the quantity of spatter I will get is about right.)

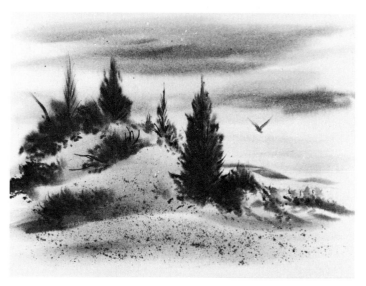

Step 4. The spatter gently spreads and softens as the foreground dries. Finally, I add a bird with a No. 6 brush and burnt sienna and cobalt blue.

Now I will show you how I produce rock formations by slipping warm and cool colors onto moist paper with a razor. This demonstration is kept simple so you can see the razor strokes. A 3/4" (19 mm) flat sable brush and a No. 6 round brush are used. I use a section of Arches mounted watercolor board with a rough surface. My palette consists of cobalt blue, burnt sienna, Hooker's green, and raw sienna, with some black India ink.

11

APPLYING COLOR WITH A RAZOR BLADE (ROCKS)

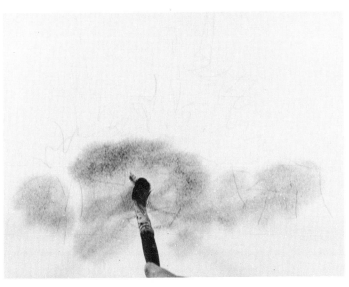

Step 1. The entire paper is wet with a sponge and clear water. With a flat brush, I paint warm and cool washes of burnt sienna and cobalt blue wet-in-wet.

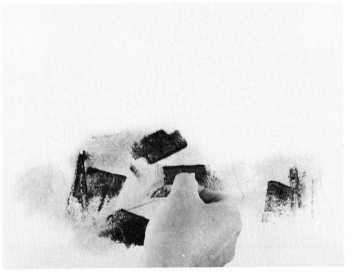

Step 2. After my colors are mingled slightly on the butcher's tray, I scoop up burnt sienna and cobalt blue on a razor blade, press the edge firmly down on the paper, and slide it into the damp washes to simulate rocks. Then I finish rendering the rocks, still continuing to use the razor blade technique.

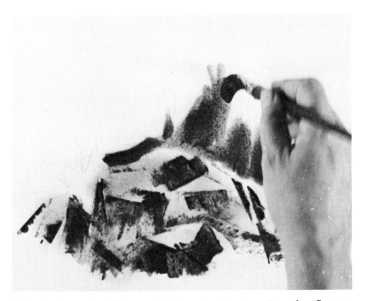

Step 3. I start work on a large pine tree, using the flat brush and raw sienna and Hooker's green.

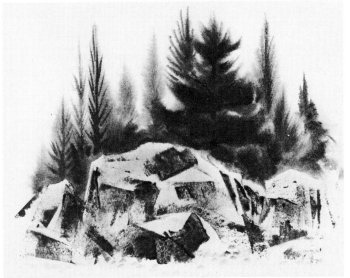

Step 4. The pine is finished and its value is deepened with cobalt blue and burnt sienna. Using a No. 6 round brush, I texture the trees on the left with raw sienna and Hooker's green with a touch of cobalt blue, and accent them with branches made with cobalt blue and burnt sienna. The small trees and bushes on the right are handled the same way. I paint the tree to the right of the large pine with burnt sienna and a touch of cobalt blue so it appears brown. The trees to the left of the large pine are painted with cobalt blue touched with burnt sienna, so they appear a soft blue-gray. I accent the large pine with India ink.

12

LIFTING OUT WITH A BRUSH (TREE TRUNKS)

Here I demonstrate the lifting out of color before the washes dry. My subject is a large dominant tree backed up by several smaller trees. My only brushes are a 3/4" (19 mm) flat sable and a No. 6 round, and my working surface is a section of a sheet of Arches 300-lb cold-pressed paper stretched on a 3/4" (19 mm)-thick plywood board. My palette is raw sienna, Hooker's green, burnt sienna, French ultramarine blue, and cobalt blue.

Step 1. I draw a simple design using a No. 2 office pencil. Then, with a natural sponge, I wet the paper several times with clear water so it penetrates the surface. When I am through sponging, I leave the surface of the paper moist. Using the flat sable brush and burnt sienna, cobalt blue, and French ultramarine blue, I paint in varying degrees of warm and cool color to simulate a simple grouping of distant trees.

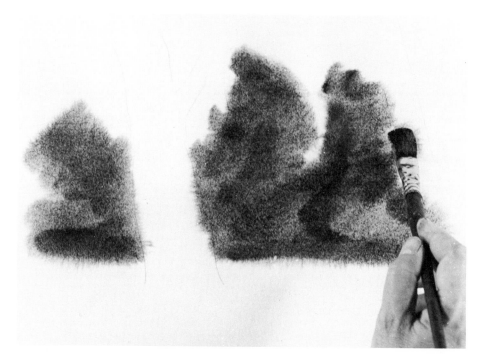

Step 2. I work a wash of raw sienna into the large tree trunk and paint into it again with cobalt blue and burnt sienna. Then I render a simple, soft foreground working wet-in-wet with Hooker's green, burnt sienna, and cobalt blue.

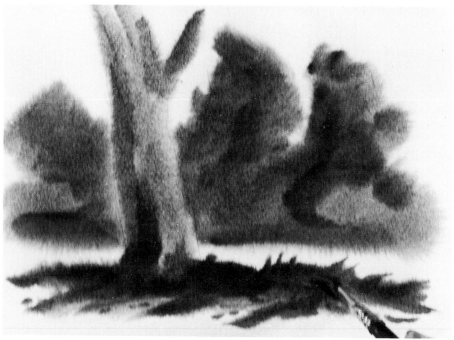

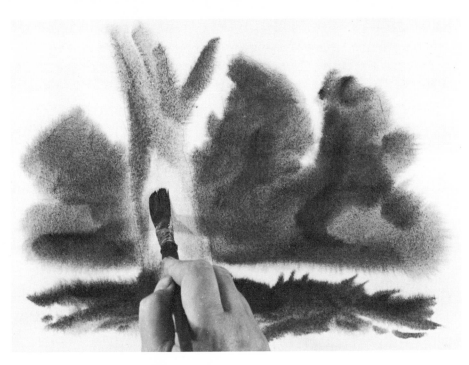

Step 3. Now, still working with the flat brush, I clean it in clear water and squeeze it between my fingers until it's almost dry. I then use it to lift paint out of the moist washes in the tree trunk: lift out, rinse, squeeze between my fingers, and lift out some more paint.

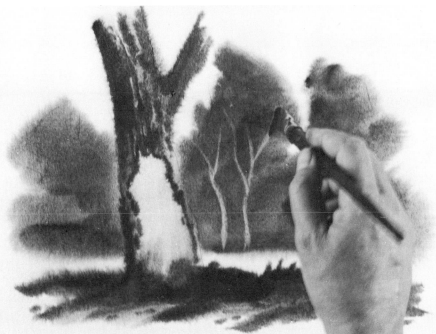

Step 4. After enough pigment is lifted out, I stipple in thick mixtures of burnt sienna and cobalt blue onto the trunk for bark texture. I'm still working wet-in-wet. I keep squeezing my brush and occasionally rinsing it in clear water, using the squeezed, knife-edged, flat tip of the brush to lift out thinner tree trunks in the distant moist foliage, as illustrated here.

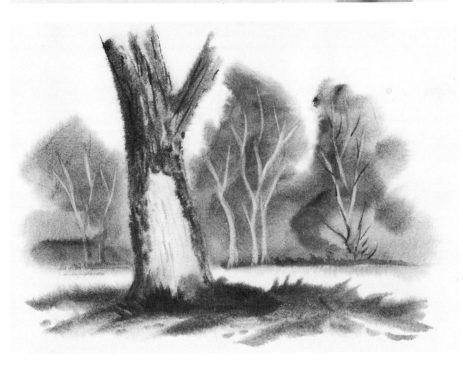

Step 5. I carry out this procedure until the washes are just about dry, always keeping the brush drier than the moist washes. This is important in order to avoid water marks. Now I add a few dark accents for branches with French ultramarine blue and burnt sienna, using the No. 6 round brush, and the picture is complete.

13

PRESSING OUT LIGHT LINES IN WET COLOR (BRANCHES)

A good way to achieve a feeling of light on sunlit branches in a distant tree grouping is by pressing wet color out of the paper with a semi-sharp instrument. For this demonstration, my tools are a No. 6 round sable brush, a 3/4" (19 mm) flat sable brush, and a razor blade. The paper is a section of Arches 300-lb cold-pressed stretched on a drawing board. My colors are burnt sienna, French ultramarine blue, and sap green.

Step 1. The paper is wet several times with a sponge and clear water. It is then sponged to remove excess moisture, but is left in a moist condition. Using the flat brush and a light wash of French ultramarine blue with a slight touch of burnt sienna, I paint in the blue-gray sky. Then I paint deep mixtures of French ultramarine blue, burnt sienna, and sap green into the wet sky to start the suggestion of distant tree groupings.

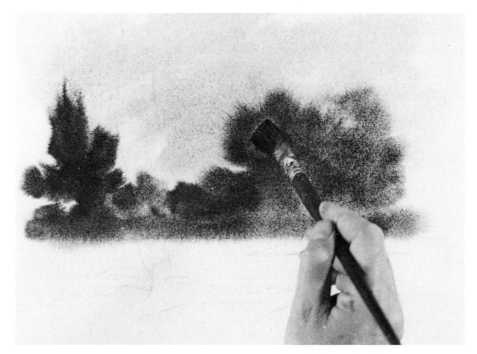

Step 2. Now I swish in light washes of burnt sienna and French ultramarine blue to represent the water, and then paint deep, thick mixtures of burnt sienna, sap green, and French ultramarine blue into the foreground for grass. I scoop up more paint on the sharp edge of a razor blade and squeegee the paint into the damp paper surface to render a foreground tree. Now, as illustrated, I paint deeper and thicker mixtures of burnt sienna and French ultramarine blue into the still-damp distant tree area with the flat brush to depict closer trees on an island in the middleground.

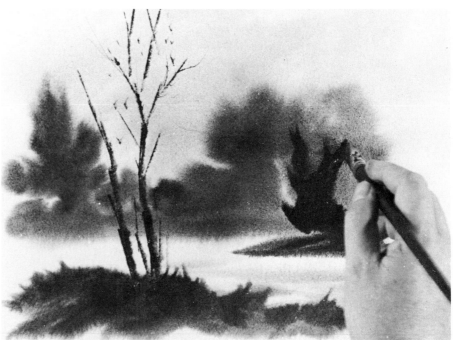

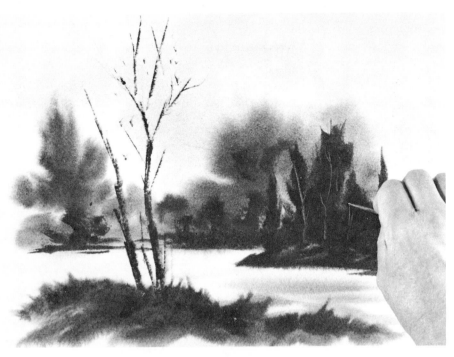

Step 3. I let the same thick mixtures of color form the nearest trees in the most distant areas to add more substance to the grouping. Then, with the handle of the round sable brush, I press out the nearly dry pigment as shown, leaving white lines to simulate branches.

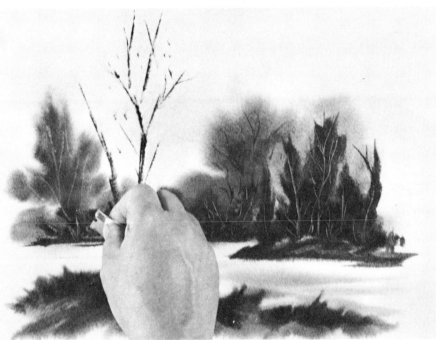

Step 4. I use this press-out technique again in the distant tree grouping, painting in several darker branches as well with the round brush and dark mixtures of burnt sienna and French ultramarine blue. Finally, as shown, I use the clean edge of a razor blade to press out the nearly dry pigment in the distant tree groupings on the left.

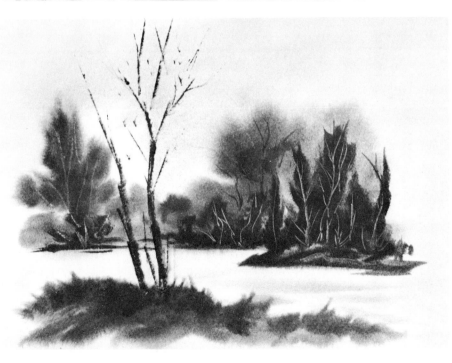

Step 5. Here is the painting, completed and dry. You can see how I get the effect of the lighter branches against the darker foliage by pressing out color, in this case, with the tip of a brush handle and a razor blade.

14

SCRATCHING DARK LINES INTO WET COLOR (BRANCHES)

In this simple demonstration I show that by pressing, scoring, or scratching into a wet surface, you can make darker lines in the wet pigment. I use a No. 6 round sable brush and a 3/4" (19 mm) flat sable brush. I am working on a stretched section of a sheet of 300-lb Arches cold-pressed watercolor paper. My palette is raw sienna, French ultramarine blue, and burnt sienna.

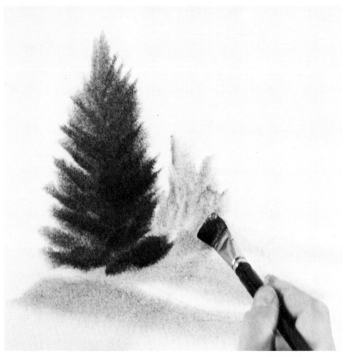

Step 1. I wet the paper several times with a sponge and clear water, leaving the surface in a moist condition. I paint a soft, diffused pine tree with the flat brush and raw sienna, French ultramarine blue, and burnt sienna, adding a few swatches of French ultramarine blue with a touch of burnt sienna for soft snow in the foreground. Then, with a thicker application of raw sienna, I render a small tree.

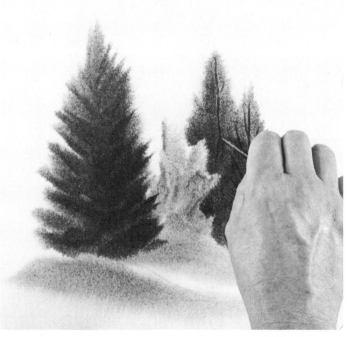

Step 2. I mix a wash of French ultramarine blue and burnt sienna on the cool blue side and paint it around the small gold tree to simulate two distant pines. While these washes are still wet (not moist, but wet), I drag the tip of the handle of the round brush along the surface of the paper, pressing it hard so that the wet pigment flows into the scratched paper and makes dark lines, to express branches.

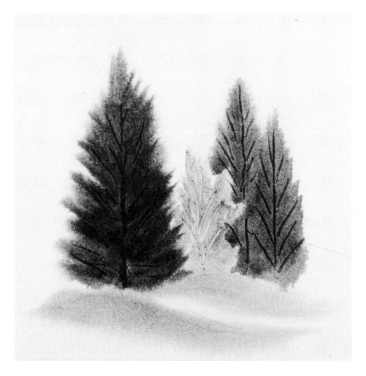

Step 3. I continue this same treatment until the tree trunks and branches are complete, pressing hard and dragging the brush handle only once for each scoring. Then I wait until the raw sienna pigment of the smallest tree is nearly dry. Now, when I press and drag the pointed handle through the half dry pigment, I am pressing the color out of the furrow made in the paper and leaving a light line in the pigment, depicting, in this instance, light branches.

By sprinkling salt into wet pigment, you can get a variety of effects. You will find a pile of the coarse salt I use pictured on page 10.

15
SALT DESIGNS

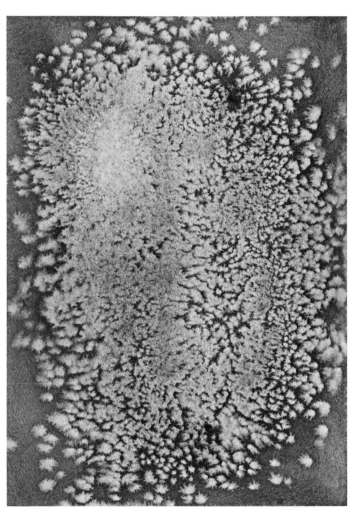

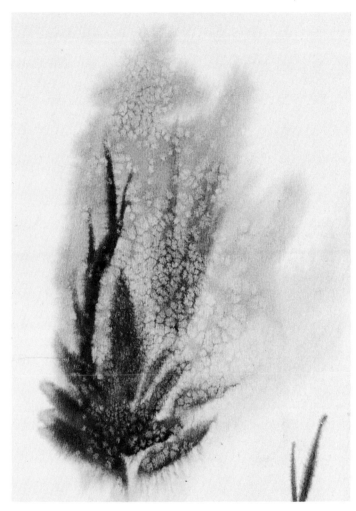

Example 1. Here we see the results of coarse salt sprinkled into a wet wash. The salt retains the water around it, keeping it wet, while the area not having salt dries faster, leaving small water marks.

Example 2. I used less salt in this example. Therefore you can see more readily where the individual grains hold the water while the paper around it dries. When all is thoroughly dry, I brush away the salt.

16

THROWING SALT INTO WET COLOR (ICE AND SNOW)

The point of this demonstration is to create a feeling of ice and snow clinging to rocks, and this is accomplished by the use of coarse table salt. My brushes are a 3/4" (19 mm) flat sable and a No. 6 round. I use a section of Arches 300-lb cold-pressed watercolor paper, stretched on a drawing board. My palette consists of cobalt blue, French ultramarine blue, burnt sienna, and sap green.

Step 1. I wet the paper several times with a sponge and clear water and sponge off the excess, leaving it moist. Then I paint in pale, cool washes of cobalt blue touched with burnt sienna with the flat brush.

Step 2. I pick up burnt sienna and French ultramarine blue on a razor blade and squeegee it into the moist washes to start the rendering of the rocks.

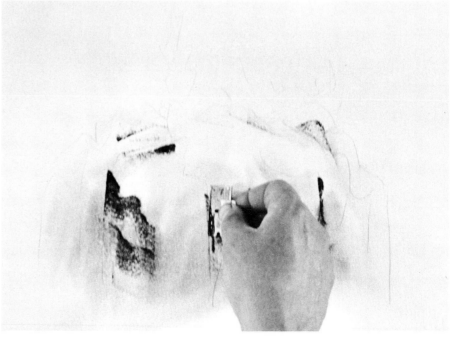

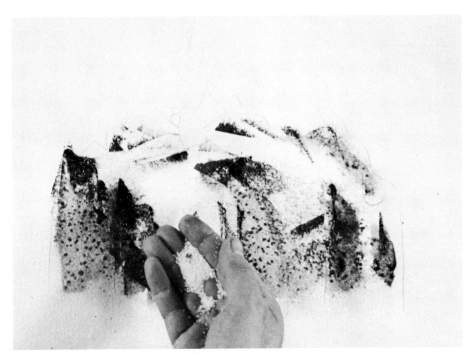

Step 3. I continue to apply paint with a razor blade, using the same treatment and colors, until the simple rock formation is complete. Then I drop coarse table salt into the wet washes to start a pattern of blotchlike textures. This action will slowly take place until the washes are dry.

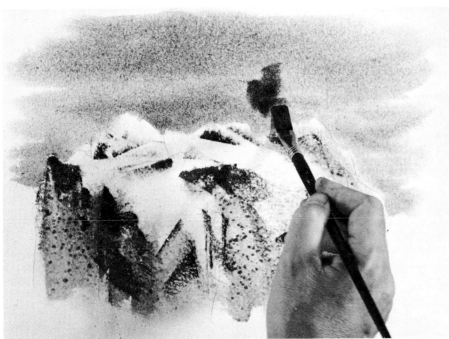

Step 4. I wash in a cool gray consisting of cobalt blue and burnt sienna above the rock formation to form the sky. Then I paint mixtures of cobalt blue and sap green into the wet sky to start rendering pine trees.

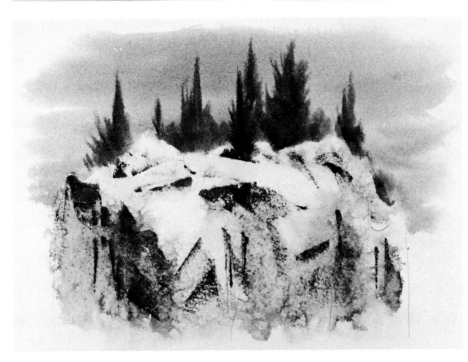

Step 5. I paint cobalt blue, sap green, and burnt sienna in colors ranging from cool blue to warm green and browns into the moist sky to complete the pine trees. When the painting is completely dry, I brush off the salt. The final textures give the feeling of rocks covered with ice and snow.

17
LIFTING OUT WET COLOR (SEA SPRAY)

In this demonstration I show how to paint a sky and water around a blank space of white paper and use a small sponge to depict foaming spray. My brushes are 3/4" (19 mm) flat, a No. 6 round, plus a razor blade and a piece of natural sponge. I work on a section of a sheet of 300-lb cold-pressed Arches paper that I previously stretched on a 3/4" (19 mm) thick plywood board. My palette is French ultramarine blue and burnt sienna.

Step 1. I wet the paper several times with a sponge and clear water, and leave it moist. Now, using the flat brush, I paint a soft blue-gray sky with French ultramarine blue grayed with a touch of burnt sienna, being careful to leave an area of white paper for a foaming spray. I use deeper mixtures of the same color to start rendering the ocean.

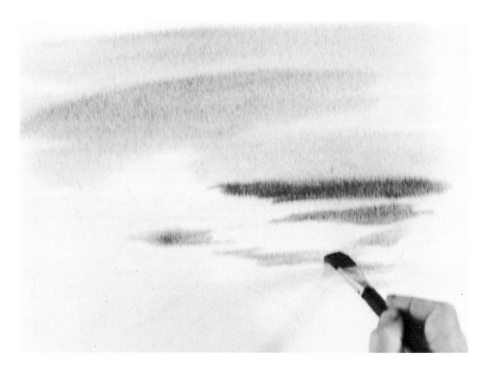

Step 2. After further work with the same brush and colors, I finish the ocean and start work on the rocks.

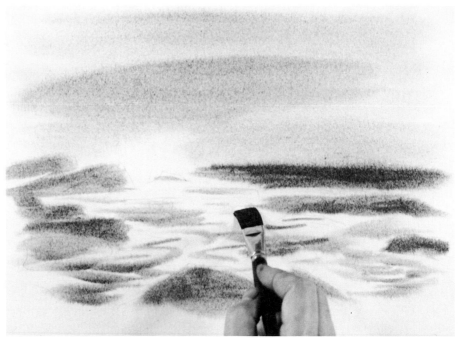

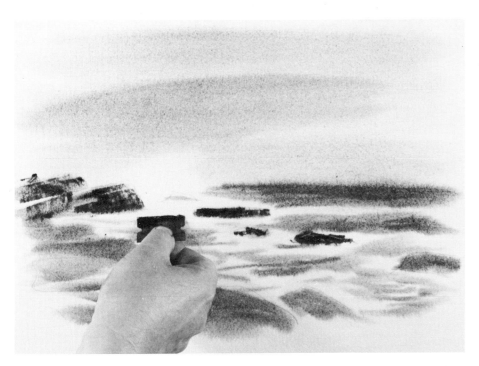

Step 3. By this time, the paper is slightly drier. So I scoop up thick mixtures of French ultramarine blue and burnt sienna on the front edge of a razor blade and use it as a squeegee to start rendering the waterswept rocks.

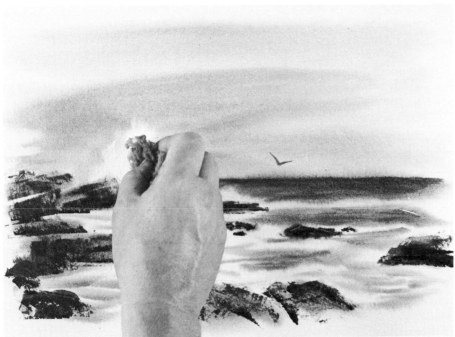

Step 4. I complete the rocks with the razor blade and color. Then, using the round brush, I paint a bird into the almost dry sky. With a moist (almost dry) sponge, I quickly lift out an edge from the still-moist sky to sharpen and enlarge the ocean spray.

Step 5. Now the picture is complete.

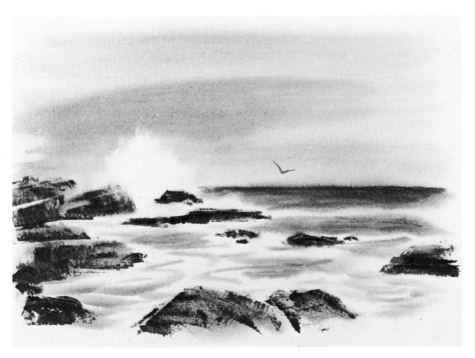

18

LET COLOR DRY AND WASH OVER (ROCKS)

I included this demonstration to show you how, by washing color over a dry area, you can adjust and harmonize its color—here, the rocks—to the tones in the rest of the painting. You will find another way to accomplish this demonstrated on pages 46-47. My tools are a 3/4" (19 mm) flat sable brush, a No. 6 round sable brush, and a razor blade. I use a section of a sheet of 300-lb Arches mounted watercolor board. My palette is burnt sienna, raw sienna, sap green, and French ultramarine blue.

Step 1. First I wet the paper surface to a moist condition with sponge and clear water. Then I scoop up French ultramarine blue and burnt sienna on the front edge of a razor blade, and stamp and squish it into the moist surface to suggest the start of rock formations.

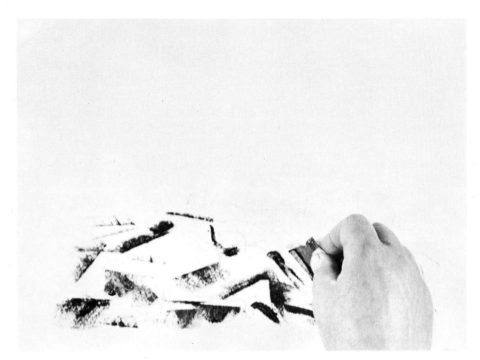

Step 2. I continue using the same technique until the rock formation seems complete in form, but still lacking its local or true color.

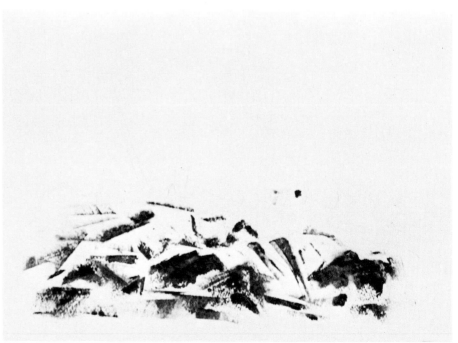

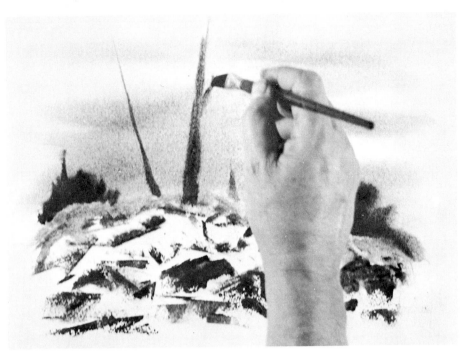

Step 3. With my flat sable brush, I mix a wash of French ultramarine blue, slightly grayed with a touch of burnt sienna, and flood it onto the paper for a soft blue-gray sky. Then, with a thick mixture of French ultramarine blue and burnt sienna, I add the tree trunks. With sap green, French ultramarine blue, and burnt sienna, I paint distant bushes and short growth, and add autumn-colored grass on top of the rock formation with raw sienna and some burnt sienna.

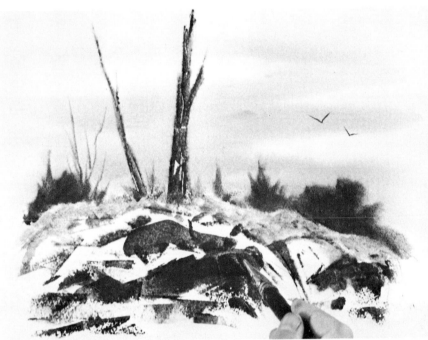

Step 4. With the round brush and burnt sienna and French ultramarine blue, I add some delicate branches in the rear at the left. Also, I strengthen the color of the autumn grass, again using raw sienna and burnt sienna. Now the painting is left to dry. When this is accomplished, I flick in a few birds with the round brush and burnt sienna and French ultramarine blue. Then I wash a light, warm glaze of burnt sienna and French ultramarine blue over the foreground rocks with the flat brush, as shown.

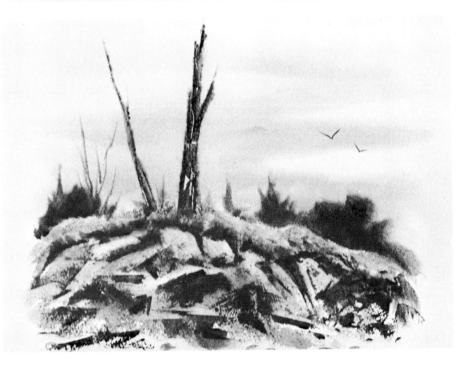

Step 5. I adjust this color right on the paper to run unevenly from warm to cool, thus adding to the color vibration while also harmonizing the color. Finally, I place a dark shadow on top of the rock formation below the brown and yellow grass to set it off, using deep mixtures of burnt sienna and French ultramarine blue, and the painting is complete.

19

LET ACRYLIC COLOR DRY AND WASH OVER (TREES)

In this demonstration, I use acrylic as an underpainting. When it dries, I paint over it with transparent watercolor. The method works well because the acrylic, once dry, doesn't lift up. This technique is used in the demonstration of rocks and sea on pages 65-69, and in the painting Another Time *on page 132. I use both acrylic and watercolor paints, a 1/2" (13 mm) flat sable brush and a single-edged razor blade. I paint on a section of a sheet of 300-lb Arches cold-pressed watercolor paper stretched on a 1/2" (13 mm)-thick plywood board. My acrylic palette is burnt sienna and cobalt blue; in watercolor, I use cobalt blue, burnt sienna, sap green, raw sienna, and black India ink.*

Step 1. I suggest a simple design, drawing it in with a No. 2 office pencil. Then I wet the paper with clear water, sponge it several times for penetration, then sponge off the excess water to a moist working surface. I begin the painting with acrylic paints only. With the flat sable brush, using burnt sienna and cobalt blue, I start to suggest tree trunks and several of the heavier branches.

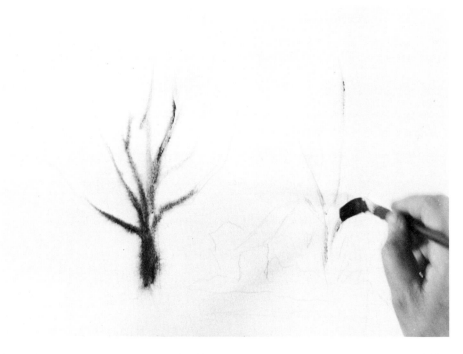

Step 2. Switching to a razor blade, I scoop up acrylic color—burnt sienna and cobalt blue—and press or squeegee on the color for more branches, establishing a simple pattern of branches. Now using a brush and burnt sienna with touches of cobalt blue, I paint the front and side of the house. Then the acrylic is left to dry.

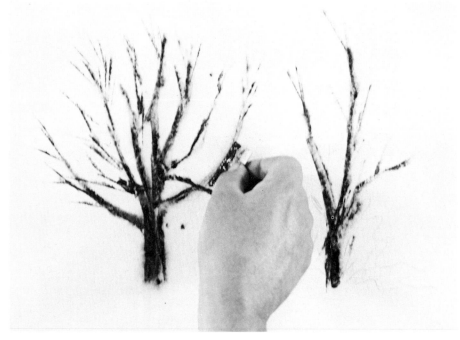

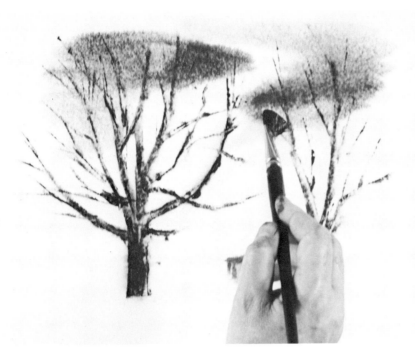

Step 3. Now I switch to transparent watercolor. First I rewet the entire surface of the paper again with a sponge and clear water. Then I flood watercolor washes of cobalt blue and burnt sienna, mixed in varying degrees of warm and cool tones, into the damp paper to form cloud formations. As you can see, the acrylic underpainting doesn't move or lift up; once dry, it's sealed in its own plastic binder.

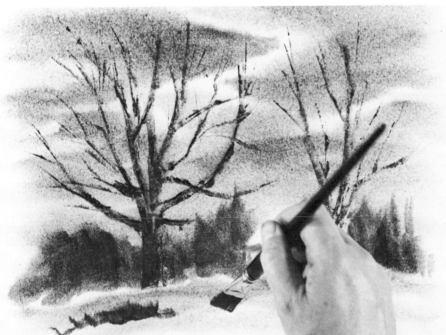

Step 4. When the sky is complete, I add a suggestion of distant trees with the brush and cobalt blue, burnt sienna, and sap green, deepened at times with India ink. Then, as illustrated, I paint an overall base color into the foreground using raw sienna and sap green. I strengthen the wash, modeling it with sap green, cobalt blue, and burnt sienna to suggest clumps of grass.

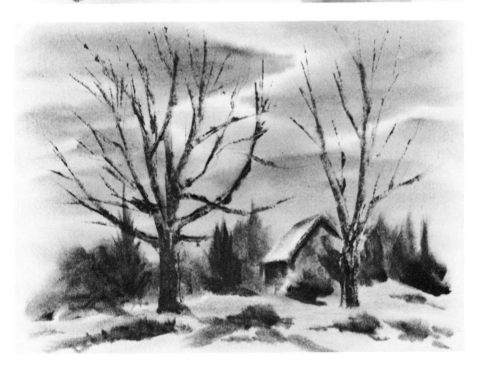

Step 5. Still using the brush, I add a bush in front of the house with sap green, burnt sienna, and India ink, and strengthen and deepen the distant trees with the same colors. Now I'm finished.

20

MOIST SPONGE ON DRY PAPER FOLLOWED BY WET WASH (TREES)

This demonstration shows how to quickly run a sky wash over a previously painted (and now dry) area of trees, deepening their value by working into the still-wet sky wash. You will also see how I use a frisket to protect certain areas I want to keep white, while I paint around them. My palette consists of raw sienna, burnt sienna, cobalt blue, sap green, and black India ink. My brushes are a 1 1/2" (38 mm) flat, a No. 10 round, and a natural sponge. I use a section of an Arches mounted watercolor board.

Step 1. I am working on dry paper. I cut out a cardboard frisket the shape of the white house and hold it in place while I sponge on sap green, raw sienna, and burnt sienna in various mixtures from blue to green and from warm to cool, to represent the surrounding trees. Next I work on the foreground, sponging in raw sienna with touches of burnt sienna and sap green for earth and vegetation, squishing and stroking on the paint with a sponge. Then I switch to a No. 10 brush and paint the tree trunks.

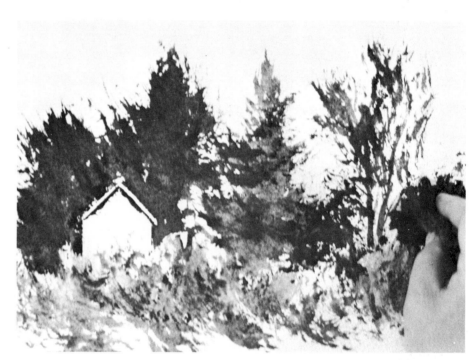

Step 2. After accenting the house with the tip of a No. 10 brush, I let the painting dry.

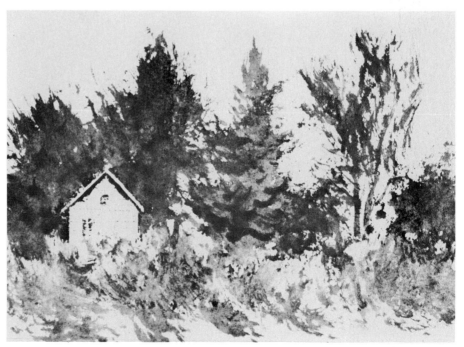

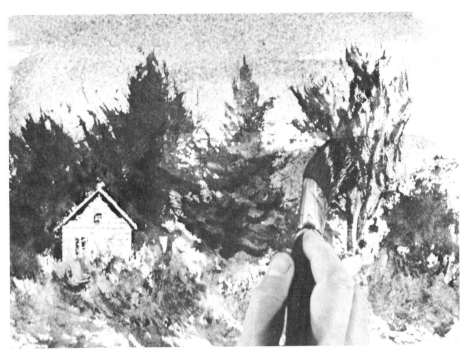

Step 3. Using the 1 1/2″ (38 mm) flat brush, I combine a puddle of raw sienna and cobalt blue on the butcher's tray and mix it to a blue-green hue. I quickly paint it across the trees for a blue sky.

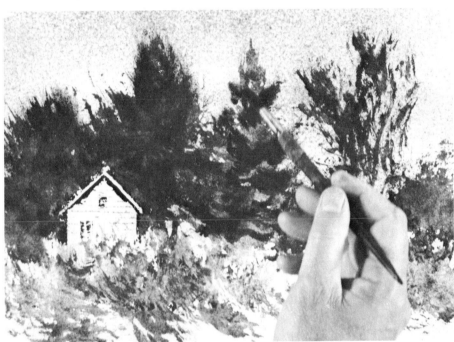

Step 4. As this wash settles, I work over the lighter passages I had previously applied with a sponge. I then paint deep mixtures of sap green, burnt sienna, and cobalt blue wet-in-wet with the No. 10 round brush to establish a dark pattern of trees with diffused edges.

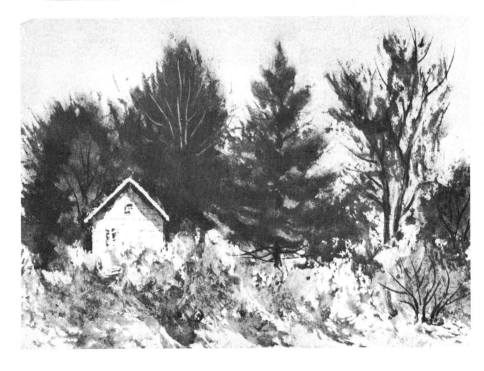

Step 5. I paint in branches in some areas with burnt sienna and India ink. Then, with the handle of a No. 10 brush, I squeeze out color from the wet paint for branches in the tree at the left center.

21

LET COLOR DRY, REWET, AND SQUEEGEE OVER (ROCKS)

The purpose of this technique—rewetting and squeegeeing on color and texture on top of dry washes—is two-fold. First, it allows you to concentrate on finishing the wet-in-wet areas first, before tackling areas requiring a different treatment.. Second, working on the rocks after the rest of the picture is completed gives me a chance to control the color relationships between the rocks and the rest of the painting to improve the color harmony. My brushes are a 3/4" (19 mm) flat sable, a No. 6 round, and a piece of folded cardboard. A section of a sheet of 300-lb Arches cold-pressed paper is stretched as usual and is ready for use. My palette is sap green, raw sienna, burnt sienna, cobalt blue, and black India ink.

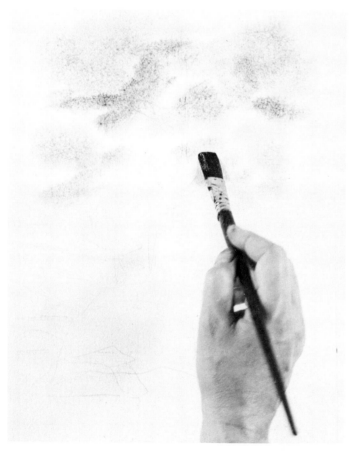

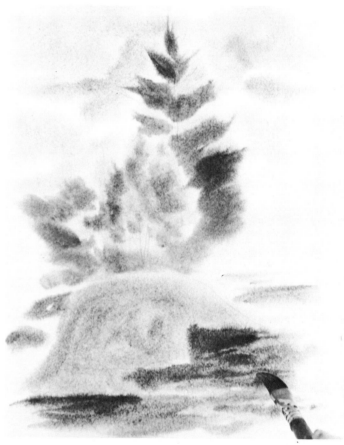

Step 1. First I wet the paper liberally several times with a sponge and clear water and then sponge off the excess until only a damp surface remains. Using a flat sable brush, I wash in a warm gray mixture of burnt sienna and cobalt blue for large cloud formations. I then dab pure cobalt blue between these warm clouds for spots of blue sky.

Step 2. I paint small leafy trees in the center of the tree grouping, using raw sienna and sap green. Then I start rendering pine trees with cobalt blue, burnt sienna, and sap green, painting them into the wet sky. Now I paint in a soft mixture of raw sienna, burnt sienna, and cobalt blue as a base for the rocks. Then I paint the water with cobalt blue, adding the subtle reflections of the overhead trees with burnt sienna, cobalt blue, and sap green.

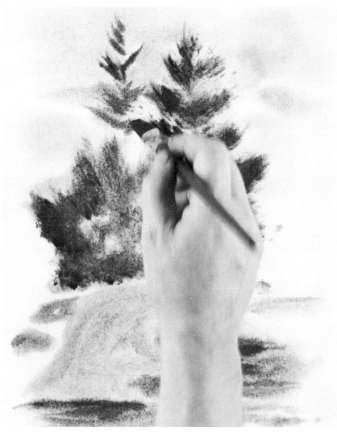

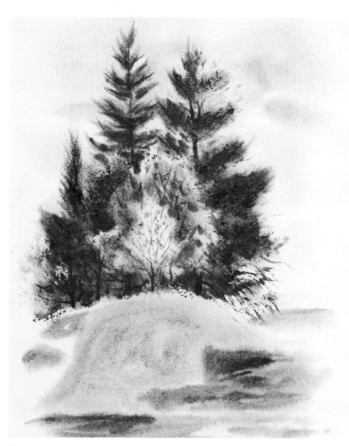

Step 3. Still using the same flat brush, I load it with sap green, cobalt blue, and burnt sienna and introduce another pine tree. I also deepen the color of the surrounding pines with the same colors.

Step 4. With a No. 6 round brush, I render the tree trunks, branches, and the smaller pine on the upper left. Then I let the picture dry.

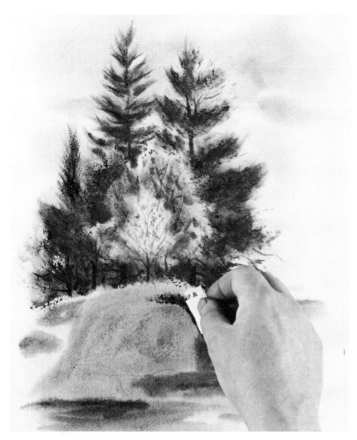

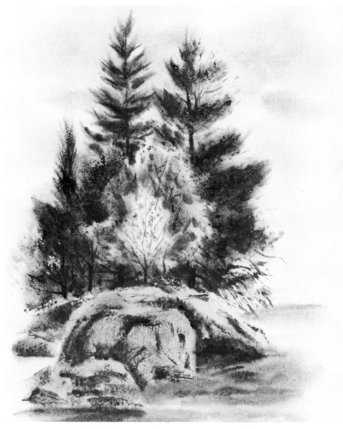

Step 5. Now I gently rewet the rock area using the flat brush and clear water. Then I take a small piece of light, folded cardboard and pick up cobalt blue and burnt sienna on one edge. I use this cardboard to start the rendering of the rocks by squeegeeing, pressing, and stamping the color onto the moist paper, as demonstrated.

Step 6. As I continue to build up the rocks using this technique, I harmonize my warm and cool mixtures. After the rocks are dry, I lightly drag the cardboard—loaded with thick mixtures of cobalt blue and burnt sienna—over the rocks in drybrush fashion to give them a crisper, sharper look.

22

LET COLOR DRY AND SPONGE OVER (TREES)

Here I demonstrate another technique for crisp, crackling texture. (I like to "see" objects with as many other senses as possible—and like to express this in my paintings. I advise my students to do the same.) This sponge technique is especially useful for tree groupings that are in the center of interest and must therefore be in sharp focus. My painting tools are a 3/4" (19 mm) flat sable, a No. 6 round brush, and a section of a natural sponge. A section of a sheet of 300-lb cold-pressed Arches watercolor paper stretched on a drawing board is also used. My palette is sap green, burnt sienna, raw sienna, and French ultramarine blue.

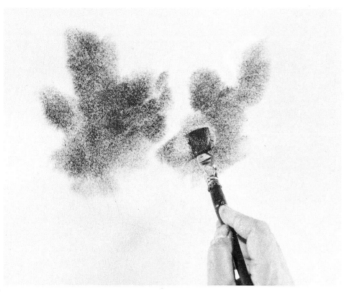

Step 1. I wet the entire painting area with clear water and a sponge, but leave the surface in a moist (not over-wet) condition. With the flat brush, I flood in swatches of sap green mixed with French ultramarine blue, raw sienna, and burnt sienna, to start rendering the trees.

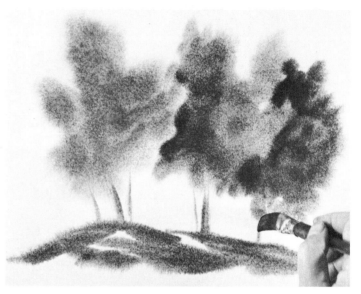

Step 2. Now, with burnt sienna and French ultramarine blue, I deepen and group the tree foliage. I paint the foreground, still using the flat sable brush with raw sienna, sap green, and French ultramarine blue, and a little burnt sienna to warm the green. Then I paint the tree trunks with a thick mixture of burnt sienna and French ultramarine blue.

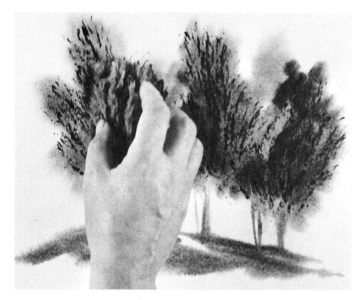

Step 3. Now I dip a moist sponge into French ultramarine blue, sap green, and burnt sienna, and stipple on texture, using the natural sponge as a painting tool. The sponging is done right on the dry paper, working right over the trees with a slight dragging motion.

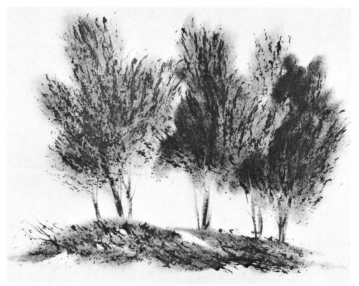

Step 4. Lightly stippling paint over the foreground with a slipping motion of the sponge gives a feeling of texture to the grass and leaves. Switching to a No. 6 round brush and using heavy mixtures of burnt sienna and French ultramarine blue, I darken some tree trunks and add some extra branches.

A good way to add more texture to bland, overly soft-looking trees is to rewet the area with clear water and sponge texture into the moist surface. To demonstrate how to do this, I use a 1/2" (13 mm) flat sable brush, a No. 6 round sable brush, and a natural sponge. I work on a section of a stretched sheet of 300-lb Arches cold-pressed water-color paper. My palette is Hooker's green, raw sienna, burnt sienna, and French ultramarine blue.

23
LET COLOR DRY, REWET, AND SPONGE OVER (TREES)

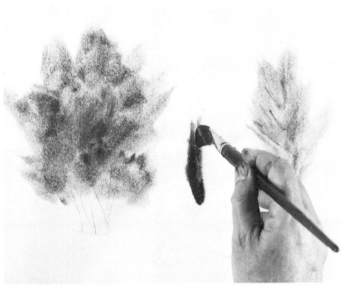

Step 1. I wet the sheet of watercolor paper with a clean sponge and clear water for a moist surface. With a flat brush, using Hooker's green and raw sienna with touches of burnt sienna, I start to suggest loosely painted tree foliage.

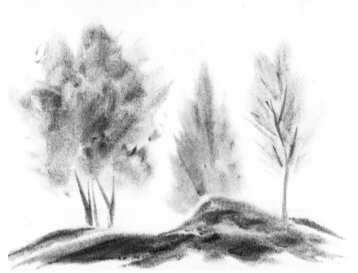

Step 2. I then render the tree trunks with a No. 6 round brush. Switching again to the flat brush, I paint a base of raw sienna and Hooker's green into the foreground, and work into it with burnt sienna and French ultramarine blue while it's still wet, for texture. Then I let the paper dry.

Step 3. When it's completely dry, I rewet the entire sheet by lightly blowing clear water over it with a fixative sprayer. I wait until the moisture on the painting surface is half dry, then with a natural sponge, I sponge on deeper-colored textures with Hooker's green, burnt sienna, and French ultramarine blue.

Step 4. Using a small section of the sponge, I continue to render the center tree, applying a cool gray mixture of burnt sienna and French ultramarine blue with a brush-like motion. I deepen the color and texture of the moist, grassy area with French ultramarine blue and burnt sienna. Then, with a No. 6 round brush and burnt sienna and French ultramarine blue, I finish the tree trunks and branches.

24

LET WET-IN-WET COLOR DRY AND ADD DRYBRUSH (FOREGROUND DETAIL)

Here I paint a picture to near completion, then finish the foreground detail with drybrush and a sponge. My brushes are a No. 10 round, a No. 6 round, a 3/4" (19 mm) flat, and a natural sponge. I use a quarter of an Arches premounted watercolor board with a rough texture. My palette consists of French ultramarine blue, burnt sienna, Grumbacher red, and raw sienna.

Step 1. I wet the entire paper by sponging it with clear water several times, and then sponging it again to a semi-wet surface. I paint in the sky, wet-in-wet, using the flat brush and French ultramarine blue and burnt sienna. Then I work a base color of raw sienna into the foreground. I add a purple mountain in the distance with French ultramarine blue and a touch of Grumbacher red.

Step 2. With a No. 6 round brush and burnt sienna and French ultramarine blue, I paint in a suggestion of tree trunks. I add a swatch of the same color in the middle foreground for texture. Then I dip a damp sponge in burnt sienna and French ultramarine blue and start texturing the dried leaves, as shown.

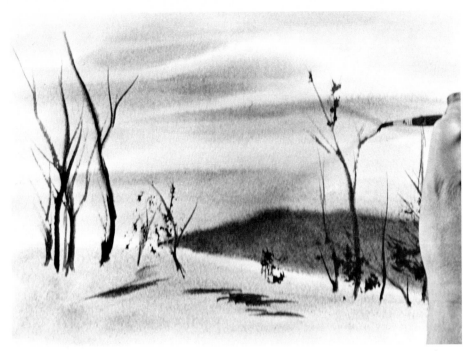

Step 3. Still using the No. 6 brush and thick mixtures of French ultramarine blue and burnt sienna, I develop the trees further. Then I let the picture dry. I plan to finish the rest of the painting mostly with a dry sponge and drybrush strokes.

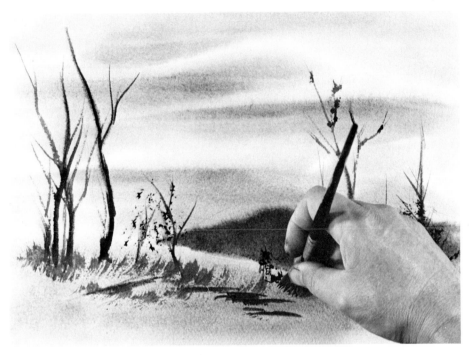

Step 4. I now take a No. 10 round brush, press it into a fan shape, and drybrush in dry, brown grass with burnt sienna.

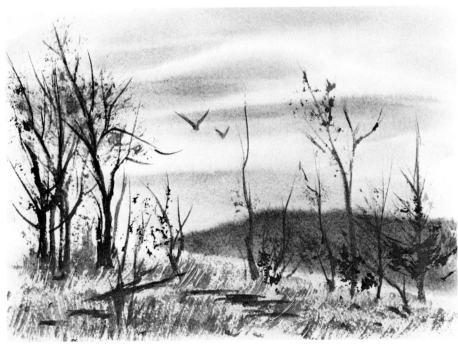

Step 5. I continue using this technique until the foreground is complete. Then I dip a damp sponge into burnt sienna and stipple and squish the suggestion of more dry leaves onto the trees. I add another tree and two birds in flight, and my picture is complete.

25

LET COLOR DRY AND SCRATCH OUT (DETAIL)

This demonstration shows how I scratch out highlights and such details as branches, twigs, and dead tree trunks on dry paper. For the demonstration, I select a section of a sheet of 300-lb Arches cold-pressed watercolor paper stretched on a 1/2" (13 mm)-thick plywood board. My tools are a No. 6 round sable brush, 1/2" and 3/4" (13 and 19 mm, respectively) flat sable brushes, and an X-Acto knife with a No. 11 blade. My palette consists of French ultramarine blue, raw sienna, sap green, burnt sienna, and black India ink.

Step 1. I wet the paper several times with a sponge and clean water for deeper penetration. Then I sponge it to a moist surface wetness. Now, with a natural sponge, I stipple, sponge, and squish on mixtures of burnt sienna, sap green, and raw sienna into the moist surface to suggest tree foliage. Switching to the 1/2" (13 mm) brush, I paint the edge of the bank beneath the trees with raw sienna, transforming it into brown fall grass. Then with the 3/4" (19 mm) brush, I drag raw sienna and burnt sienna with sap green into the water area for grass and tree reflections.

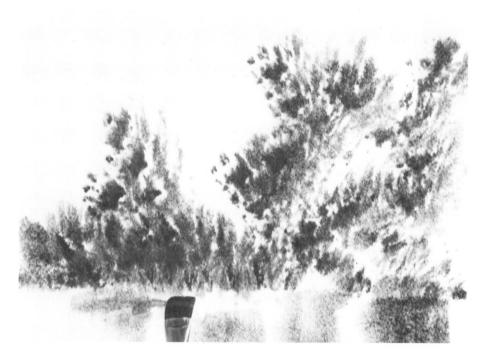

Step 2. With the 1/2" (13 mm) flat brush and the same colors, I cut the water around the fallen tree trunk. Then I paint the long, surface-tension ripples on the water, from the edge of the bank down, with the same brush and French ultramarine blue and burnt sienna mixed to a blue-gray. I sponge burnt sienna and sap green with India ink into the tree areas to deepen their value.

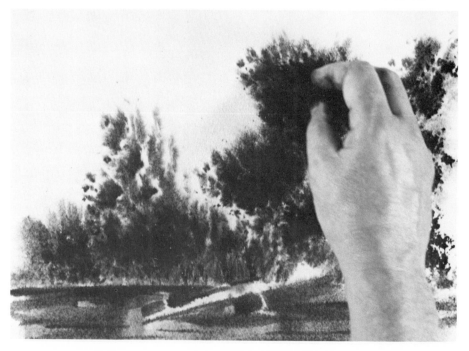

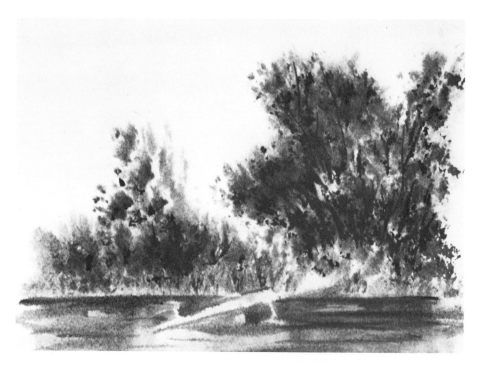

Step 3. Using a No. 6 round brush and India ink with burnt sienna, I paint branches into the larger mass of trees. Then I let the painting dry.

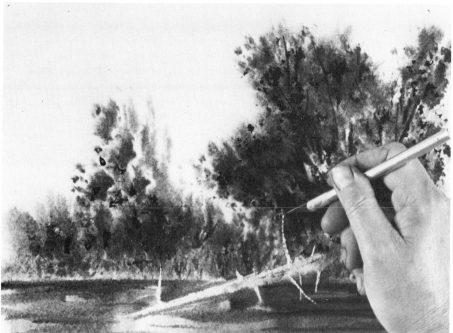

Step 4. After it's dry, with an X-Acto knife, I scratch out the highlights on the fallen tree trunk. I press and drag the knife firmly, being careful not to cut the paper.

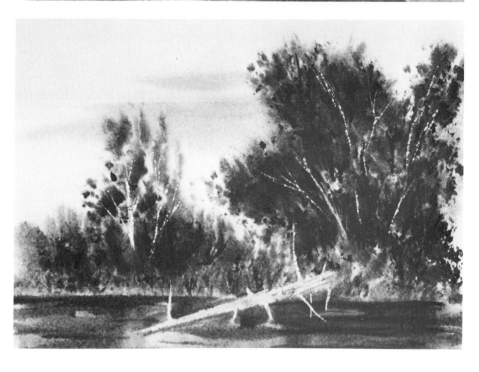

Step 5. I also use the knife to scratch out branches in the groupings of trees to help give the illusion of flashing sunlight.

VALUES: THE KEY TO SUCCESSFUL PAINTING

When planning the composition of your paintings, it's a good idea to consider the basic division of light and dark areas and the percentage you allot to each division. If you analyze practically all successful paintings, you'll find that certain basic patterns or distribution of values occur regularly. To figure out the value distribution in a finished painting, consider all whites, near whites, and their neighboring middle values as one value group, and all darks, near darks, and their neighboring values as another.

Now decide approximately what percentage of the picture is occupied by light values and what percentage by dark values. You may find it helpful to make a little diagram of this breakdown such as the examples on the facing page.

If equal amounts of these two groups comprise the entire picture, you have a 50/50 or nearly 50/50 percentage division of light and dark. This division can be rather dull, since a picture that's equally divided in values lacks emphasis and excitement. The simplest way to correct this error is by subduing all the unnecessary visual passages or details by darkening them. Try to aim for an overall value arrangement of approximately 1/3 light contrasted with 2/3 dark for more visual excitement. However, to avoid repainting a finished painting, it's much better to plan your overall value arrangements in advance, before you start painting.

The concept of a 1/3, 2/3 distribution of values is not really contrary to the idea of the three-value picture that is proclaimed by most theorists because, as I see it, the third or middle value generally masses with either the light or the dark values, still leaving two values dominant. Therefore, for the best value arrangement, make sure your middle values join with either the light or the darks for a 1/3, 2/3 division: 1/3 light, 2/3 dark or 2/3 light, 1/3 dark.

Let's now consider a painting where the darks and lights are dispersed through the entire composition. Once again, to analyze the painting, you compute the whites, near whites, and their neighboring middle values visually and add them up to form one light value group. Then add up your darks, near darks, and their neighbor-

ing values to form a dark value group. Again, for a good picture, these groups should fall into the 1/3, 2/3 value pattern, with either light or dark dominating.

Since the eye usually travels to light areas, as an artist, you direct the viewer's eye wherever you wish it to go. The area you select is known as *the center of interest*. To get the eye to travel through a painting and fix on the center of interest, you must subordinate other areas or passages so they don't demand attention. This can be accomplished in any or all of three ways: 1) by diffusing the subordinate areas with soft edges; 2) by lowering their value to keep them out of the field of vision; and 3) by keeping neighboring values in subordinate areas in close relationship to each other so that their divisions are muted and they mass together. All these devices keep the eye from being trapped in less important areas, leaving it free to focus on the center of interest.

At the same time, you can emphasize the center of interest in four ways: 1) by making it lighter than the other areas; 2) by placing the greatest contrasts in value there; 3) by sharpening or hardening the edges in that area; and 4) by using a combination of these ideas.

In many paintings the lighter values are grouped in the center and surrounded by darker values near the perimeter. Your eye slips over the darker values to the lighter values in the middle. Though this is true of many paintings, the direct opposite is true in vignettes. In the vignette arrangement, the stronger, deeper values lay near the center of the painting and the eye slips over the white surrounding the painting and is trapped by the values and color in the center of the composition.

It might be a good idea to mention at this point that color can also be thought of and handled in much the same way. For areas of greater interest, use brighter color; for sections that you want the eye to slip over, use soft or muted color; and for passages that should be barely visible, use dark color.

Study the typical value groupings on the next page. The lights and darks on all but the first example could be reversed while still keeping a 1/3, 2/3 balance in value. We shall see how I put this two-value concept to use in the next four paintings.

50/50 Division. A poor painting concept.

2/3 Light, 1/3 Dark. Anywhere between 2/3 to 3/5 light and 1/3 to 2/5 dark, as here, or vice versa, is the range of tolerance I prefer.

Asymmetrical Distribution. Here range is between 1/3 to 2/3 light and 2/3 to 3/5 dark, distributed asymmetrically.

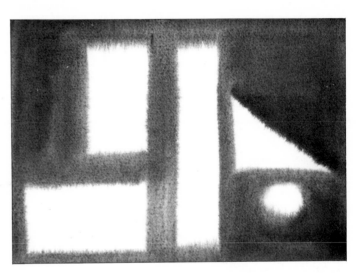

Scattered Distribution. Here the 1/3 light and 2/3 dark division is scattered throughout the painting.

Horizontal Composition. This is a horizontal arrangement of 1/3 light, 2/3 dark, one that is commonly seen in the landscape.

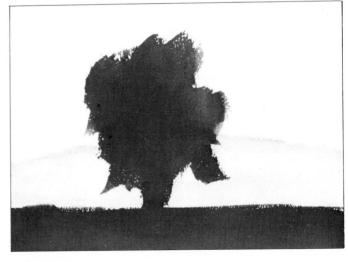

An Example. This is the way a distribution of 2/3 light, 1/3 dark might be incorporated in a landscape painting.

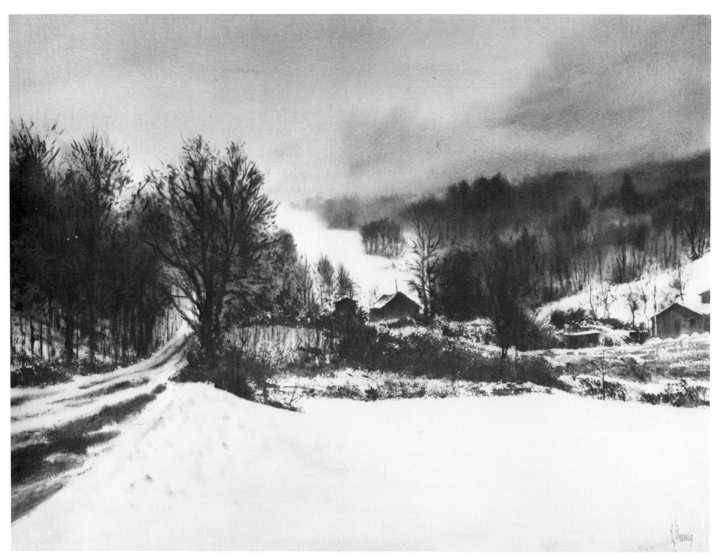

Catamount No. 1. (Above) Watercolor on 300-lb Arches cold-pressed, stretched watercolor paper, 21 1/2″ x 29 1/2″ (54.6 x 74.9 cm).

Value Breakdown. (Right) The sky and foreground become a single value of 2/3 light, with the dark center passages making it a 1/3 dark. This gives a slightly lighter atmospheric feeling compared to *Catamount No. 2*. (This painting can be seen in color on pages 126–127.)

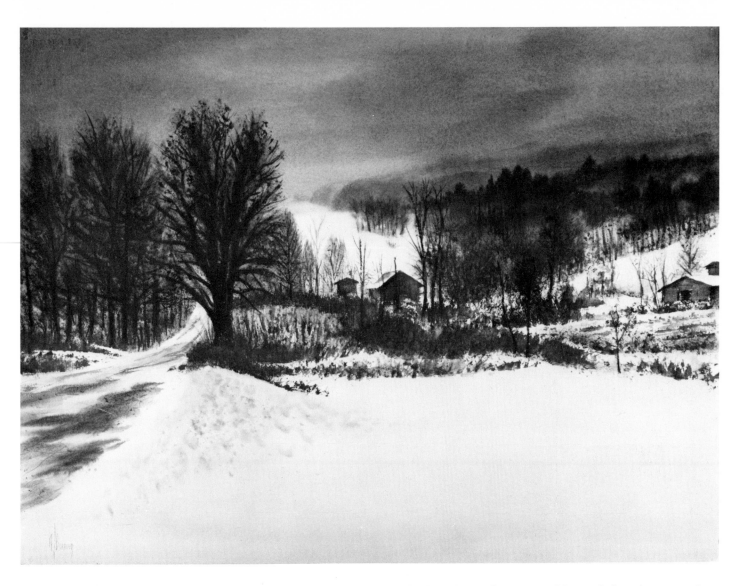

Catamount No. 2. (Above) Watercolor on 300-lb Arches cold-pressed, stretched watercolor paper, 21 1/2″ x 29 1/2″ (54.6 x 74.9 cm).

Value Breakdown. (Left) Here the darker sky is more closely related in value to the darker passage of the trees and building. Having them both combine to become a 2/3 dark with an approximately 1/3 light foreground gives the same composition a heavier mood.

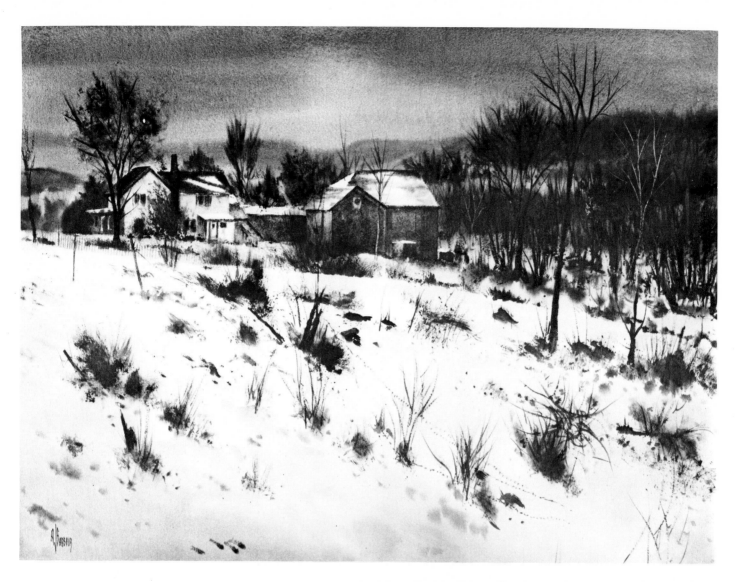

New York Farm. (Above) Watercolor on 300-lb Arches rough-textured, mounted watercolor board, 21 1/2″ x 29 1/2″ (54.6 x 74.9 cm).

Value Breakdown. (Right) The *New York Farm* picture is another simple example of this concept. Here the dark sky and the group of dark mountains and trees merge together for an approximately 1/3 dark area, contrasting with a foreground that is 2/3 light.

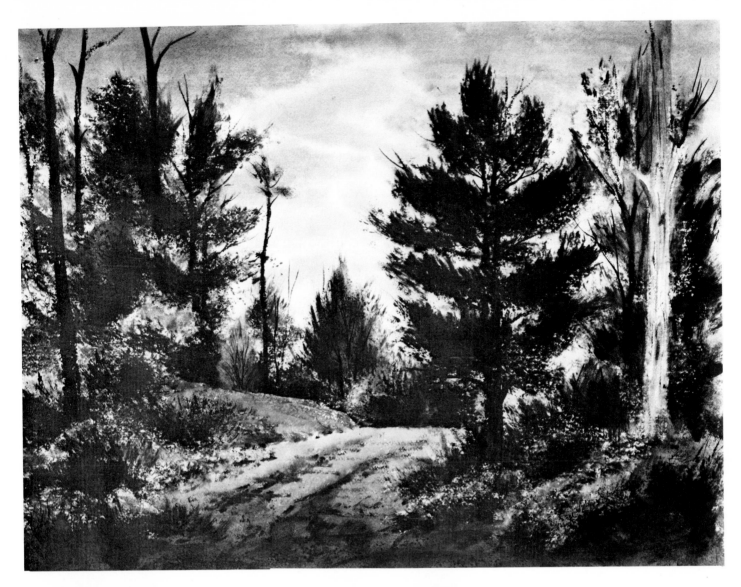

Just Over the Rise. (Above) Watercolor on 300-lb Arches cold-pressed, stretched watercolor paper, 21 1/2″ x 29 1/2″ (54.6 x 74.9 cm).

Value Breakdown. (Left) This monoprint shows a vertical distribution of major values and comprises a 1/3 light area in the center, surrounded by 2/3 dark. (A complete demonstration of this painting appears in color on pages 120–123.)

COLOR DEMONSTRATIONS

1

A MISTY MOUNTAIN

In this demonstration, I paint a foggy mountain top in the early morning mist. My palette consists of just two colors for simplicity and unity: cobalt blue and burnt sienna. My materials are a 1" (25 mm) oval wash brush, a No. 6 round sable brush, a folded cardboard matchbook cover, and an X-Acto knife with a No. 11 blade. I am using a half sheet—15" x 22" (38 x 56 cm)—of Arches 300-lb cold-pressed watercolor paper stretched on a small 1/2" (13 mm)-thick plywood board.

Step 1. First I wet the entire upper portion of the sheet with a sponge and clear water. Then I spread a rather heavy wash of cobalt blue and burnt sienna into the damp paper with the 1" (25 mm) oval wash brush.

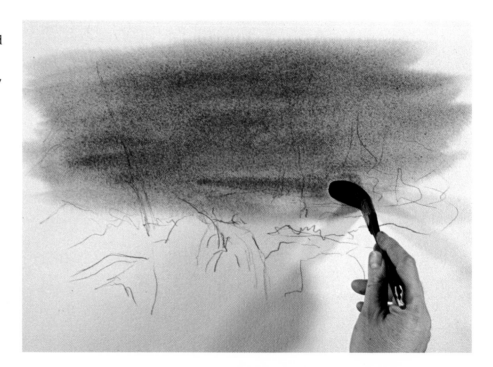

Step 2. I wash in cobalt blue and burnt sienna loosely with the same brush to start the development of the distant, misty trees. They are then accented with the same colors, using a No. 6 round sable brush. As this wash settles into the paper, I add deeper mixtures of burnt sienna and cobalt blue for the dead tree trunks.

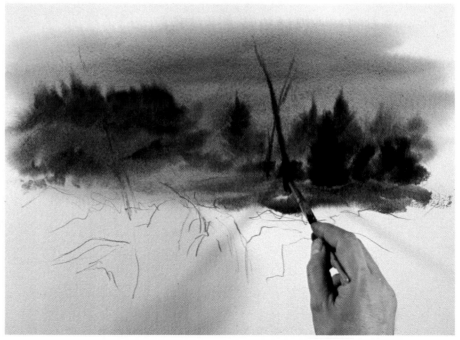

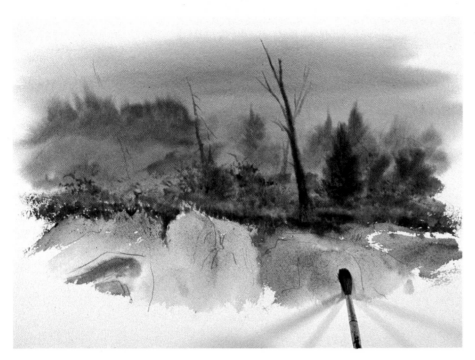

Step 3. I complete the trees and begin work on the foreground. First burnt sienna with a touch of cobalt blue is painted into the bottom washes on top of the rocks for dried grass. Then I sponge on a little of the same colors in the middle of the painting for a hint of bush. A warm, pale wash of burnt sienna and cobalt blue is then put in to start the rendering of the foreground rocks.

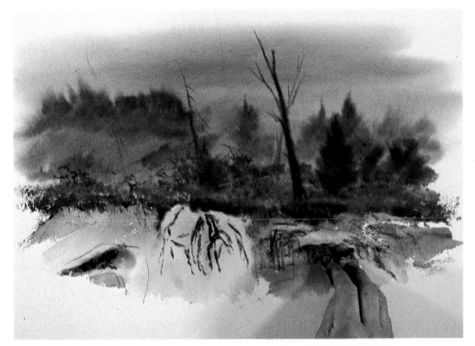

Step 4. While the rock wash is still moist, I fold a matchbook cover in half, dip it into the two colors in uneven amounts, and gently mingle the colors together by slipping the cardboard on the palette. I then use this matchbook cover as a squeegee to stamp and drag the paint onto the paper and add a loose touch of realism to the rocks.

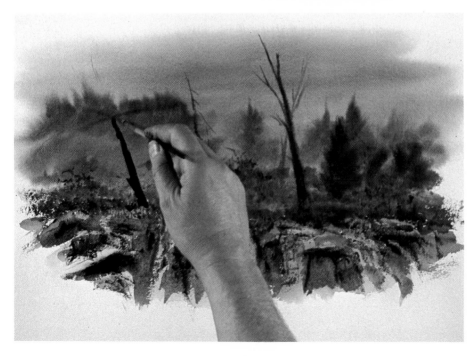

Step 5. When this area is dry, I run over it again with the squeegee for a crackly, drybrush effect. I add another dead tree for better balance.

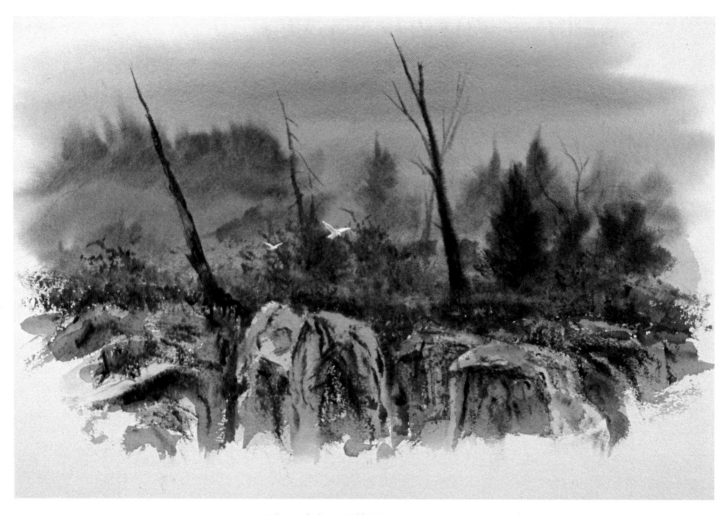

Edge of the Cliff. When the paper is thoroughly dry, I scratch in two white birds with an X-Acto knife and tint them very lightly with burnt sienna. The soft trees contrast with the sharper nearby foreground rocks and add to the illusion of morning mist.

In this picture of the rocky coast off Maine, I explore the meeting of two types of watercolor media: transparent watercolor and acrylic watercolor. My tools are a 1" (25 mm) oval wash brush and 3/4" (19 mm) and 1/2" (13 mm) flat sable brushes, plus razor blades and sponges, and, in this instance only, wood alcohol. My palette consists of the acrylic colors of Grumbacher red, cobalt blue, and burnt sienna. In transparent watercolor, I again select tubes of Grumbacher red, cobalt blue, and burnt sienna, plus raw sienna and a jar of opaque white tempera. I stretch a 22" x 30" (56 x 76 cm) sheet of 300-lb cold-pressed Arches watercolor paper on a 3/4" (19 mm)-thick plywood board, and I'm ready to begin.

2
ROCKS AND SEA

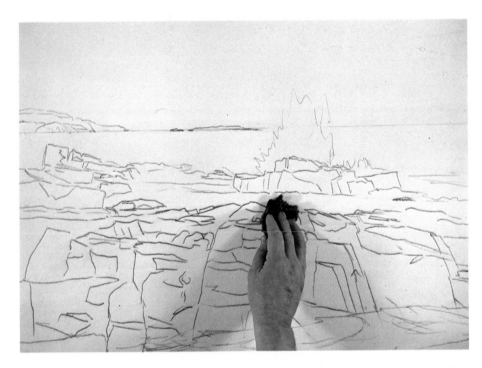

Step 1. I first wet the entire lower half of the sheet, sponging it liberally with clear water from the horizon down. I then remove the excess moisture from the surface of the paper with a damp sponge.

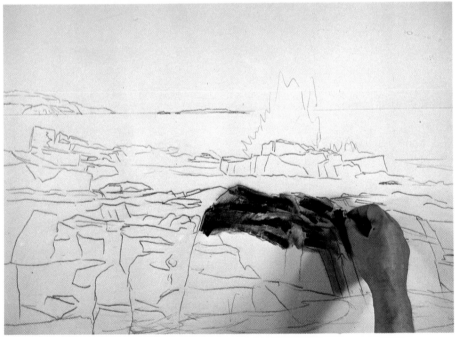

Step 2. From now on, and until Step 9, I will be using acrylic paints only. With a 3/4" (19 mm) flat brush and cobalt blue and burnt sienna, I paint a warm middle value on the large central rock. I then scoop up cobalt blue and burnt sienna from the watercolor tray onto the edge of the razor, keeping the colors broken and uneven. I then stamp and squeegee the blade into the moist surface to indicate the start of rock formations.

Step 3. I now slip burnt sienna, cobalt blue, and Grumbacher red onto the blade to render the central rock formation in the water.

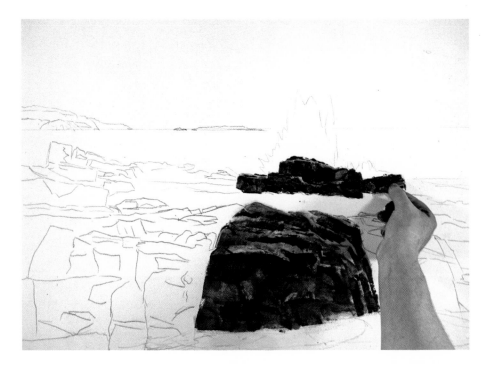

Step 4. With a 3/4" (19 mm) flat brush I apply a wash of burnt sienna and cobalt blue, mixed to a warm gray with a dash of Grumbacher red as an undertone, in preparation for rendering the rocks with color and razor blade.

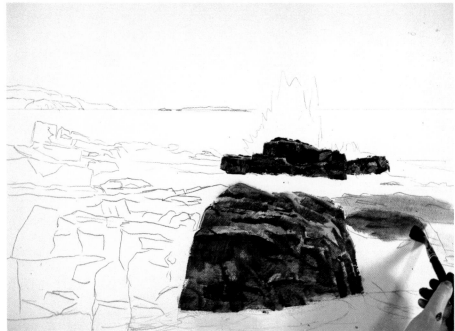

Step 5. With the razor blade, using burnt sienna and cobalt blue, I finish that section of rock and insert a small one just above it. The paper is now just about dry, and I'm still not satisfied with the center rock; there are too many rocks of the same shape here. So with a sponge and wood alcohol, which will remove acrylic, I sponge off most of the acrylic and correct that area.

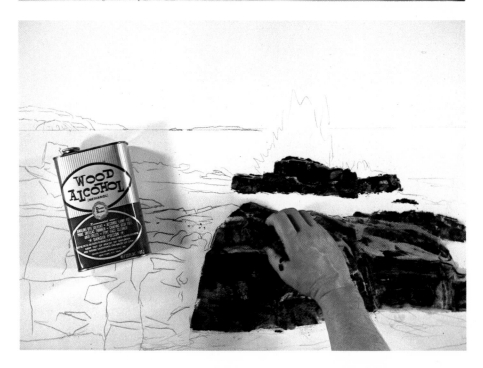

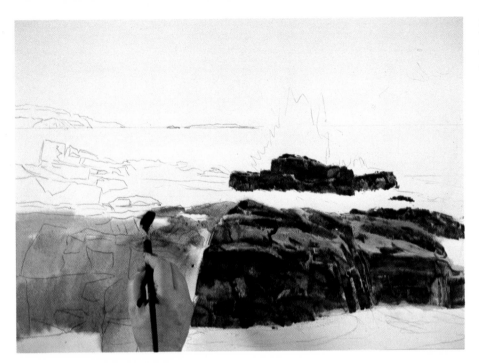

Step 6. Now, with a 3/4″ (19 mm) flat brush I run a warm wash of burnt sienna and cobalt blue over the left side of the rocks.

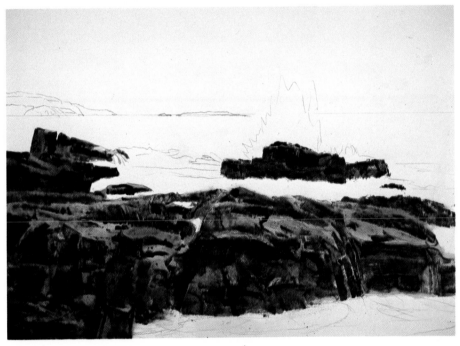

Step 7. I then run the same wash over the rocks above and to the rear. Both areas are finished in shape and texture by stamping, pressing, and dragging the razor blade, dipped in burnt sienna and cobalt blue with a touch of Grumbacher red.

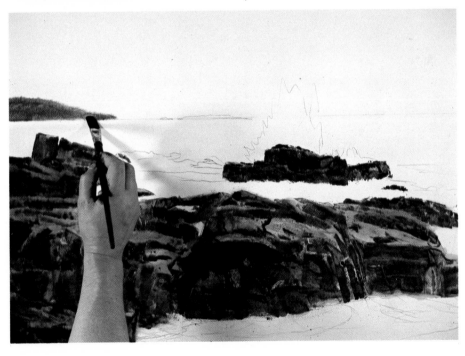

Step 8. I wet the upper section of the picture with a sponge and paint in the coastline on the upper left with a 3/4″ (19 mm) flat brush and cobalt blue, a little burnt sienna, and Grumbacher red.

Step 9. With the same colors, I paint in the middle island next and allow it to dry. At this point, the whole picture is completely fixed, since acrylic is indissoluble. I can now work over the acrylic with regular watercolor, without it lifting up. I wet the entire upper portion of the painting several times with a sponge and clear water—right over the top section of the rocks, island, and coastline. Now I switch to transparent watercolor. I paint a strong wash of raw sienna into the sky and water with a 1″ (25 mm) oval wash brush, working around the area where I will place the white spray of water.

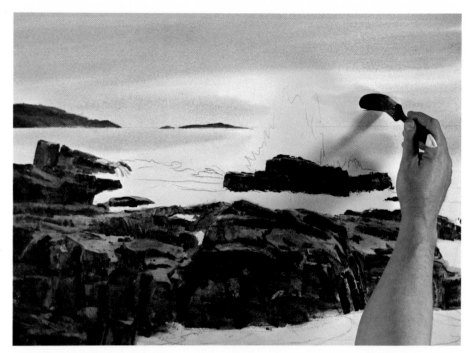

Step 10. I mix cobalt blue and burnt sienna directly into this wet sky undertone to form gray, windswept clouds.

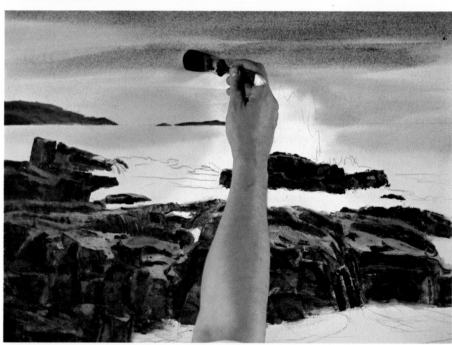

Step 11. After the sky is complete, I mix cobalt blue and burnt sienna into the ocean area for a slight blue-green effect, painting it rather carefully around the shape of the large ocean spray. The ocean water is completed with a 1/2″ (13 mm) flat brush, leaving generous amounts of white paper above the rocks for ocean foam.

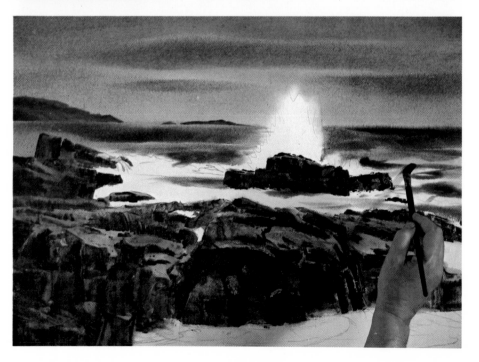

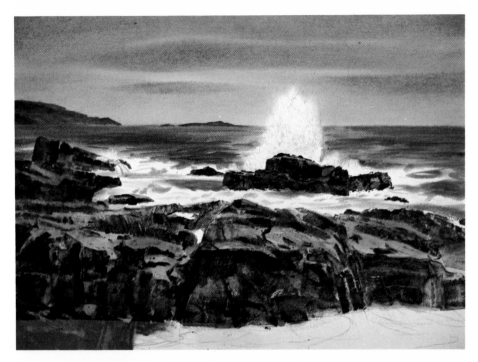

Step 12. With a 1/2″ (13 mm) flat brush charged with cobalt blue and raw sienna, I ripple and texture the ocean somewhat more to completion. I work into the foam area gently with the same brush and colors to add depth and motion.

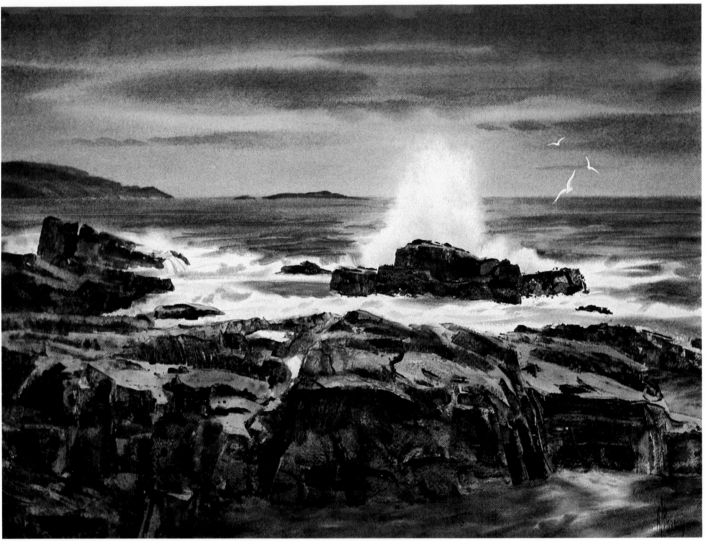

Breaking Surf. Next I sponge the bottom section with clear water and introduce burnt sienna for rock reflections. I then paint in raw sienna and cobalt blue for water. I am unhappy with the sky. I rewet the entire area carefully with a 1 1/2″ (38 mm) flat brush and clear water so as not to lift the underwash of transparent watercolor, and paint back into it with raw sienna, burnt sienna, and cobalt blue. When it's dry, I add three birds with white tempera. I soften the spray by lifting the color with a moist sponge, then blotting it with a paper towel. I also lift a smaller spray on the far left with the sponge. I tint the puddles on the rocks a pale gray.

3
A SOUTHERN MANSION

In this painting, I again explore the razor-blade technique along with some salt treatment, using an architectural subject. Vertical washes or planes of light are introduced into the painting to help integrate and hint at a mystical mood of bygone days. This painting will be a composite of several sections of this mansion. A sheet, 22" x 30" (56 x 76 cm), of 300-lb Arches cold-pressed paper is stretched on a drawing board. I use sponges, razor blades—both whole and broken, a 1" (25 mm) wash brush, a 1/2" (13 mm) and 3/4" (19 mm) flat sable brushes, a No. 6 round sable, and coarse, kosher salt. My palette consists of cobalt blue, burnt sienna, raw sienna, sap green, Thalo blue, Grumbacher red, and French ultramarine blue.

Step 1. I soak the entire paper thoroughly with clear water by sponging it several times, and bring its surface to the proper degree of wetness by sponging off the excess moisture. I then flood in a pale wash of Thalo blue with a 1" (25 mm) oval wash brush.

Step 2. I paint raw sienna and sap green into the sky area around the building at the upper left using a 1/2" (13 mm) flat brush. Then, with a sponge dipped into thick colors of burnt sienna and French ultramarine blue touched with sap green, I stipple on the trees.

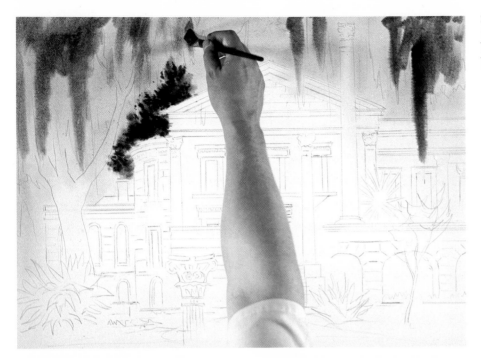

Step 3. I wet the sky area and begin to indicate Spanish moss with Grumbacher red and French ultramarine blue and a 3/4″ (19 mm) flat brush.

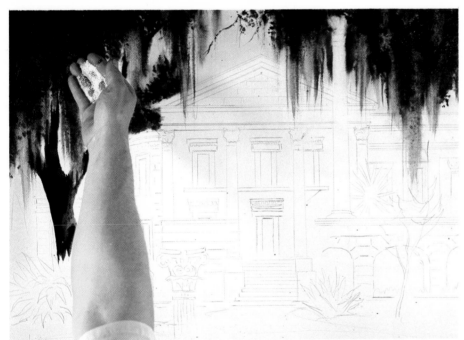

Step 4. I add sap green and burnt sienna to modify the color of the moss, and stipple on texture with a sponge dipped in French ultramarine blue and burnt sienna. I also stipple on the leaves in the center sky area between both trees. The tree trunks are painted in next with a 1/2″ (13 mm) flat brush and thick, dark mixtures of French ultramarine blue and burnt sienna. I then add salt to further texture the damp moss and foliage as the paper dries.

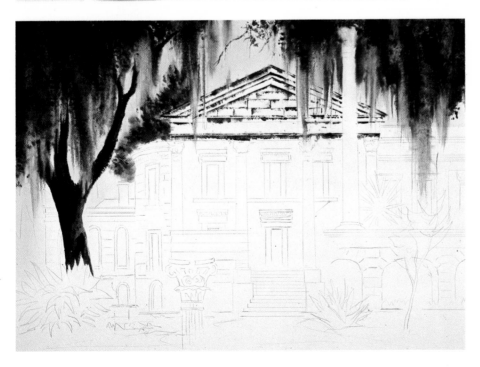

Step 5. While the paper is still moist, I dip a razor blade into cobalt blue and burnt sienna and press and slightly squeegee it into the building area in order to start developing the stone structure. This is as far as I can go with one wetting, so the paper is left to dry.

Step 6. I wet the sections between the main columns and paint raw sienna into the shadow areas first with a 3/4" (19 mm) flat brush. Next I start to paint in a rich, deep purple with a mixture of Grumbacher red and French ultramarine blue, letting the raw sienna shine through softly.

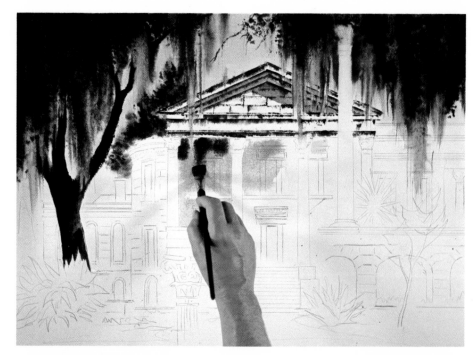

Step 7. As these washes settle a bit and start to dry, I paint in the windows and the area beneath the overhanging balcony with a No. 6 round brush and black India ink mixed with burnt sienna.

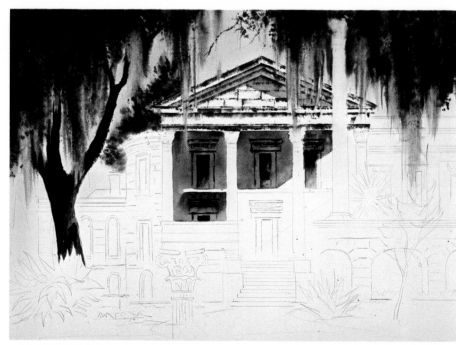

Step 8. Using the same razors and brushes, I rewet the paper in sections and inject first raw sienna, then French ultramarine blue and Grumbacher red into the rest of the building. I scoop up cobalt blue and burnt sienna from the tray with a razor and use the edge to render stonework. Burnt sienna and Grumbacher red are used for the roof. I wet the large composite column head and render it with the razor blade and paint. The small palm tree area is then wet and painted with burnt sienna, raw sienna, and sap green, plus a touch of India ink. I render the diagonal shadow on the right-hand side of the building with French ultramarine blue and Grumbacher red, and add raw sienna for the reflected light. The horizontal projections are rendered with burnt sienna and cobalt blue on a razor blade.

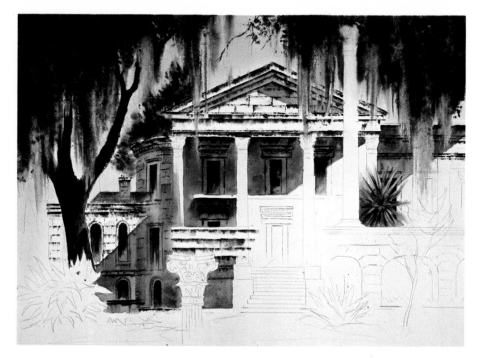

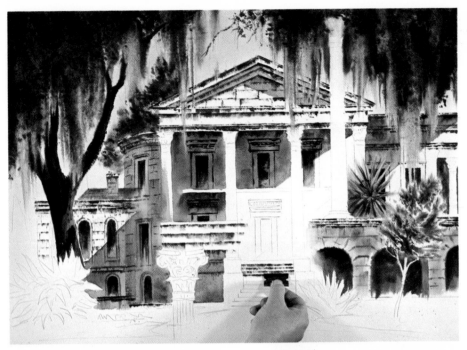

Step 9. I wet the tree and archway area on the right. First I paint in sap green and raw sienna for the tree. Then I stipple it lightly with a sponge and dark, thick colors of French ultramarine blue and burnt sienna. The archways are painted in with a 1/2″ (13 mm) flat brush, starting with a light wash of burnt sienna, Grumbacher red, and cobalt blue. The top ledge section above the archways is squeegeed in with cobalt blue and burnt sienna on a razor blade. The arches themselves are painted with dark mixtures of French ultramarine blue and burnt sienna, painting around the tree trunk. The steps are started with a razor blade and cobalt blue and burnt sienna.

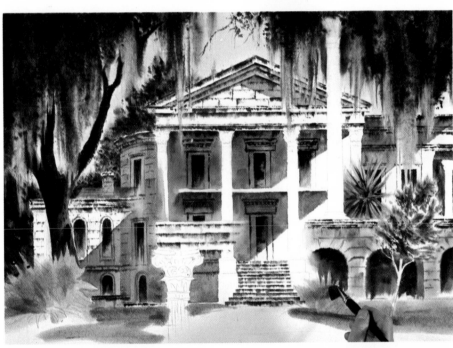

Step 10. I now rewet the foreground with clear water and sponge. Washes of raw sienna and sap green are painted in with a 3/4″ (19 mm) flat brush as I start the rendering of the foreground and the bush on the left. I finish painting the steps.

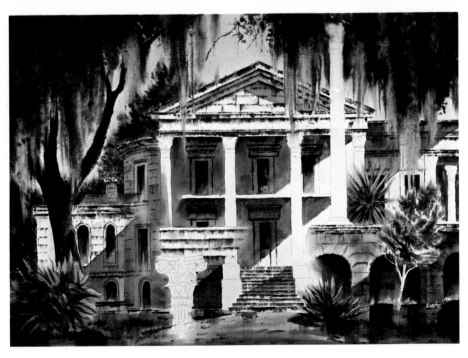

Step 11. I wash in raw sienna and burnt sienna for the unpaved path, further developing, deepening, and texturing it in the foreground with burnt sienna and cobalt blue. I then render the grass and shrubs with a 1/2″ (13 mm) flat brush and French ultramarine blue, burnt sienna, and sap green. By dragging planes of color—burnt sienna and French ultramarine blue—vertically through the damp foreground, I integrate the shapes and help further the illusion. I decide to add a shadow made up of cobalt blue and Grumbacher red over the staircase and to the side of it to better integrate and tone down the area.

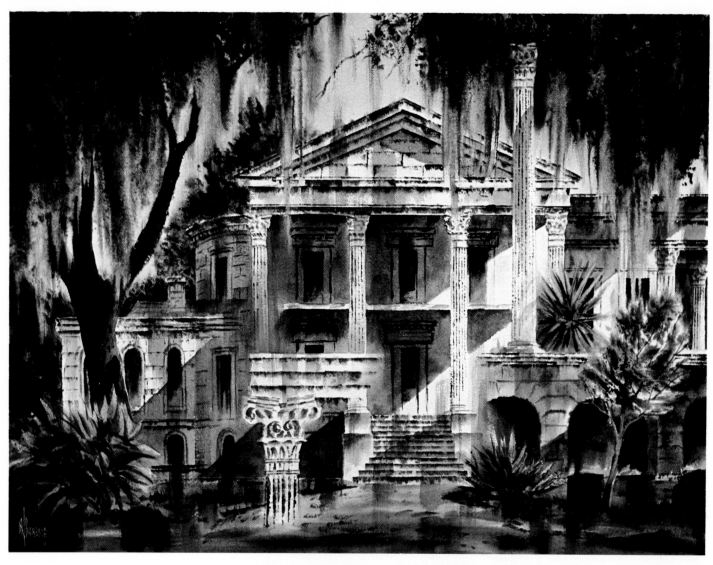

Belle Grove. The side stair sections are finished next with pale touches of Grumbacher red, raw sienna, and cobalt blue. I paint in the small tree trunk at the right with burnt sienna, touched with cobalt blue; then paint the large column head with cobalt blue and burnt sienna using razor blade and brush. I finish the columns by rewetting them, then print their decorations and vertical fluting with a razor blade and color, adding cast shadows with cobalt blue and burnt sienna. To finish the painting, I integrate and unite overlapping shapes for an overall unity by dragging more planes of cobalt blue and burnt sienna through shadows, stairs, and other sections of the building.

This painting shows how much can be accomplished using the razor blade as a painting instrument. The building is catching the rays of the late afternoon sunlight. The dark foreground and the subdued sky present a contrasting note. I apply paint with the following tools: a 1 1/2" (38 mm) flat sabeline brush, 1" (25 mm) oval wash brush, 3/4" and 1/2" (19 and 13 mm) flat sable brushes, and a No. 6 round sable brush—plus sponges and razor blades. My palette consists of raw sienna, burnt sienna, cobalt blue, Thalo blue, cadmium red, sap green, Grumbacher red, and black India ink. A 22" x 30" (56 x 76 cm) sheet of 300-lb Arches cold-pressed watercolor paper is stretched and ready to go.

4
A MUSEUM

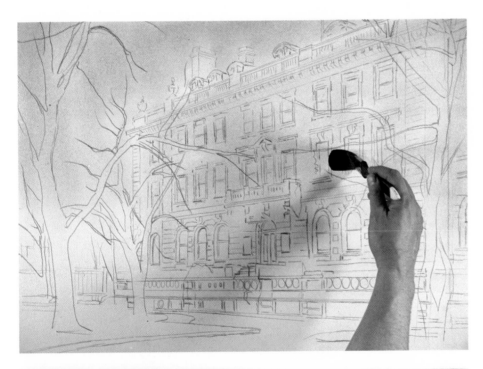

Step 1. I first sponge the entire building area several times with clear water so it stays wet for a long time. I then flood raw sienna into the sky and building areas with a 1" (25 mm) oval wash brush.

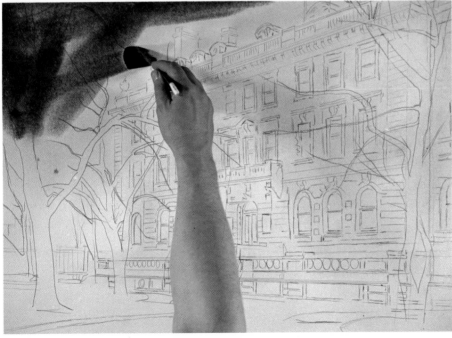

Step 2. Using the same brush, I paint cobalt blue, with a touch of Thalo blue, into the sky area.

Step 3. Working wet-in-wet, I manipulate the sky around the building. While the wash is still damp, I paint the chimneys with a 1/2″ (13 mm) flat brush, using cobalt blue and cadmium red. For the dormers, I use raw sienna and sap green, accentuating the shadow with sap green and India ink.

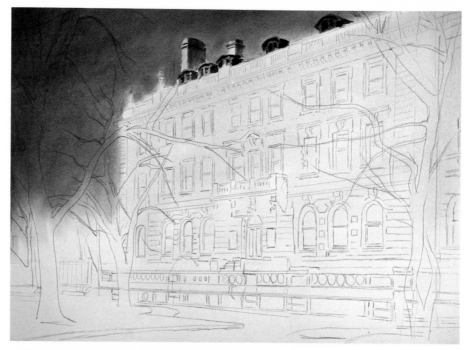

Step 4. With the sharp edge of a razor blade, I squeegee burnt sienna and cobalt blue into the moist paper as I start the development of the upper façade of the building. I apply a thick mixture of these colors with a 1/2″ (13 mm) flat brush to the decorative cornice construction under the ledge. A pale wash of cobalt blue, grayed with burnt sienna, is added in uneven fashion as an underpainting in the window areas. Then with a razor I apply thicker, warmer mixtures of cobalt blue and burnt sienna.

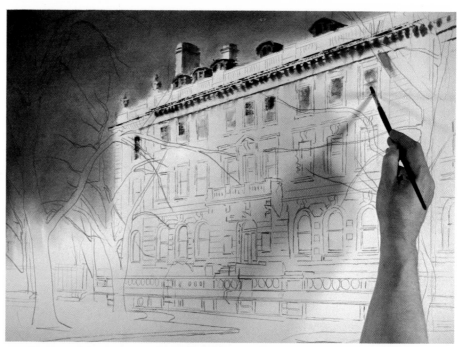

Step 5. I squeegee on the paint in the window areas using half a razor blade.

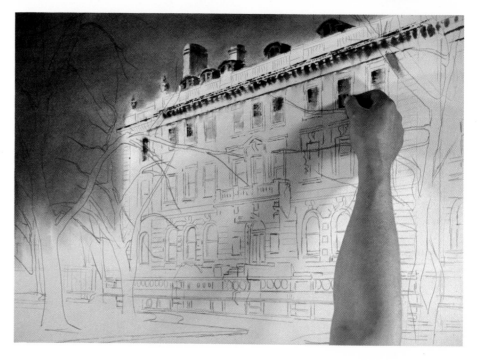

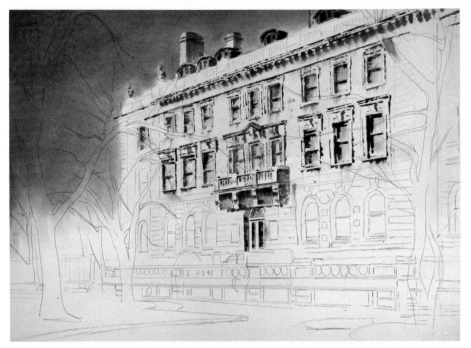

Step 6. All the windows are treated in the same manner, using the razor blade 90% of the time. I use the 1/2″ (13 mm) flat brush sparingly to control and keep a slight edge on curved shadow shapes. With the same colors and tools, I add the balcony door and large chimney. By now, the paper appears to be nearly dry, so I leave it to dry completely.

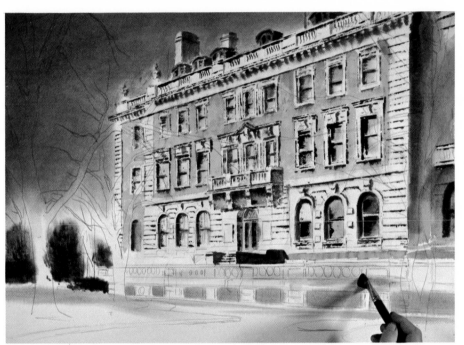

Step 7. When the paper is dry, I rewet it with a 1 1/2″ (38 mm) flat brush and clean water. I now finish the building, working as before with both razor blade and brush. Then I carefully rewet the sky and paint into it with a 3/4″ (19 mm) flat brush, using burnt sienna and Thalo blue. Burnt sienna and cadmium red slightly grayed with cobalt blue is flooded in for the bricks and the warm sunlight falling on the distant walks. I use a mixture of burnt sienna and cobalt blue for the warm wash on the concrete part of the wall.

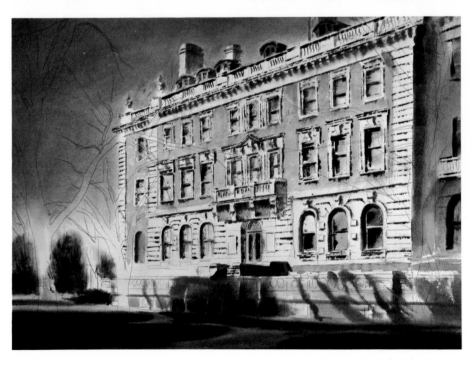

Step 8. With a mixture of warm and cool grays of burnt sienna and cobalt blue, I render the deeper shadow areas of the walks. I then paint in raw sienna and sap green with Thalo blue for the deep green shadow tone of grass. I create shadows on the wall with mixtures of cobalt blue and burnt sienna, applied with a 1/2″ (13 mm) flat brush while the paper is still wet.

Step 9. Still working into the wet wash, I again use the razor blade to complete the strong accents on the walls. For the row of grillwork I paint in burnt sienna and Thalo blue with a touch of India ink on a No. 6 round brush. Black India ink, Thalo blue, and burnt sienna applied with 3/4" (19 mm) flat and No. 6 round brushes are used to render the trunk and branches of the trees. I also add burnt sienna and cobalt blue with a small sponge for the dried vines and branches.

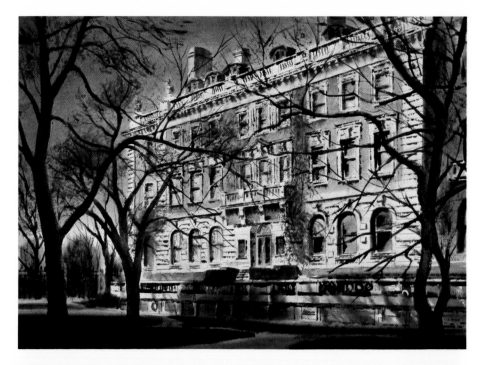

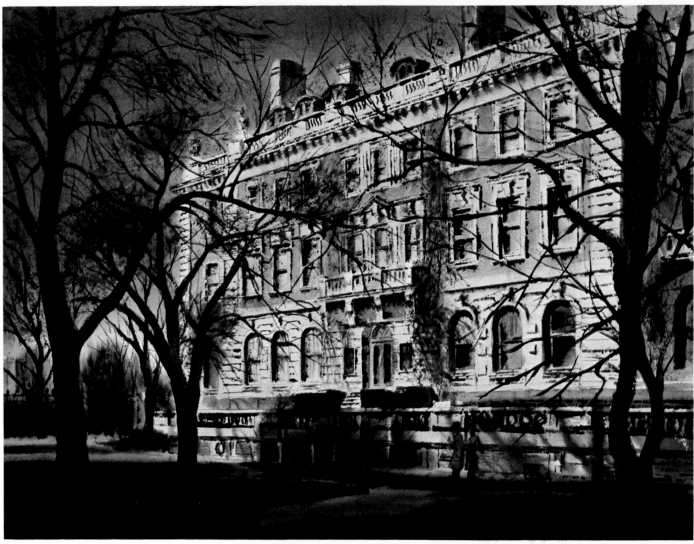

Cooper-Hewitt Museum. I add a few extra branches to the trees and paint a couple of people walking along the path with raw sienna, cobalt blue, burnt sienna, and Grumbacher red. The people give a feeling of life and movement to the painting. Now I'm finished.

I am painting a view of the Grand Canyon from the South Rim. Rather than paint the canyon itself, I decide to focus attention on one of the unique rock formations bordering the edge. I use a 1 1/4" (32 mm) flat sabeline, a 1" (25 mm) oval wash brush, a 1/2" (13 mm) flat sable, a No. 6 round sable, sponges, and a palette that consists of cadmium red, raw sienna, cobalt blue, French ultramarine blue, Thalo blue, sap green, and white tempera. A 22" x 30" (56 x 76 cm) sheet of 300-lb Arches cold-pressed watercolor paper is stretched on a 3/4" (19 mm)-thick plywood board.

5
THE GRAND CANYON

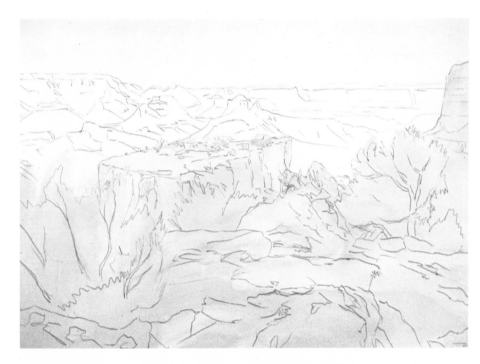

Step 1. I wet the bottom part of the paper with a sponge and clear water and paint a light wash of raw sienna into the big rock and the foreground with a 1 1/4" (32 mm) flat brush.

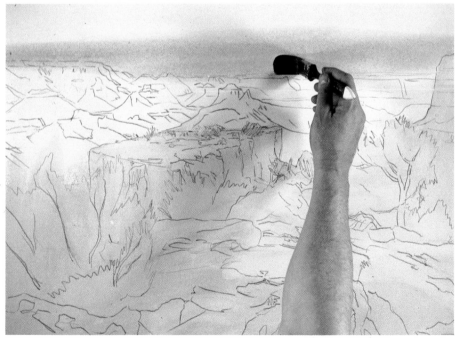

Step 2. Now I start work on the sky. I wet the sky and canyon area with a sponge and clear water several times and then flood in a wash of raw sienna near the horizon with a 1" (25 mm) oval wash brush.

Step 3. I work a wash of cobalt blue right into this to give the sky a green cast, then quickly add warm mixtures of burnt sienna and cobalt blue to the upper areas of the sky for clouds, using a 1″ (25 mm) oval wash brush.

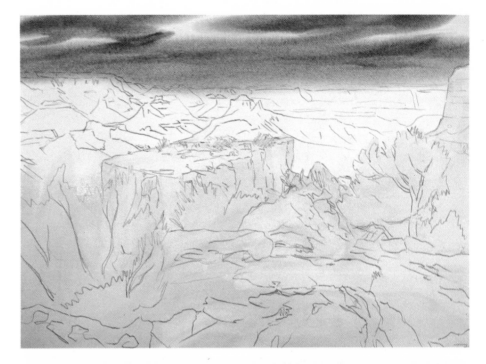

Step 4. I work pure cobalt blue into the sky for patches of blue between clouds, and then paint in the far rim of the canyon with a No. 6 round brush, using cobalt blue and a touch of cadmium red.

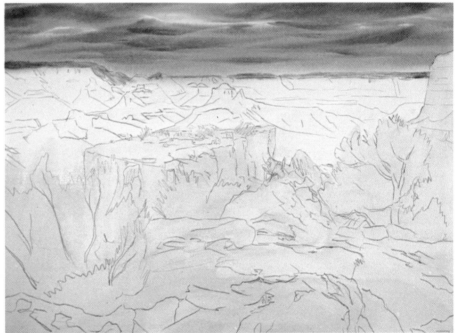

Step 5. I now flood in a wash of raw sienna and burnt sienna as an under-color for the distant canyon walls.

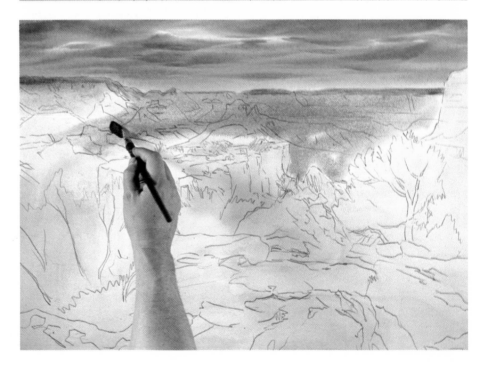

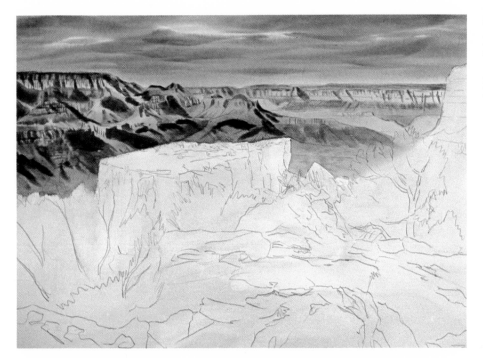

Step 6. Using a 1/2″ (13 mm) flat sable and cobalt blue, burnt sienna, and French ultramarine blue, I render the sculptured aberrated rock formations into the wet underwash. This is now left to dry.

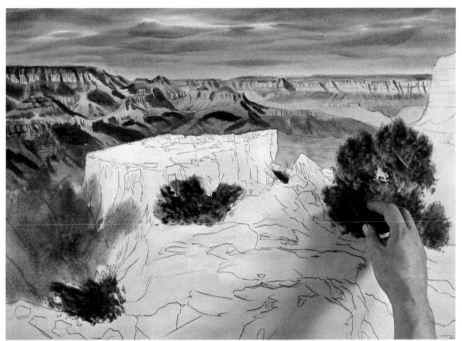

Step 7. When the paper dries, I use masking tape to block out the trunk and limbs of the tree in the right-hand side of the painting. I then rewet the bottom area with clear water and a 1 1/2″ (38 mm) brush, being careful not to lift the underwash. I start the rendering of bushes with mixtures of sap green and raw sienna, painted in with a 3/4″ (19 mm) flat brush. Then sap green, burnt sienna, and a touch of Thalo blue are pressed in on a moist sponge to further render the bushes.

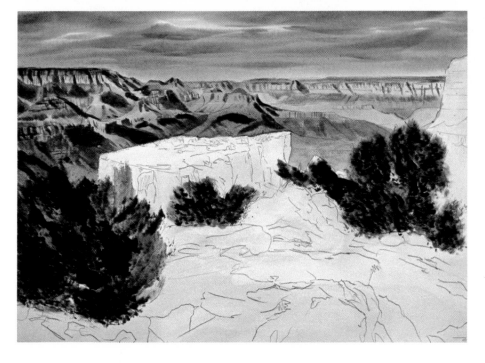

Step 8. After I spot in a few stronger mixtures of Thalo blue and burnt sienna here and there, work on the bushes is finished.

Step 9. I paint the small bushes on the top of the flat rock next with the same technique, and raw sienna, sap green, and burnt sienna touched with French ultramarine blue. Now the foliage is complete and I can gently pull the masking tape off the trunk and limbs of the tree on the right. Then, while the foreground is still moist, I start the texture rendering of the foreground rocks by stamping in mixtures of cobalt blue and burnt sienna with crumpled paper.

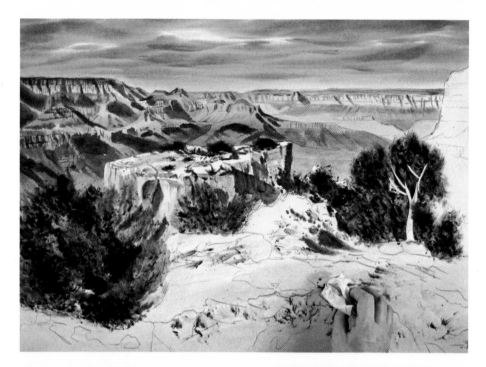

Step 10. I first work pale washes of cadmium red into the moist foreground for the red earth, then paint in washes of cobalt blue and burnt sienna with a 3/4″ (19 mm) flat brush to delineate the shadows and forms of the rocks.

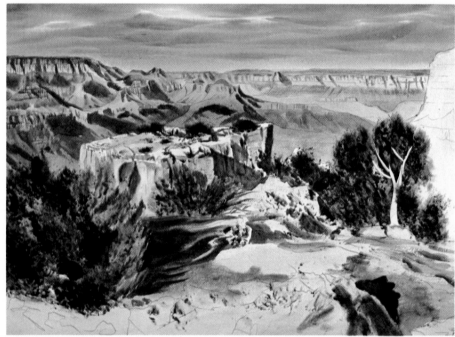

Step 11. I finish the foreground using the same brush and colors. I now start work on the rock formation on the right. I wet the area with clear water and wash in raw sienna, then cobalt blue and cadmium red, into this wet area with a No. 6 round brush. Finally, adding some touches of burnt sienna and cobalt blue, I finish the rock formation. With the tip of the No. 6 brush, and with sap green and Thalo blue, I stipple in small, distant shrubs and complete this area.

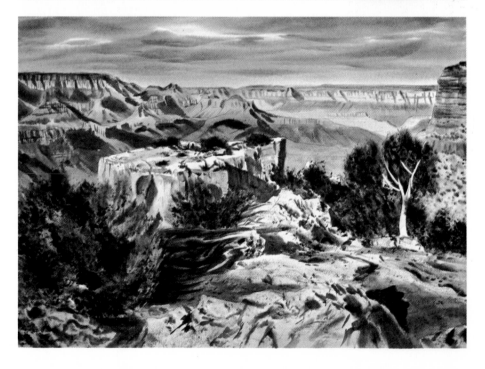

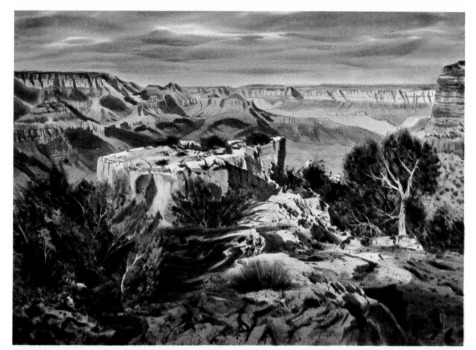

Step 12. With opaque touches of white tempera and burnt sienna, I paint branches into the bush at the left and on the right-hand tree. I tint the tree trunk in the darker areas and then cast a shadow over the foreground rocks with cobalt blue and burnt sienna. (I often cast shadows in areas where I want to lower the value so they don't compete with the center of interest.) Using the fanned-out brush technique (described in Demonstration 5), and raw sienna, cobalt blue, and burnt sienna, I paint a small bush into the middleground.

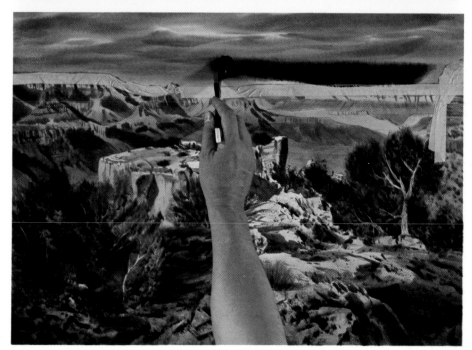

Step 13. I lightly rewet the foreground with a 1 1/4″ (32 mm) flat brush and clear water and alter the rock formations, trying to increase the feeling of rocks. The picture seems to lack strength around the sky and horizon on the right-hand side, so I decide to repaint the sky for more contrast. I mask out the horizon so the rocks won't be disturbed, rewet the area with a fixative blower and clear water. Then I repaint the area with a strong mixture of cobalt blue and burnt sienna for deeper clouds and more contrast, using a 1″ (25 mm) oval wash brush.

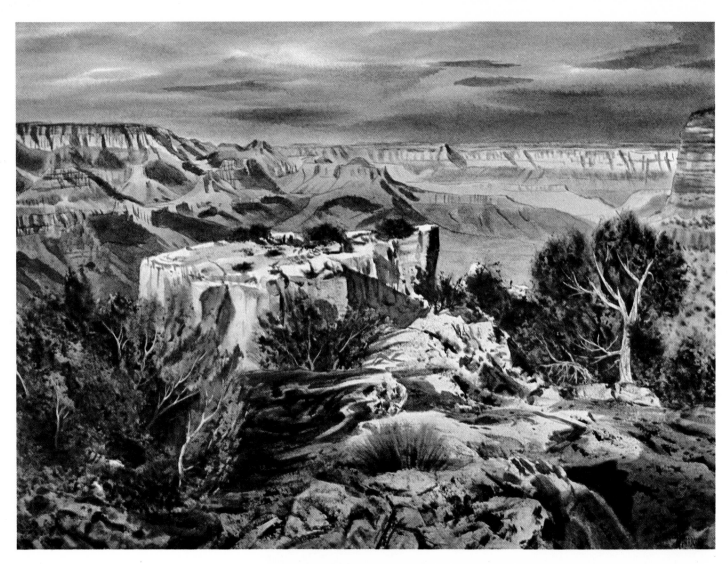

View from the South Rim. I carry some of the dark washes into the upper cloud formations to create a transition in value and greater unity. Now the picture is dry and it seems to have a better value pattern, more interesting lighting, and a stronger mood.

This picture depicts the mood of winter at day's end. I develop this painting in a manner that allows for casual but still somewhat controlled textures. This method helps establish a design that is stamped out all at once but does not allow for easy alteration. It should not be altered too much or it will spoil the original effect. I use a 24" x 32" (61 x 81 cm) sheet of white formica with a slight texture, a pencil, sponges, and the usual brushes—a 1 1/4" (32 mm) flat sabeline, 1/2" and 3/4" (13 and 19 mm) flat sables, and a No. 6 round sable. My palette is French ultramarine blue, burnt sienna, cadmium red, raw sienna, and cobalt blue. A 22" x 30" (56 x 76 cm) sheet of 300-lb Arches cold-pressed paper is used.

6
SNOW, HOUSE, AND HILLS (CONTROLLED MONOPRINT)

Step 1. I soak the watercolor paper in the bathtub and meanwhile begin work on the formica sheet. First I draw the design on the formica with a No. 2 office pencil.

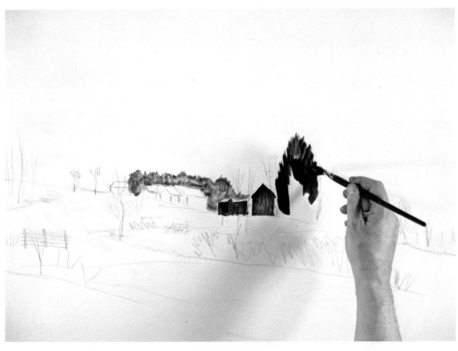

Step 2. Then, using a 3/4" (19 mm) flat brush and burnt sienna, cobalt blue, and a touch of cadmium red, I proceed to paint the distant foliage, large tree, and barns rapidly and directly with colors as thick as paste.

Step 3. I paint the picture as fast as possible, before the pigment dries. I paint the foreground bushes with thick mixtures of burnt sienna and French ultramarine blue. Then the small houses, barn, and bare trees are completed using a No. 6 round brush.

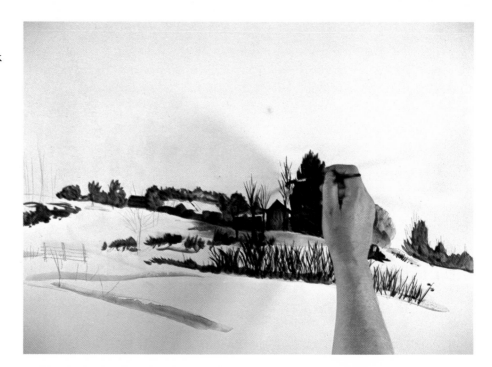

Step 4. I put in the rest of the trees, the shadows in the snow, and the remaining shrubs.

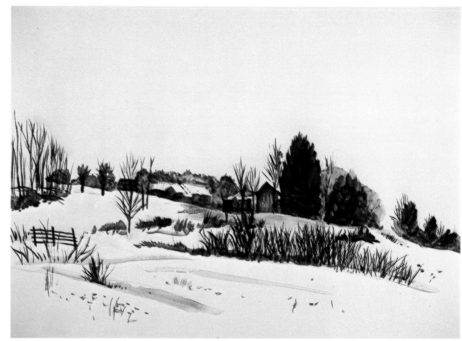

Step 5. The sheet of watercolor paper, previously soaked and still dripping wet, is lying nearby. Now comes the most difficult part of the whole procedure: I sponge the paper gently until the right amount of water is left on the surface—not too runny, not too dry. Then I gently place it over the painted picture. Even though the damp paper will still soften and dissolve any dry pigment, the picture should not be completely dry at this point. Now I rub gently but firmly with a wet sponge, going all over—across, up and down—pressing the entire sheet against the formica painting. Next I quickly peel the watercolor paper off the formica in one even swoop and lay it on a waiting watercolor board.

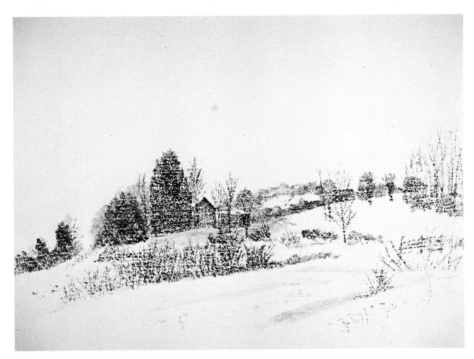

Step 6. This is the way the painting looks after it's peeled off the formica. The watercolor paper was too dry and so the imprint is not quite bold enough, but I shall try to correct it.

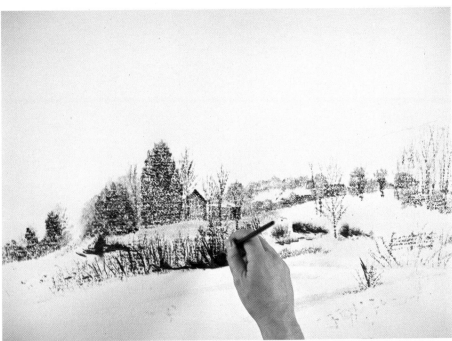

Step 7. With a No. 6 round brush, I paint the straggly foreground thicket much deeper in value using French ultramarine blue and burnt sienna. I try to retain some of the natural texture from the formica printing.

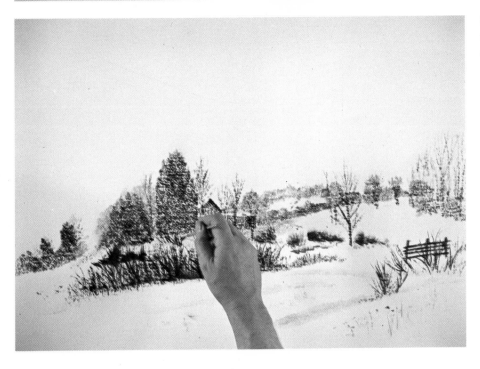

Step 8. Using the same brush and color, I continue to strengthen other areas in the foreground.

Step 9. Since the sky portion is still damp, with a 1 1/4″ (32 mm) flat brush I add clear water to moisten it even more. I now paint a rich mixture of raw sienna with a touch of cadmium red into the sky area.

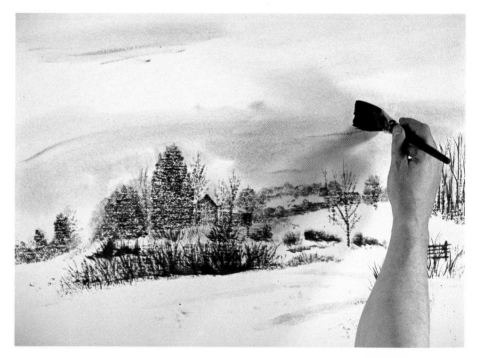

Step 10. With the same brush, I mix a large pool of cobalt blue and burnt sienna in a cool mixture on the palette. This is then loaded onto my brush and dropped into the bottom of the sky area. I tilt the board back and forth until the paint flows over the trees and bushes on the hill top.

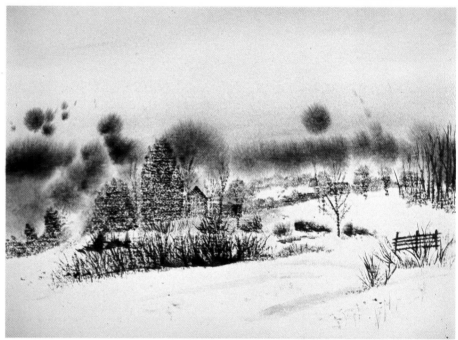

Step 11. With the same mixtures and brush, I paint in cloud formations wet-in-wet in thick, juicy mixtures starting at the top of the picture and working down to the middle. I add some thinner, longer, more distant cloud formations into the still-wet bottom of the sky. The sky now seems finished.

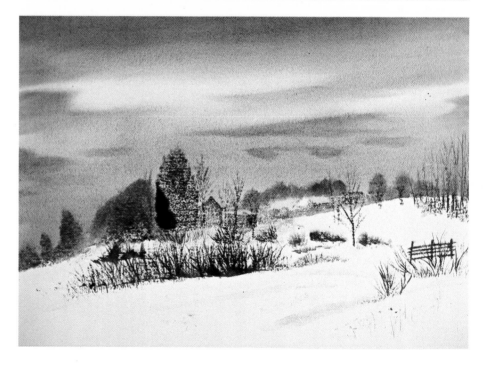

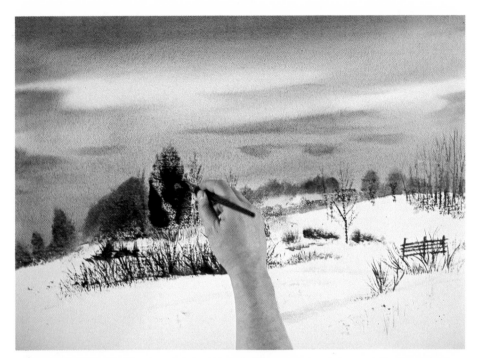

Step 12. As these sky washes settle and begin to dry, I use a 1/2″ (13 mm) flat brush loaded with burnt sienna, French ultramarine blue, and cobalt blue to deepen the color of the trees and houses and strengthen the design.

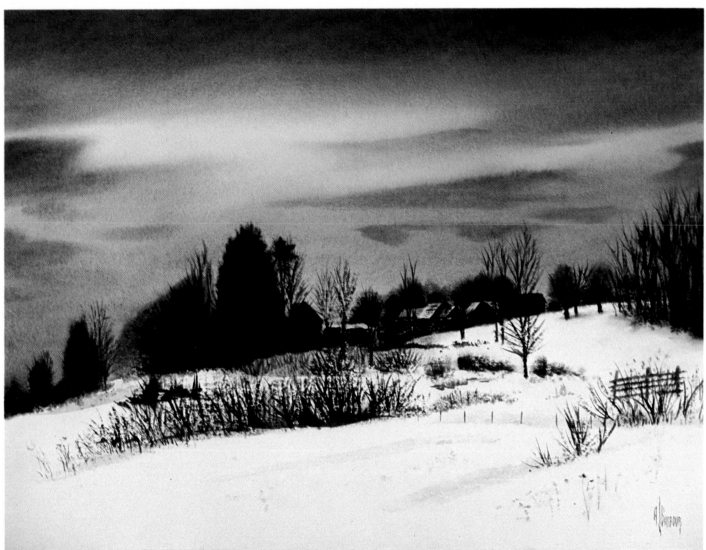

Winter in the Hills. I add some weeds here and there to give better continuity to weak areas, and the picture is finished. I feel certain this picture would not have this simple straightforward look if it were painted from the beginning directly into wet paper instead of first starting as a monoprint.

7
WESTERN BUTTES

This painting depicts the huge rock formations or buttes of Sedona, Arizona, on a somewhat overcast day—the kind of day that lends itself to subtle hues and values in its treatment. My palette consists of burnt sienna, raw sienna, raw umber, cobalt blue, French ultramarine blue, sap green, Grumbacher red, and black India ink. My usual brushes—1 1/2" (38 mm) and 3/4" (19 mm) flat brushes, a 1" (25 mm) oval wash brush, and Nos. 6 and 10 round sables—plus razors and sponges are again brought into play. A 22" x 30" (56 x 76 cm) sheet of 300-lb cold-pressed Arches watercolor paper is soaked and stretched on a 3/4" (19 mm)-thick drawing board.

Step 1. First, the entire upper half of the paper is soaked using a sponge and clear water. Then I start the sky by washing in a warm pale tint of raw sienna. I mix burnt sienna and cobalt blue to a slightly warm gray tone and flood it into this area with a 1" (25 mm) oval wash brush.

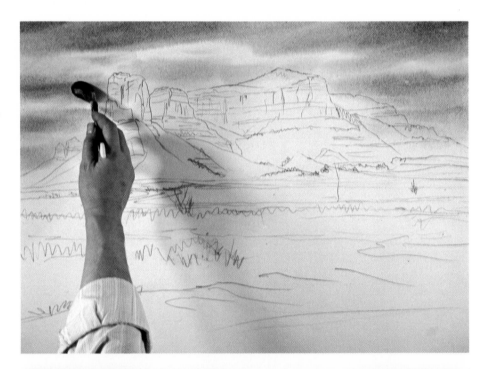

Step 2. With a 3/4" (19 mm) flat brush, I paint the open area of blue sky between the clouds with cobalt blue. Then I start the rock formations, first painting the top of the butte with a deep purple mixture of Grumbacher red and French ultramarine blue.

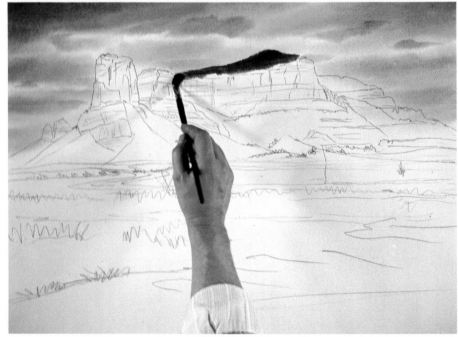

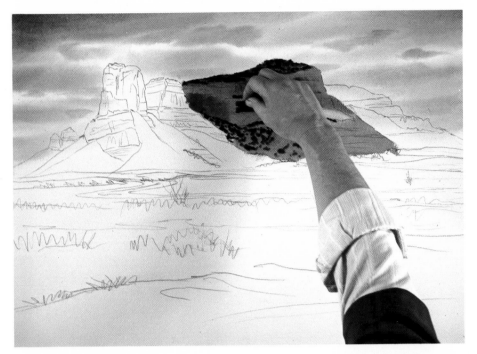

Step 3. I carry this color down the entire section of the larger mass of the butte, then I stipple in shrubs with a No. 6 round sable brush using black India ink and sap green. Thick mixtures of burnt sienna and cobalt blue combined on a razor edge is used to print and squeegee in rock sections and add texture.

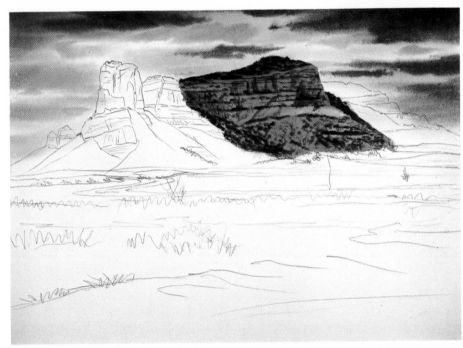

Step 4. After that section is completed, the paper is left to dry. I rewet the sky area with a 1 1/2″ (38 mm) flat brush and clear water and add darker cloud formations of French ultramarine blue and burnt sienna, painting them into the existing sky.

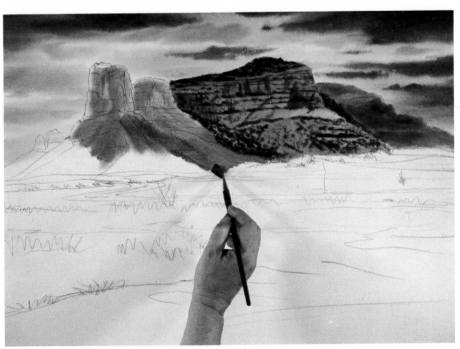

Step 5. While the sky is still wet, I paint in the rock formation in the background on the right with a 3/4″ (19 mm) flat brush, using Grumbacher red, burnt sienna, and French ultramarine blue. I rewet the lower sky and butte areas on the left. As I did earlier, I start painting the butte by covering it with a pale wash of raw sienna, followed by the deeper colors of burnt sienna, cobalt blue, and Grumbacher red.

Step 6. I finish the rock formations by applying the same colors—burnt sienna, French ultramarine blue, and Grumbacher red—in thick mixtures on razor blades (some are whole blades, some broken in half) to further texture the rocks. Again, I stipple in the bushes with a No. 6 round brush and sap green and India ink. I wet the foreground with a sponge and clear water and, with a 3/4″ (19 mm) flat brush, I paint in a strong wash of raw sienna.

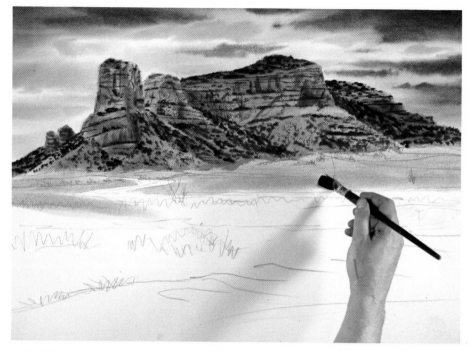

Step 7. I work this raw sienna wash around the roadway, flooding it right down to the bottom of the paper. Then I reinforce it with some raw umber, applied with a 1″ (25 mm) oval wash brush.

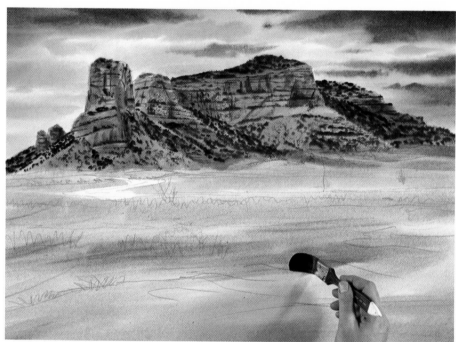

Step 8. Continuing work in this area with the same brush, I add thick, juicy washes of Grumbacher red and French ultramarine blue, along with the suggestion of some bushes.

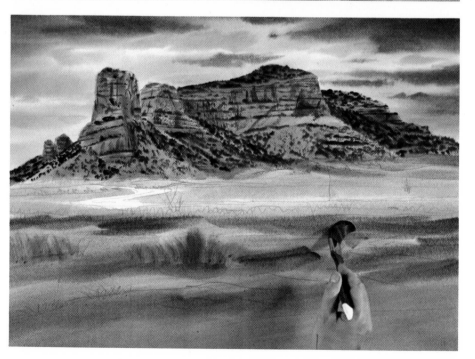

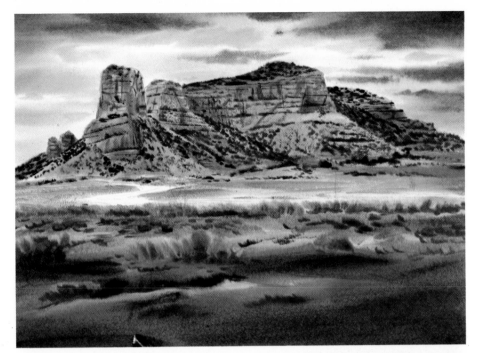

Step 9. Working wet-in-wet, I paint in deeper washes of French ultramarine blue and Grumbacher red in order to further darken the foreground. I now render small bushes and shrubs with sap green, raw umber, cobalt blue, and burnt sienna, adding a textural feeling to the foreground desert. The paint is stippled on with a 3/4″ (19 mm) flat brush and with a fanned-out No. 10 round brush.

Step 10. I work deep tones of Grumbacher red, burnt sienna, and sap green into the foreground. Then I stamp on green growth in the foreground with thick color on a damp sponge.

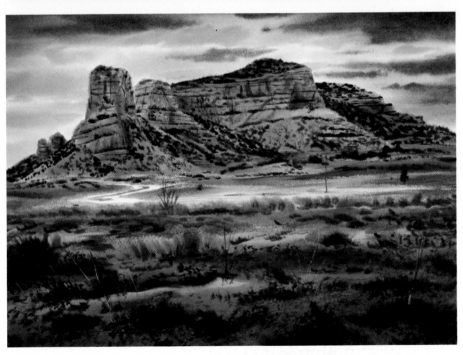

Step 11. While the paper is still damp, I press the handle of a No. 6 round brush into the moist pigment, leaving light lines for the effect of branches and low brush. Spattering and further sponging on of deep colors and the addition of more bushes and small branches bring the picture near completion.

Step 12. I rewet the lower left-hand side of the sky with a 1 1/2″ (38 mm) flat brush and clear water and paint in cobalt blue to give a feeling of space to open up the design. I also add a larger bush, supported by a smaller one in front of it with some bare branches in order to break up the horizontal plane at that point and to better integrate the foreground and the background. But the picture still lacks unity.

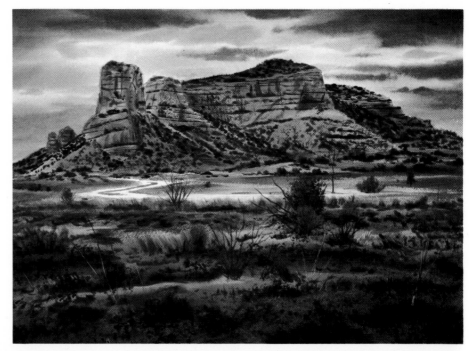

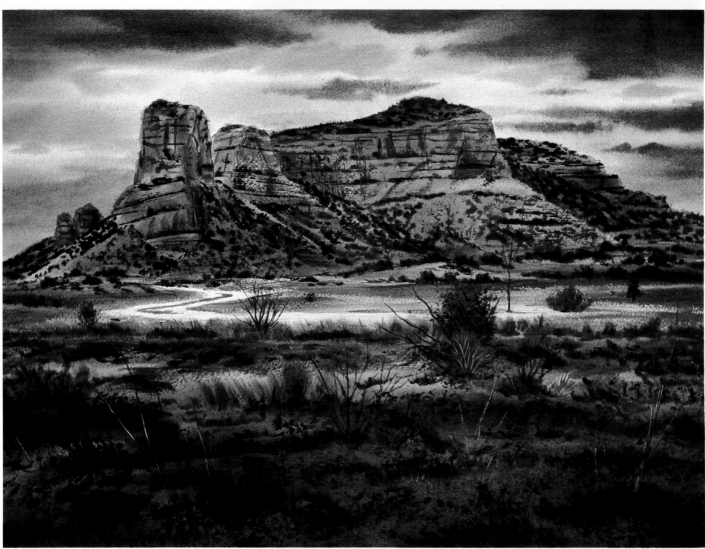

Step 13. I darken another horizontal plane of exposed earth in the foreground with more green foliage, because it prevents the viewer from moving into the picture. But upon studying the painting, what really bothers me most is the feeling that the strong central horizontal line cuts the picture in half. The bush I added doesn't help enough. I am getting two pictures rather than one. So I decide to crop out part of the foreground.

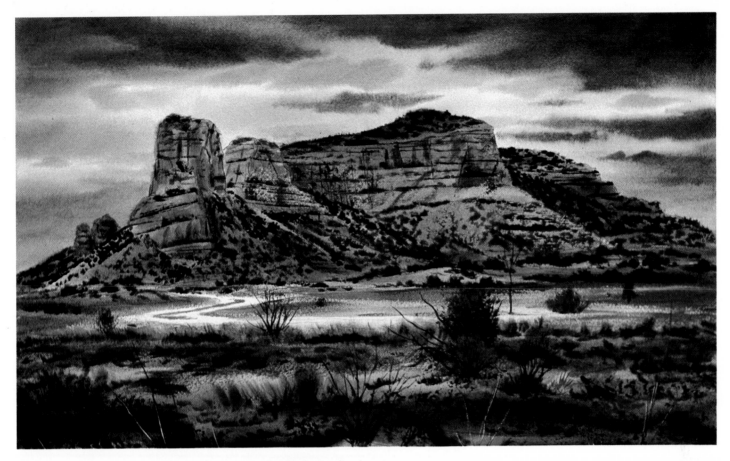

Buttes in Sedona. This is how the picture looks in its final state.

8
MISTY ROCKS AND SNOW

In this picture, I try to convey how values recede when lost in the mist and fine snow without showing the actual snowflakes. A 22" x 30" (56 x 76 cm) sheet of 300-lb cold-pressed Arches watercolor paper is stretched and lies prepared on a drawing board. I use a simple palette of burnt sienna, cobalt blue, sap green, and black India ink. The usual brushes are brought into play, here a 1" (25 mm) oval wash brush, a 3/4" (19 mm) flat sable brush, and a No. 6 round sable brush. I also use kosher, coarse salt.

Step 1. The entire paper is wet several times with a sponge and clear water. I plan to work wet-in-wet as long as I can with this first wetting. I flood a mixture of cobalt blue and burnt sienna into the sky area with a 1" (25 mm) oval wash brush.

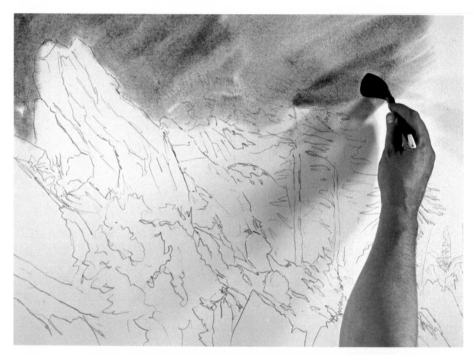

Step 2. I gently bring this wash down almost into the foreground.

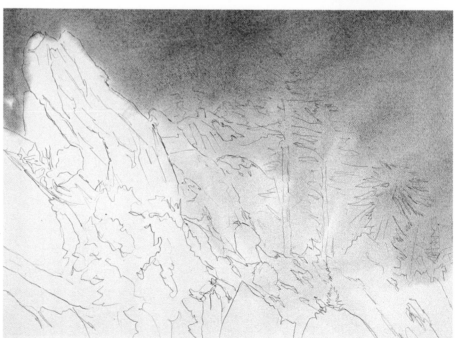

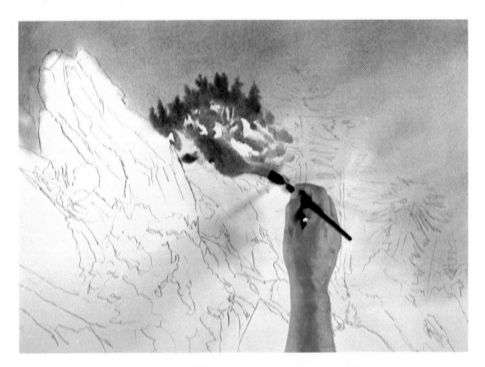

Step 3. With a 3/4″ (19 mm) flat brush, I lift out some of the wet wash on the distant hill for the effect of nearly white snow. Then I introduce a deeper and thicker mixture of cobalt blue and burnt sienna into the distant hill for rocks and trees.

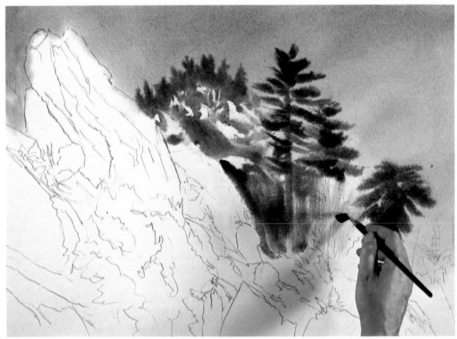

Step 4. I paint in thicker and darker mixtures of cobalt blue and burnt sienna with the same brush for the closer and larger trees.

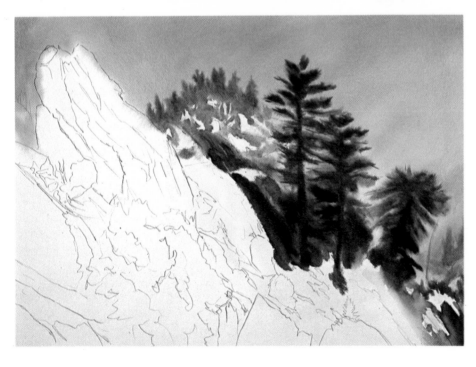

Step 5. I develop these trees further with the same brush and color mixtures. I switch to a No. 6 round brush to paint in the trees and rocky mountain in the distance on the lower right-hand side. By now the paper is almost dry, so I let it dry completely.

Step 6. I then take the entire paper and board outside and dump a large container of clear water over it. When the paper reaches the proper degree of dampness, I proceed to develop the painting further. Using the same brush and colors, I paint in thicker and deeper tones as I start rendering the rocks in front of the trees.

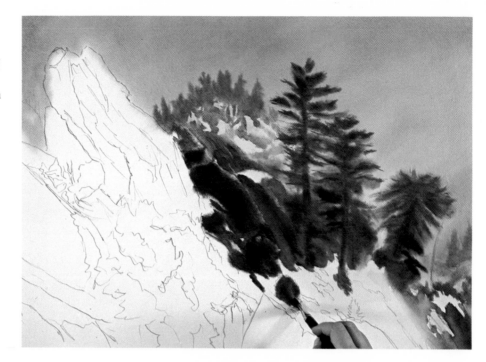

Step 7. I continue to render, in simple terms, the rocks in the foreground on the lower right-hand portion of the picture using the same No. 6 brush and the same two colors, burnt sienna and cobalt blue. I also start work on the large rock on the left-hand side with a warm wash of these colors.

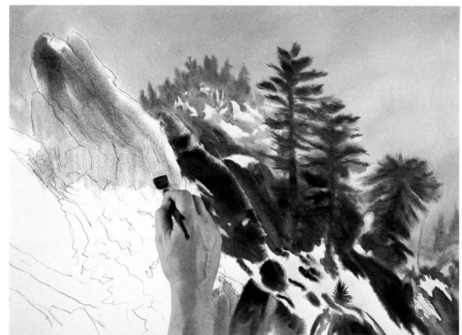

Step 8. While this area is still damp, I introduce the large growth of bushes in the foreground using sap green with a touch of burnt sienna, sponging in some sap green and black India ink for texture. I throw in large crystals of coarse, kosher salt to further increase the texture. The distant trees and hill on the upper left are put in with the No. 6 round brush. I then wash in the large rock on the extreme left.

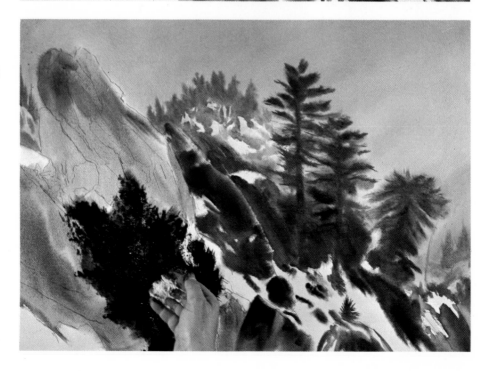

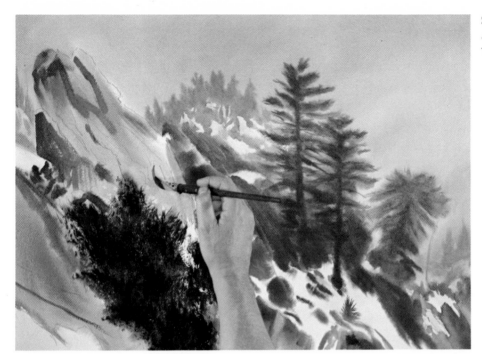

Step 9. While the paper is still moist, I add the illusion of cracks and crevices with the same brush and colors.

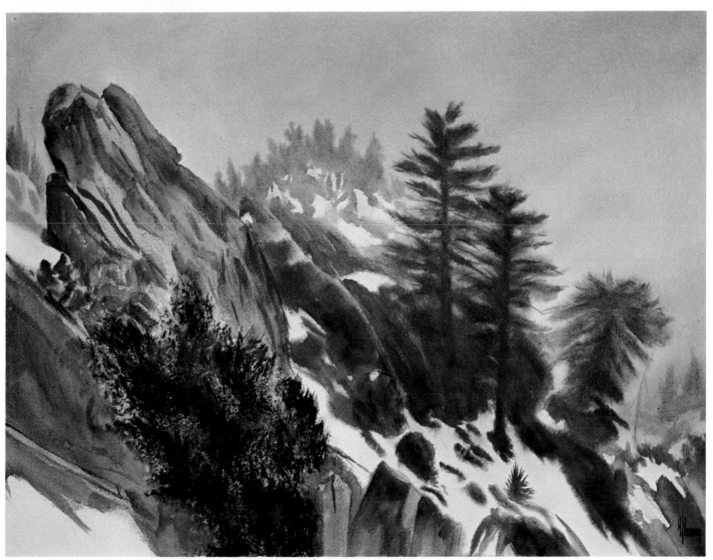

Out of the Mist. (In special memory of a good friend and fellow artist, Florian G. Kraner.) I complete the development of the nearby rocks in the left-hand foreground using a 3/4″ (19 mm) flat brush and burnt sienna and cobalt blue. When the painting is dry, I brush away the salt, leaving small, granular water marks, and the picture is complete.

9
NEW YORK FARM AND OLD SHACKS

I want to depict the mood of a heavy-laden sky over snow-capped hills in late afternoon. I use 22" x 30" (56 x 76 cm) Arches rough-surface watercolor board, a 100% rag paper commercially mounted on heavy cardboard. With masking tape, I tape the watercolor board 1/4" (6 mm) all around to a heavy drawing board to keep it flat. Whole and broken razor blades, an X-Acto knife, kosher salt, sponges, and the usual brushes—a 1" (25 mm) oval wash brush, 3/4", 1/2", and 1/4" (19, 13, and 6 mm, respectively) flat sable brushes, and a No. 6 round sable—are used. My colors are burnt sienna, cobalt blue, French ultramarine blue, sap green, and cadmium red.

Step 1. The paper surface is sponged several times a few minutes apart to keep it wet. Then excess moisture is removed by sponging the surface to get the desired moisture, which is not too wet. Burnt sienna, cobalt blue, and French ultramarine are scooped up on a broken half piece of razor blade. These colors are then squeegeed and stamped into the moist design to give the illusion of rocks, tufts of grass, earth, and small bushes breaking through the snow.

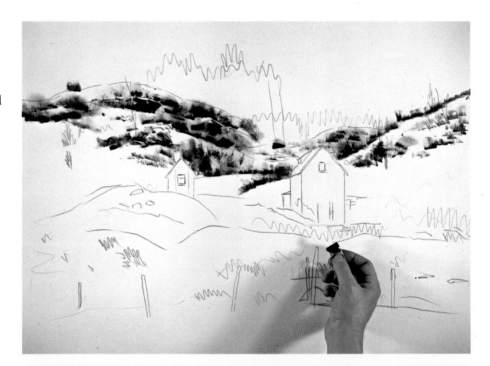

Step 2. Using a 1" (25 mm) oval wash brush, a pale wash of burnt sienna is run over the entire sky area. Then cobalt blue and burnt sienna are mixed for a cooler gray and washed right into the wet sky for the cloud formations.

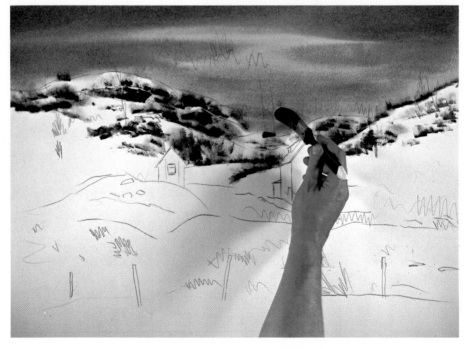

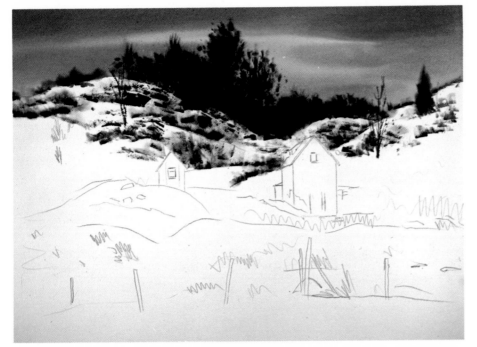

Step 3. Burnt sienna and French ultramarine are painted in with a 3/4" (19 mm) flat brush to start the formation of the distant trees on the hill tops. They are further modified by lightly sponging on these same colors. A little kosher (coarse-granule) salt is dropped in for a subtle texture change. Bare trees are added to the moist paper by using a razor blade loaded with thick, pure color. Small pine bushes on the right are added with a No. 6 round brush charged with a mixture of burnt sienna and sap green. Small modifitions on the rocks are made with a razor blade and paint. Then the area is left to dry.

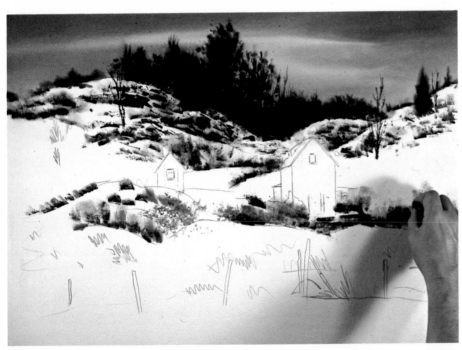

Step 4. I rewet the bottom area of the paper and continue working with half a razor blade and mixtures of burnt sienna, cobalt blue, and French ultramarine. I squeegee in sections of the bottom of the house and tufts of brown grass.

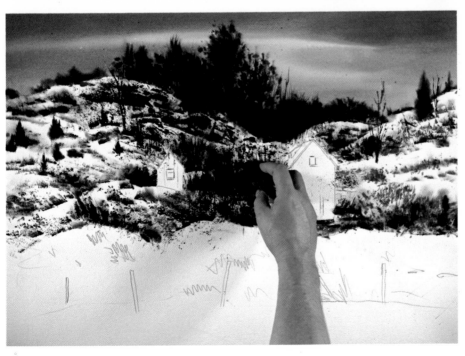

Step 5. A damp sponge dipped into the same mixtures of paint is stippled and lightly stroked into the middle-ground for small twigs and branches. Small evergreens are indicated on the left hill top using sap green, burnt sienna, cobalt blue, and a No. 6 round brush.

101

Step 6. I remoisten the foreground with a damp sponge. With heavy applications of paint and the half razor blade, I render rocks and dried weeds.

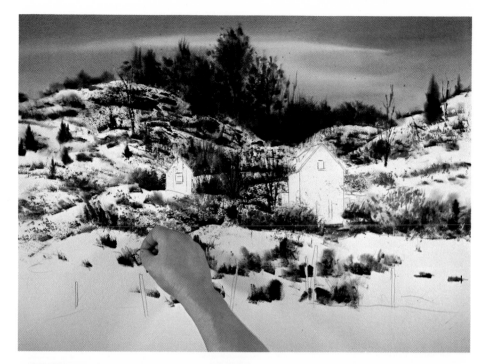

Step 7. The paper is almost dry again. I squeegee in the fence posts with a razor blade and French ultramarine and burnt sienna. The 90° corner at the tip of the razor is loaded with moist paint and dragged in drybrush fashion across the paper to produce the wire fencing.

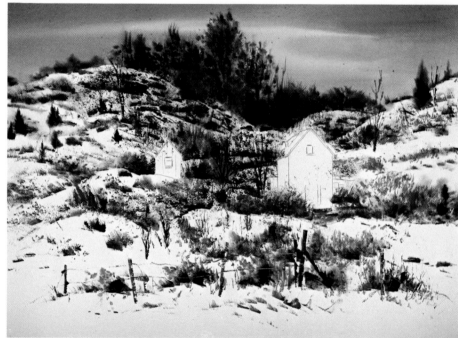

Step 8. The little shack is painted in next using a No. 6 round brush with a touch of sap green and burnt sienna and textured with a razor blade filled with French ultramarine and burnt sienna. The angle of the roof is also squeegeed in with the razor blade and mixtures of thick paint. The bigger shack is started with the same mixtures of sap green and burnt sienna applied with a 1/2" (13 mm) flat sable.

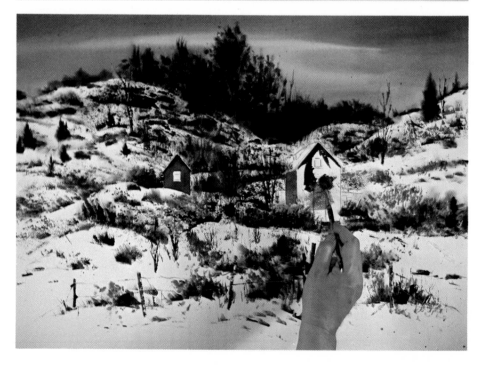

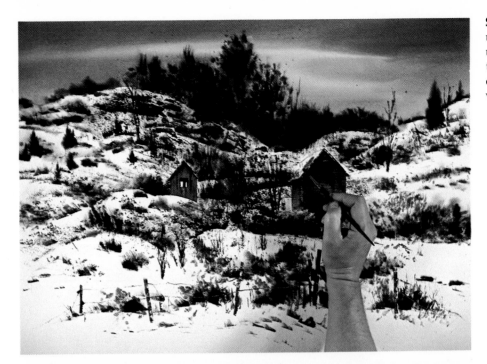

Step 9. The large shack is finished using the same colors and brush as used in the preceding step. It is textured by stamping the paint-covered edge of the razor blade into the moist wash on the shack.

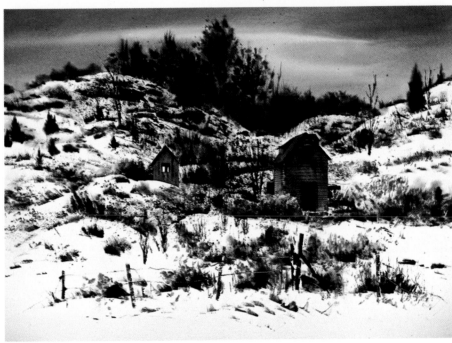

Step 10. The roof is then painted with a 1/4″ (6 mm) flat brush using cadmium red and burnt sienna touched lightly with French ultramarine. Again I accent it with a small brush and the same dark colors.

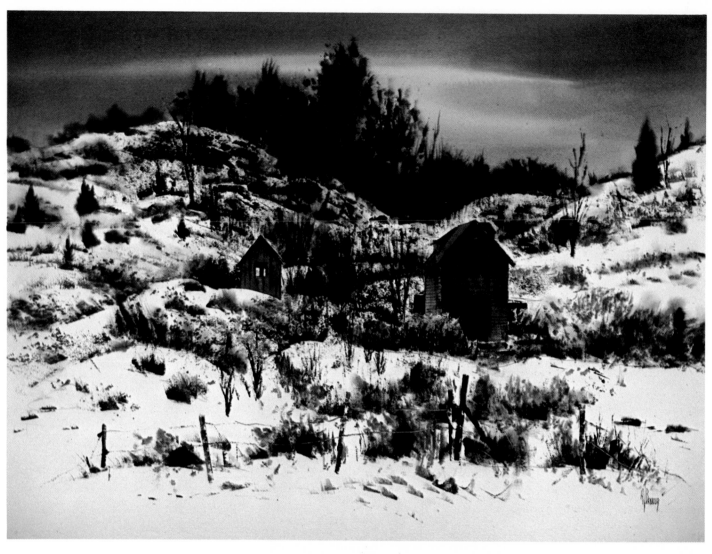

Left to the Elements. I scrape the roof line on the right-hand side of the small shack with an X-Acto blade and extend it down for better balance to complete the picture.

In this painting I want to capture the early morning sun trying to break through an overcast sky. This picture is based primarily on using large wet washes to produce the sky, water, and the wet sand effect. I use razor blades and sponges, together with the usual brushes—1 1/2", 3/4", and 1/2" (38, 19, and 13 mm) flat brushes, and a 1" (25 mm) oval wash brush. My palette consists of cobalt blue, burnt sienna, sap green, French ultramarine blue, and raw sienna. A full sheet of 300-lb Arches cold-pressed watercolor paper, 22" x 30" (56 x 76 cm), is stretched, and I'm ready to start.

10
BEACH SCENE

Step 1. I sponge the entire paper with clear water several times, waiting two or three minutes between wettings so that the paper can drink up more water and thus stay wet longer. I then run a damp sponge over the paper to remove any excess water. Then I brush a pale wash of raw sienna into the wet sky area with a 1" (25 mm) oval wash brush.

Step 2. With the same brush I wash in cobalt blue and burnt sienna for grayer, cooler clouds, leaving the area where the sun is trying to come through lighter than the rest of the sky.

Step 3. With a 3/4″ (19 mm) flat brush, I paint pure cobalt blue into the bottom of the sky; it mixes gently into the wet undercolor. This color establishes the ocean horizon. Now, with a few strokes of the same color, I indicate ocean waves; I also add a few strokes to the wet sand for reflections of the sky.

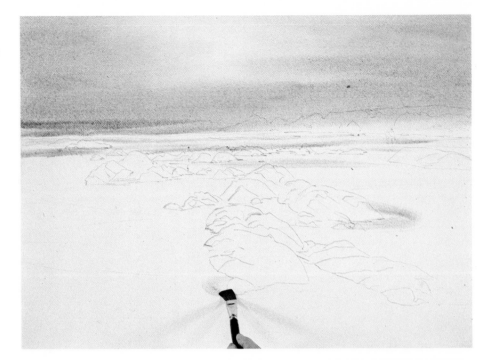

Step 4. I brush a very pale wash of raw sienna into the moist sand area using the same brush. I then paint burnt sienna and cobalt blue into this wet wash and around the rocks, deepening the colors as I work them into the foreground. As this wash settles into the paper, I spatter it with burnt sienna and cobalt blue.

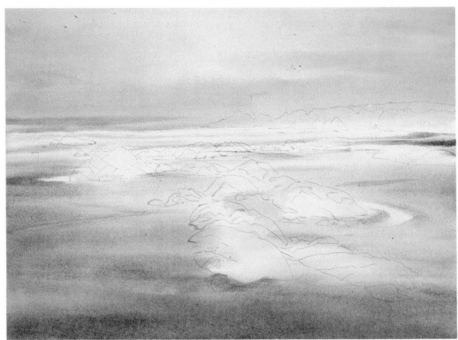

Step 5. I paint the rocks with cobalt blue and burnt sienna with touches of sap green and a 1/2″ (13 mm) flat brush for the rocks in the middleground. I then quickly and sparingly touch it with half a razor blade dipped in this color. I paint the large rock on the right completely by brush.

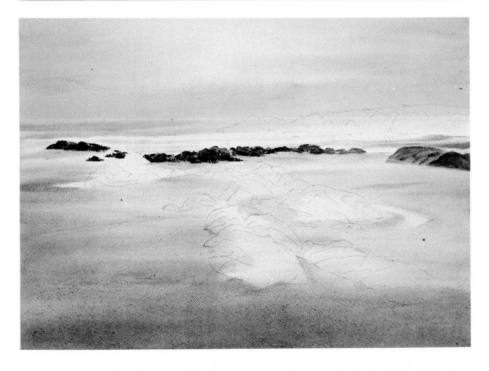

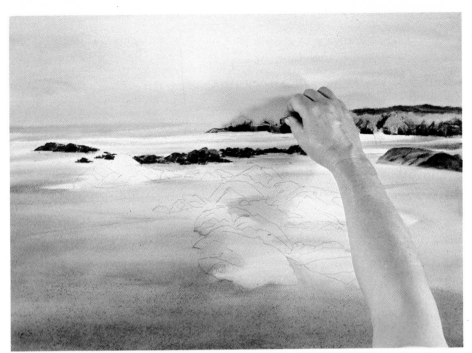

Step 6. I brush burnt sienna with a touch of cobalt blue into the distant rocky knoll with a 1/2″ (13 mm) flat brush dipped in warm and cool mixtures. Sap green with a touch of cobalt blue and raw sienna represents the grass. Now I scoop up burnt sienna and cobalt blue on a half piece of razor blade and quickly stamp, squash, and squeegee colors into the distant rock formations.

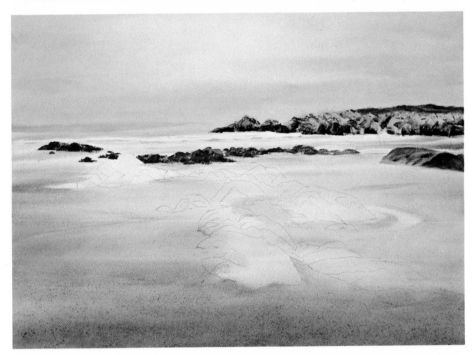

Step 7. When this is dry, I take the board outside in order to dump a container of clear water over the foreground to rewet it. I tilt the board so that the sky stays dry, then bring it back to my studio.

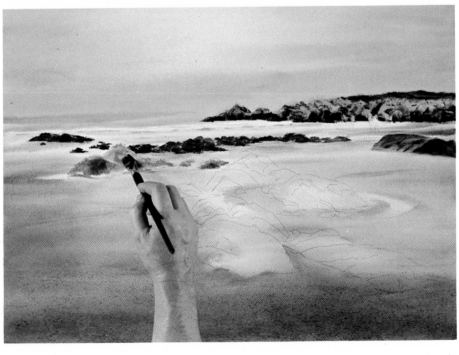

Step 8. As the water settles, I start painting the closer rocks using French ultramarine blue, cobalt blue, burnt sienna, and sap green. As I did on the previous rocks, I work into it with the razor blade and color.

Step 9. Now I abandon the razor blade. With a 3/4″ (19 mm) flat brush, I render the larger rocks in the foreground using mostly French ultramarine and burnt sienna touched with sap green for deeper grays. I use the sharp chisel tip of the brush to render details such as cracks and shapes, painting wet-in-wet.

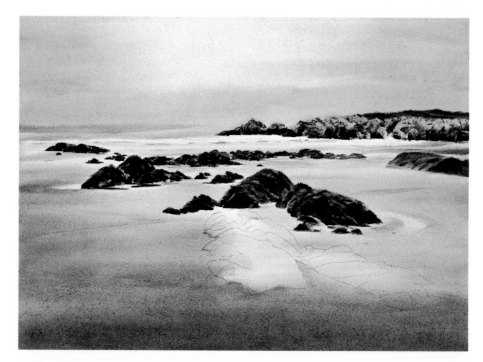

Step 10. The process continues as the paper is drying. When I finish the last rock mass on the right of the paper, I examine the composition.

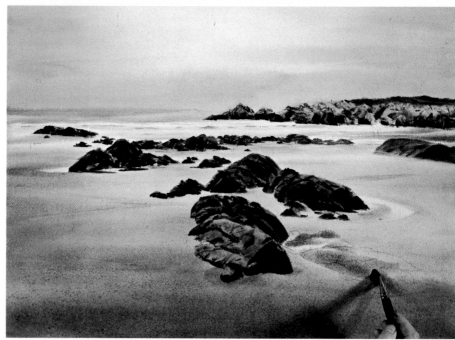

Step 11. Since I feel the need to balance the composition better, I rewet a section of paper on the left bottom with a 1 1/2″ (38 mm) flat brush and paint in three smaller rock groupings. Cobalt blue and burnt sienna are worked into the sand around the rocks depicting a rivulet of tide water. The two little figures are painted in next using a No. 6 round brush, cobalt blue, and burnt sienna.

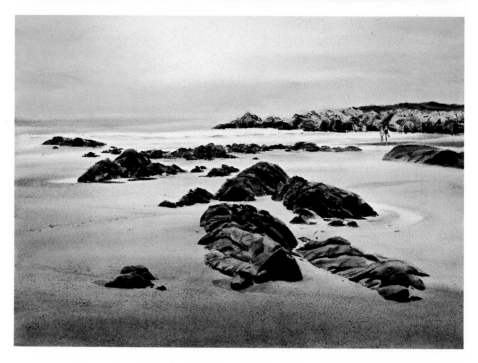

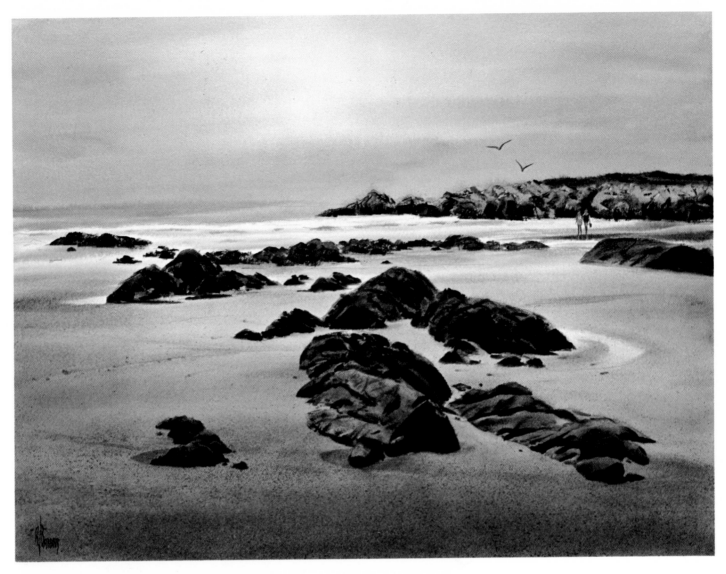

Beach at Rockport. Those last-painted rocks seem too small, so I rewet the area with a large brush and clear water and gently expand the small rock formation. Two birds are added to the picture to help break up the flat horizon. Now the picture is complete.

11
SAND DUNES

The morning sunlight spilling over the Delaware dunes in the early spring before the strong greens have come out creates a variety of textures which I shall try to capture in this painting of dunes. My usual brushes—a 1" (25 mm) oval wash brush, 1 1/4" and 3/4" (33 and 19 mm) flat brushes, and Nos. 6 and 10 round sable brushes—and sponges are used. My colors consist of burnt sienna, raw sienna, cadmium red medium, cobalt blue, sap green, and black India ink. A sheet (22" x 30"—56 x 76 cm) of 300-lb Arches cold-pressed water-color paper is soaked and lies stretched on my drawing board, and I'm ready to start.

Step 1. The entire paper is wet with a sponge and clear water several times so the water will penetrate deeper into the paper and remain wet longer. I paint in a pale wash of cadmium red medium and cobalt blue with a touch of raw sienna with a No. 10 round brush.

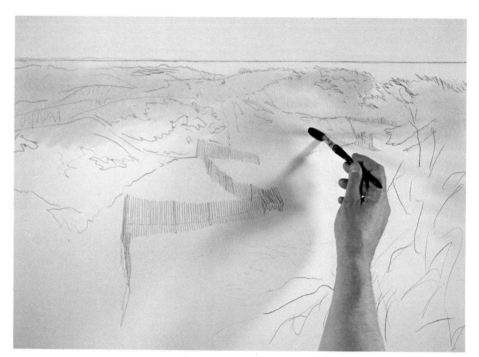

Step 2. With a No. 6 round brush, using sap green, burnt sienna, cobalt blue, and India ink, I start work on the grass on top of the dunes.

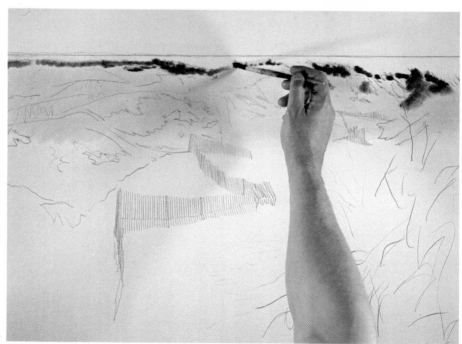

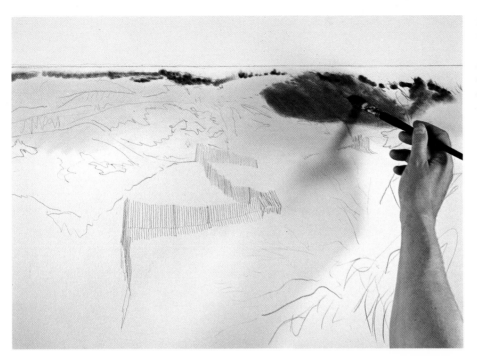

Step 3. I paint cobalt blue, burnt sienna, and cadmium red medium wet-in-wet into the wash of Step 2 with a 3/4″ (19 mm) flat brush to start the rendering of the shadow side of the dunes.

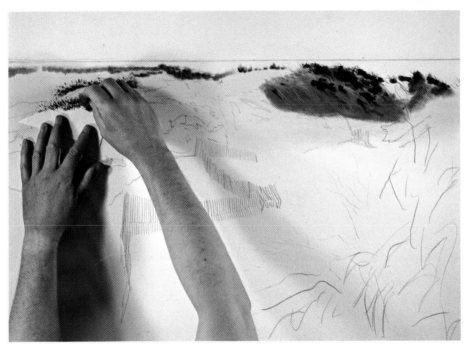

Step 4. I place a piece of paper over the moist washes and stipple in burnt sienna and cobalt blue with a touch of sap green with a sponge onto and over the edge of the white paper into the moist underwash to further render the wild dune grass.

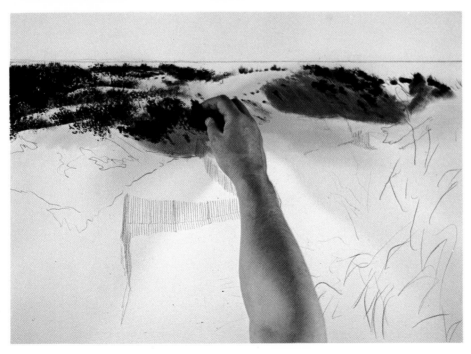

Step 5. As you can see, by using a piece of paper to block off some of the sponging, I can hold a sharper edge in the rendering. I can also tilt the piece of white paper in different directions to conform to an irregular curve. After some more dunes are rendered this way and another dune shadow tone is placed in, I stipple the whole area slightly with burnt sienna, cobalt blue, sap green, and touches of India ink to pull it together. Now I let the paper dry.

Step 6. I rewet the bottom part of the paper up to the dune area several times with clear water and sponge. Then I flood in washes of cadmium red medium, raw sienna, and cobalt blue using a 1" (25 mm) oval wash brush.

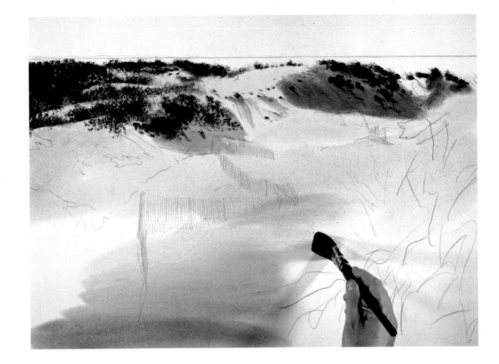

Step 7. I continue this same wash, bringing it down into the foreground as a rich, deep tone. With the same brush, I paint cobalt blue, raw sienna, and burnt sienna in a heavier consistency for the shadow side of the left dune. A few brushstrokes of the same colors are added next to depict large mounds of sand.

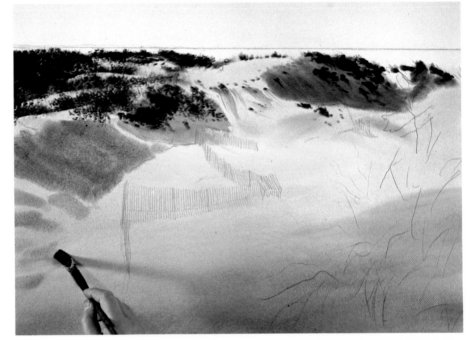

Step 8. I paint in sap green, burnt sienna, cobalt blue, and some India ink with a No. 6 round brush for tufts of grass. I drag the same thick mixtures through the damp shadow side of the dune to depict old, straggly grass and roots.

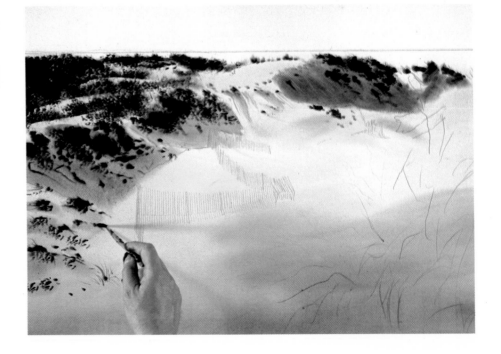

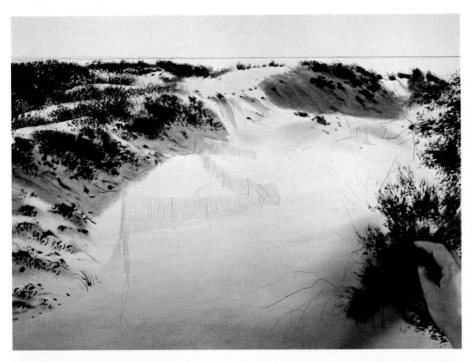

Step 9. Now, as I start to render the wild growth of grass, branches, and roots on the bottom at the right, I sponge on cobalt blue, burnt sienna, raw sienna, and India ink. Some of the same treatment is also stippled in on the distant upper right-hand side for better unity.

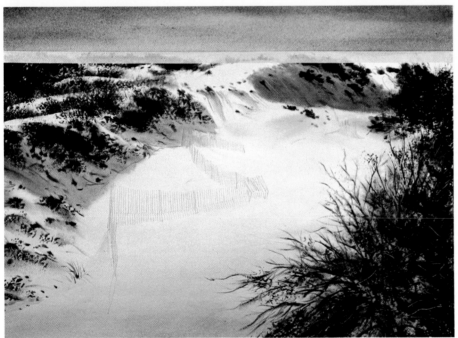

Step 10. I complete the foreground with the same mixtures of colors using the No. 6 round brush for finer strokes and by reversing the brush so its stiff, pointed end can be used to wipe and press out color for lighter branches. Now I work on the sky. To paint the sky, I first mask the horizon line so the grassy dunes are not disturbed, then wet the sky area. A pale wash of raw sienna is painted in first. Next, I mix cobalt blue and burnt sienna into this for darker cloud formations. After the sky washes are dry, the masking tape is *gently* removed so as not to pick up any pigment or paper.

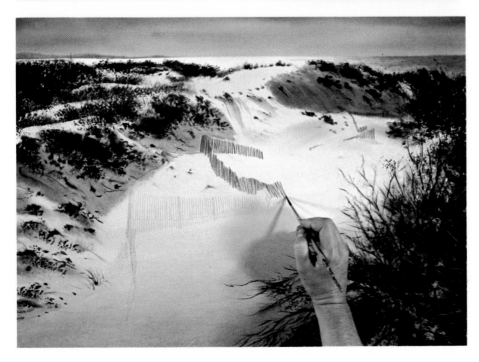

Step 11. I add a suggestion of distant land on the left side. I leave paper white where I wish to give the effect of sunlight striking the water, except on the right-hand side, where cobalt blue and burnt sienna are melted in for the ocean color. I paint the fence in last using a cadmium red medium and cobalt blue touched lightly here and there with watered down India ink and a No. 6 round brush.

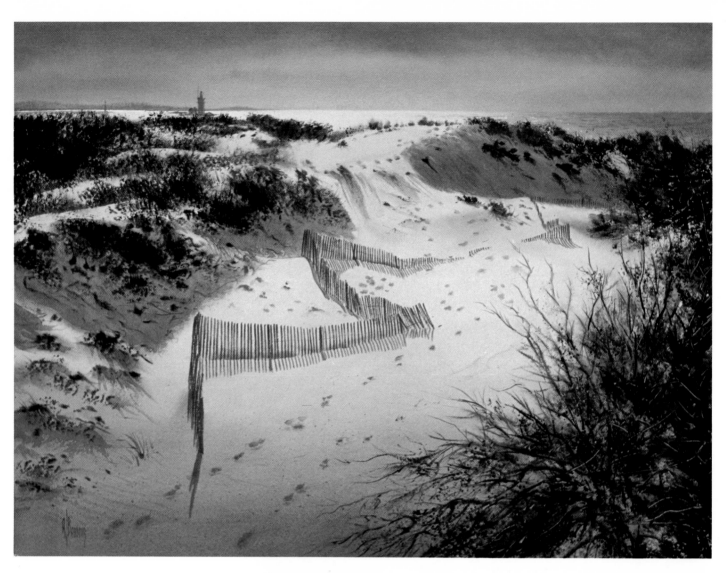

Cape Henelopen Dunes. I paint in the lighthouse last, using a No. 6 round brush and cobalt blue and cadmium red medium. Switching to a 1 1/4" (32 mm) flat brush, I then rewet sections of the lower foreground area with clear water. Then with burnt sienna and cobalt blue I add the footprints—and the picture is complete.

The subject of this demonstration is a moving stream winding through the woods in early autumn. A 22" x 30" (56 x 76 cm) sheet of Arches cold-pressed watercolor paper is prepared by soaking and stretching it on a 3/4" (19 mm)-thick plywood board. The usual array of brushes—1" (25 mm) oval wash brush, 3/4" and 1/2" (19 and 13 mm) flat sables, and a No. 6 round sable—along with sponges, a No. 2 drawing pencil, and a razor blade are used. My palette consists of raw sienna, burnt sienna, Thalo blue, cadmium orange, Grumbacher red, and sap green.

12
STREAM, ROCKS, AND WOODS

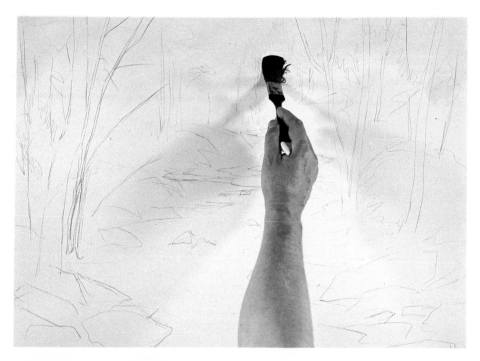

Step 1. I first draw the basic design on the paper with a No. 2 drawing pencil. Then the entire board is sponged several times in order to work the water deep into the paper. I spread a pale wash of Thalo blue into the sky area with a 1" (25 mm) oval wash brush.

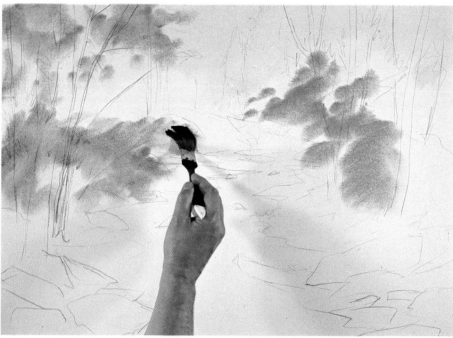

Step 2. Now I brush large rich swatches of raw sienna and cadmium orange onto the wet paper.

Step 3. Using the same brush, I introduce raw sienna and sap green to depict some of the closer bushes and wild grass areas. I sponge Grumbacher red and a touch of burnt sienna into the main foliage areas to help establish variety in the colors there.

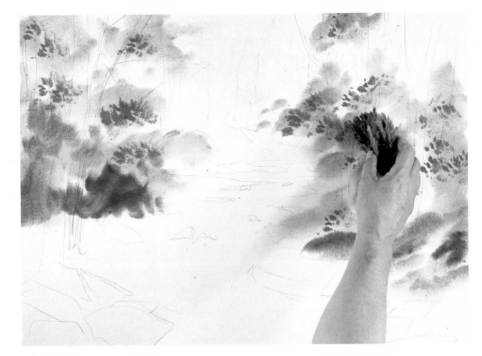

Step 4. I build up the texture of the foliage and the foreground by sponging on thick applications of Grumbacher red, cadmium orange, and burnt sienna. I shape darker tree patterns in the distance with sap green, burnt sienna, and Thalo blue applied to the wet paper with a 1/2″ (13 mm) flat brush.

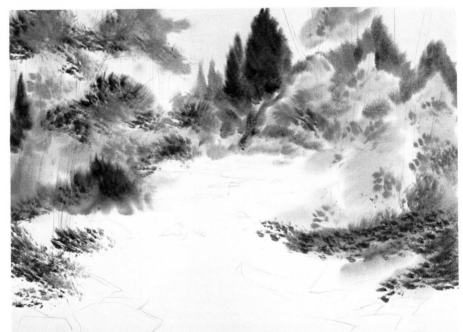

Step 5. As the paper slowly dries, the design is developed still further. Using a No. 6 round and a 1/2″ (13 mm) flat sable brush alternately, and thick, pasty mixtures of burnt sienna and Thalo blue, I paint the dark tree trunks and finer branches wet-in-wet to develop the design further. The paper is then left to dry.

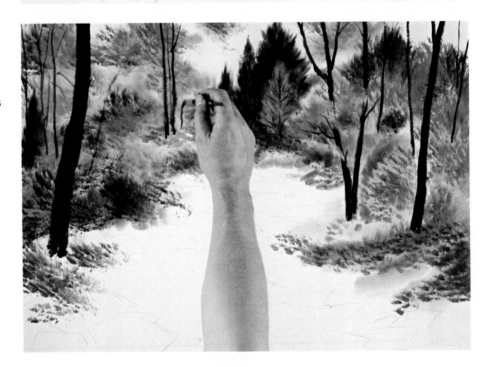

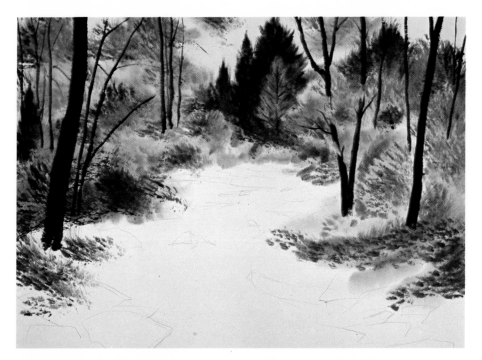

Step 6. At this point, the upper part of the picture is finished. I carefully rewet the lower part of the paper several times with clear water and a sponge, and I'm ready for the next plunge.

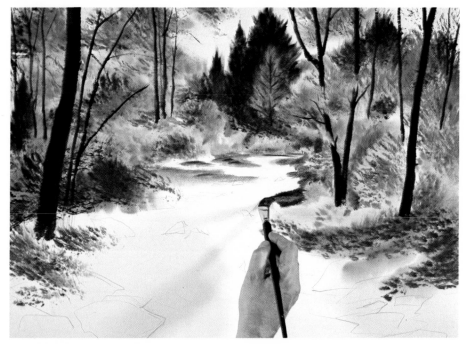

Step 7. I paint the distant sunlight on the stream with negative shapes, that is, by painting the shape of the darker shoreline on both sides of the stream, thus reserving the white paper for reflected sunlight. This is accomplished by using a 3/4" (19 mm) flat brush with sap green, burnt sienna, and a touch of French ultramarine blue.

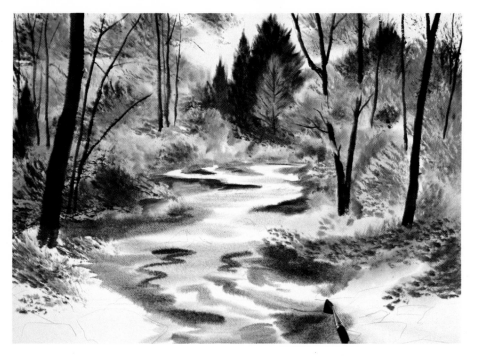

Step 8. Using the same brush and Grumbacher red, French ultramarine blue, and a bit of burnt sienna in a purple mixture, I continue working the effect of turbulent water flow down to the foreground.

Step 9. As the paper becomes drier, finer swirls of moving water are introduced with the same 3/4" (19 mm) flat brush. I add thick mixtures of burnt sienna with touches of Thalo blue in the stream for rocks. Then I place raw sienna and sap green in the wet stream area for grass and paint dark rocks below this. At the upper left, I sponge into the sky area dark green color representing pine trees in order to bring out the lighter trees in front of them. Some texture for fine branches is also sponged into the sky at the upper right-hand area near the dark trees.

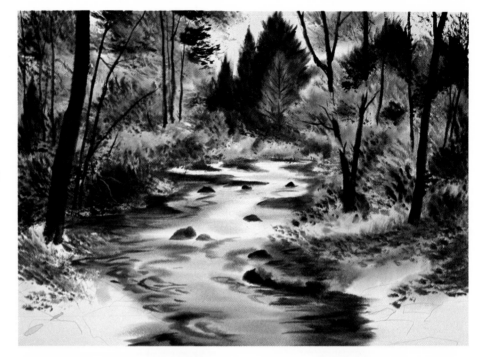

Step 10. I paint in both foreground corners with sap green, raw sienna, and burnt sienna and a brush and sponge to depict earth and grass textures. Then I introduce burnt sienna and French ultramarine blue into the still-moist paper for a suggestion of rocks, with the same flat brush. I further define these rocks by using these same thick colors pressed on sparingly with a razor.

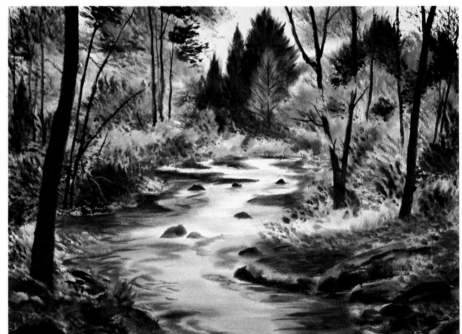

Step 11. I add some smaller trees and branches to the foliage and place some quick, dry strokes on the water's surface. I also alter and build up the rocks in the stream and add a stump in the middle of the stream. On the right-hand side in the middleground, a small bush is developed further by re-wetting it and adding color.

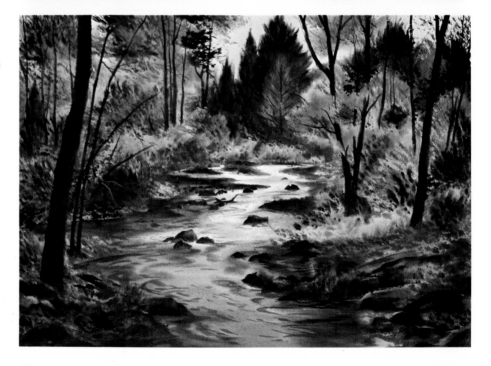

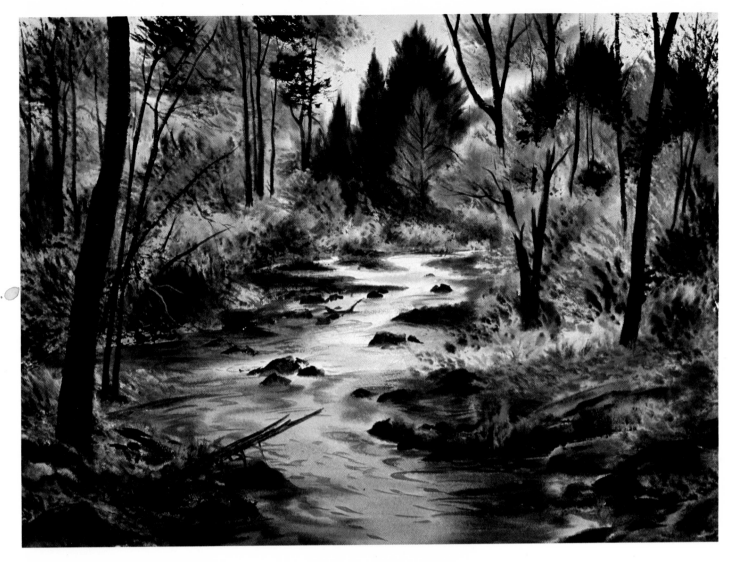

Burst of Autumn. I stipple a few spots of pure cadmium orange for dried leaves over the water at the lower right-hand corner with a No. 6 round brush. Now I stand back and inspect my composition. It is found wanting, so I place a fallen tree on the left bank to help keep the eye in the center of the composition, using a 1/2″ (13 mm) flat brush with burnt sienna and a touch of Thalo blue. Now the painting is finished.

13
WOODS AND ROAD (MONOPRINT)

As in Demonstration 6, I paint a complete painting on a lightly textured white formica sheet, and transfer the image to a moist sheet of watercolor paper. I expect the end result, if I'm lucky enough to do it correctly, to be a bold, textured design. My tools are as follows: one slightly textured piece of white formica (23" x 31"—58 x 79 cm) plus the usual sponges, a No. 2 drawing pencil, and a 1" (25 mm) oval wash brush and a 3/4" (19 mm) flat brush. My palette is raw sienna, cobalt blue, burnt sienna, sap green, cadmium red light, Thalo blue, and black India ink. A sheet of 300-lb cold-pressed Arches watercolor paper, 22" x 30" (56 x 76 cm), lies ready for use with an empty drawing board standing by.

Step 1. I sketch the drawing on the sheet of formica with a No. 2 drawing pencil. I then soak the watercolor paper in the bathtub.

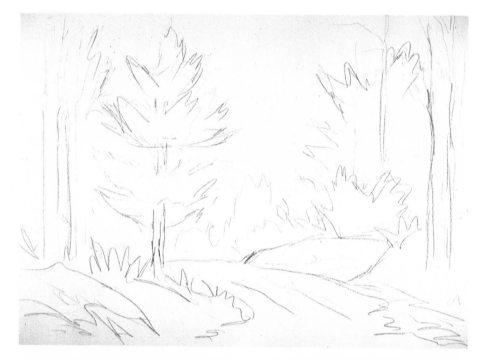

Step 2. At this stage, I am painting on the formica sheet. I start by painting in the sky with burnt sienna, cobalt blue, and a 1" (25 mm) oval wash brush.

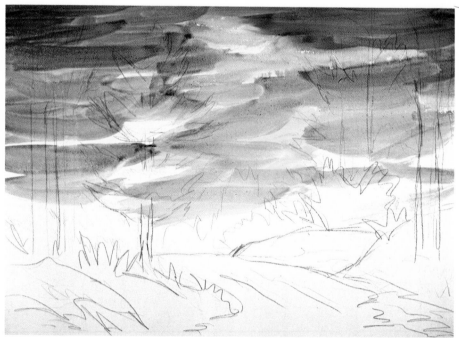

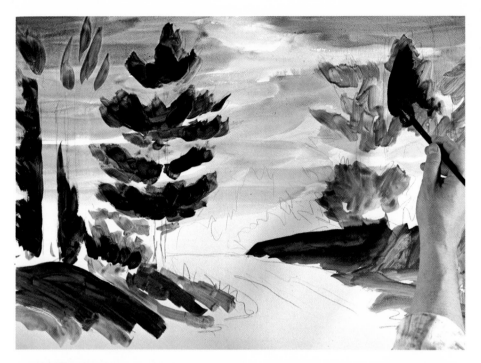

Step 3. I next paint in raw sienna, sap green, and Thalo blue—in that order—with a 3/4″ (19 mm) flat brush, as I start to indicate the landscape.

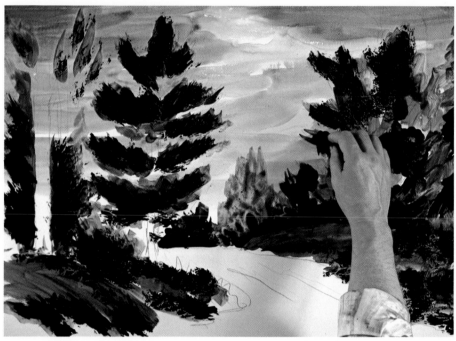

Step 4. The shapes form rapidly. With some burnt sienna, sap green, and black India ink on a moist sponge, I deepen and build up the foliage.

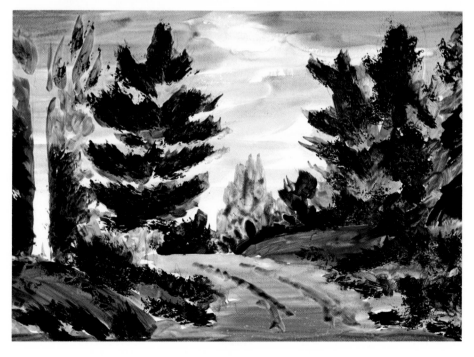

Step 5. For the road, I use burnt sienna, with cobalt blue to gray it, and paint in the distant trees with a purple formed by cobalt blue and cadmium red. The picture is done rapidly in about ten to fifteen minutes. Here's how it looks on the formica sheet before I make a print from it.

Step 6. It's now time to remove the wet watercolor paper from the tub and lay it on a flat surface. The next step is the most difficult. I carefully sponge the surface of the wet paper to just the right consistency: not too wet, not too dry. When I feel this is right, I place the paper carefully on the formica, lining up one edge and letting it gently roll down the rest of the way, covering the entire picture. I then rub all over the back of the paper with a wet sponge, pressing the moist paper into the semi-dry picture on the formica.

Step 7. Then I peel the paper back quickly, completely removing it from the formica, and place it on the waiting drawing board.

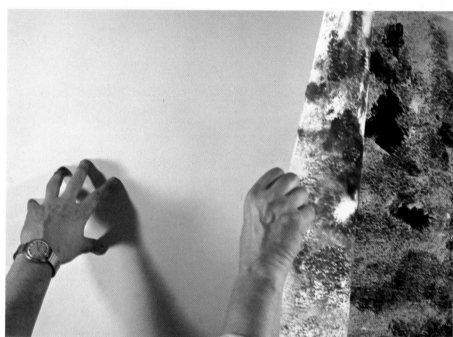

Step 8. This is how the print looks in its unaltered state. (Notice that it is a complete reverse. This will throw you only for a short while.)

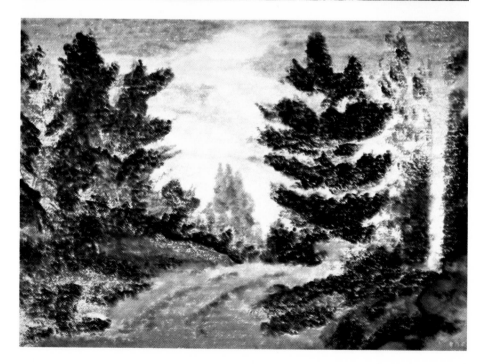

122

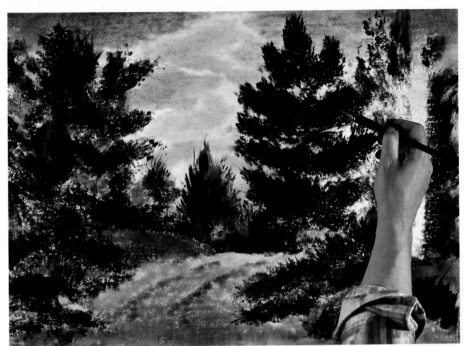

Step 9. I place a soft wash of cobalt blue between the clouds with a 3/4" (19 mm) flat brush. With a sponge, brush, and colors I gently adjust different areas, trying not to overpaint them too much. I turn the purple trees in the distance into a pine tree with cobalt blue, a touch of burnt sienna, and India ink applied on a small sponge.

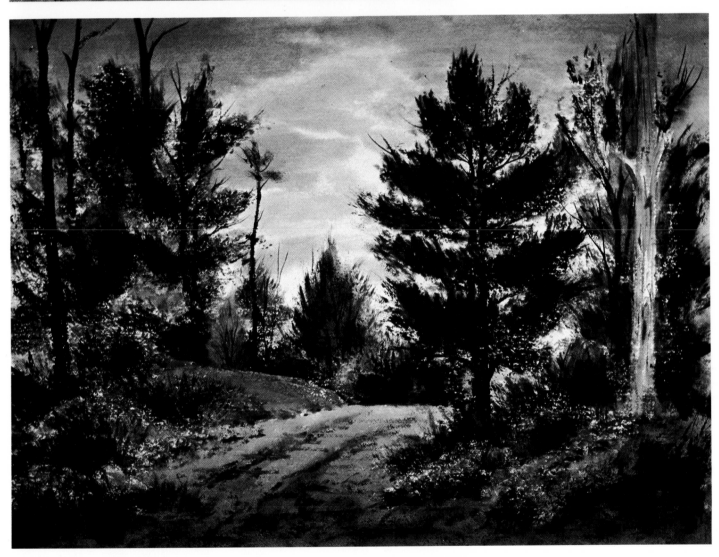

Just Over the Rise. With burnt sienna and India ink, I paint in dark tree trunks and branches. Cobalt blue, cadmium red, and burnt sienna with India ink are used to render the dead tree trunk on the right. Finally, I darken the road in the foreground with deep mixtures of cobalt blue and burnt sienna and then lightly spatter it with these same deep colors, and my painting is complete.

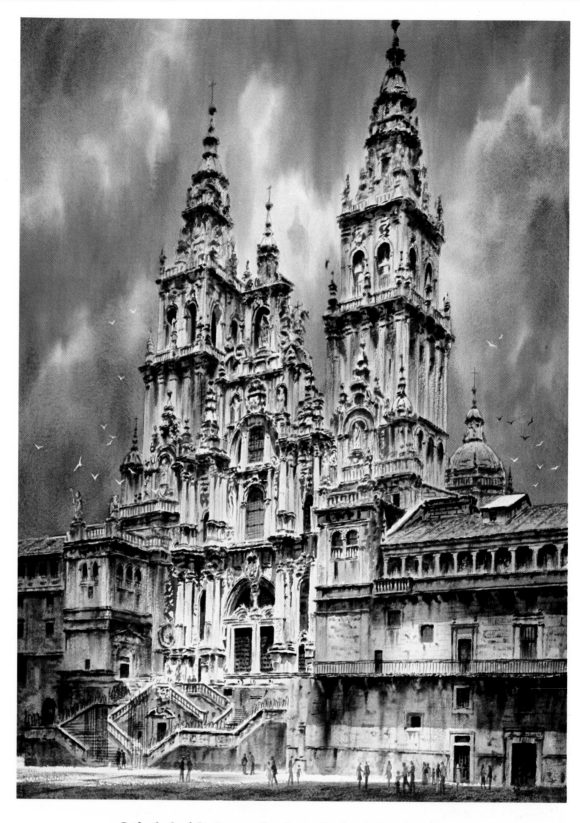

Cathedral of St. James, Santiago, Spain. (Above) Watercolor and black India ink on 300-lb Arches cold-pressed, stretched watercolor paper, 21 1/2" x 29 1/2" (54.6 x 74.9 cm), Collection of The Blue Army of Our Lady. Donated in memory of James Peter Hines, father of Margie Barbour. It was in Europe, where I was gathering material to paint several major shrines of the Mother of God, that the Basilica of St. James in Santiago, Spain, overpowered me. In fact, it overpowered me for two years before I decided to finally paint it. It was the idea of trying to get the feeling of all that elaborate detail onto a piece of paper that kept me from painting it sooner. I painted the sky and towers wet-in-wet in one shot; the rest was done by rewetting and working the paper in sections.

Detail. (Right) When viewed as a whole, this painting seems to be filled with tight detail. But in this closeup, note how much wet-in-wet and suggestive painting there actually is, with the careful pencil drawing carrying the main body of the rendering.

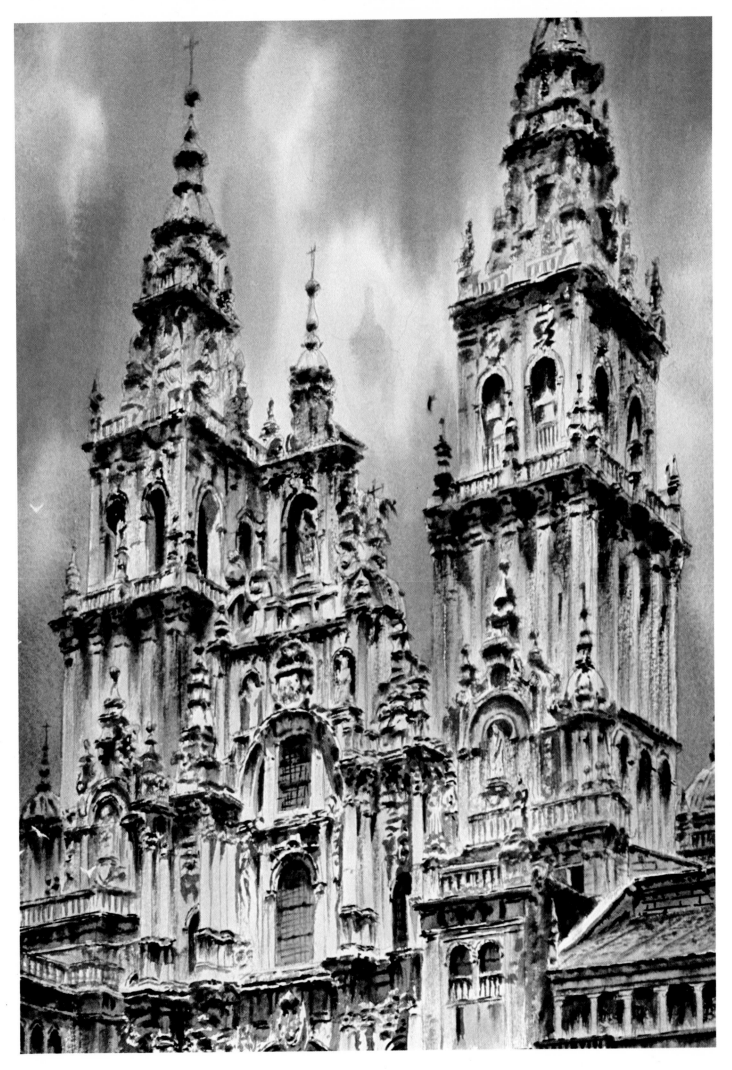

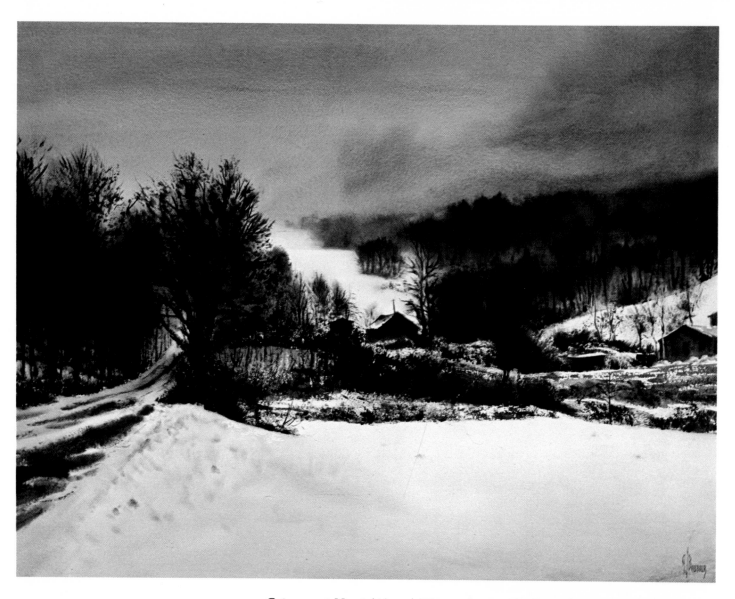

Catamount No. 1 (Above) Watercolor on 300-lb Arches cold-pressed, stretched watercolor paper, 21 1/2″ x 29 1/2″ (54.6 x 74.9 cm). Catamount is a ski area located in Massachusetts on the New York State border. In this painting of the smaller ski run there, I intended to capture the mood of a winter day, with its heavily laden sky, just before the onslaught of another snowfall. Besides working wet-in-wet with brush and sponge, I used sponge and color on dry paper to give a feeling of crispness to the middle foreground shapes.

Detail. (Right) This detail shows how the sky area was worked wet-in-wet in contrast to the grass and underbrush beneath it, which was sponged in for a drybrush effect.

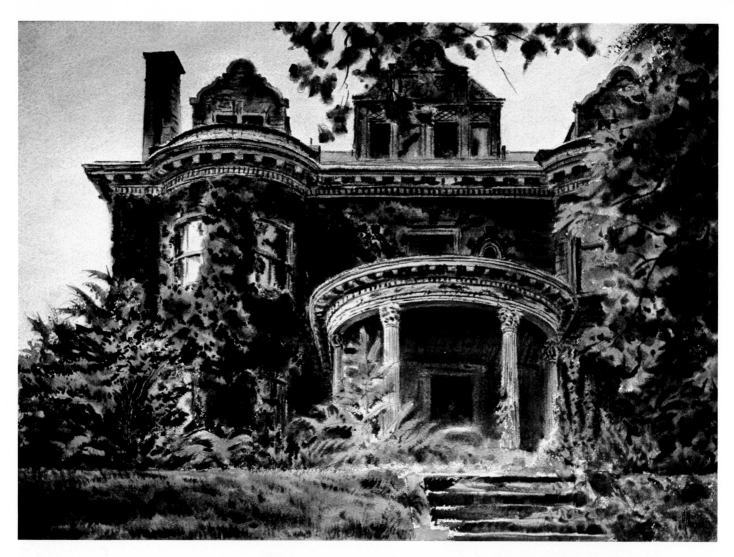

Shadows of Yesterday. (Above) Watercolor on 300-lb Arches rough, stretched watercolor paper, 21 1/2″ x 29 1/2″ (54.6 x 74.9 cm), Collection of Mr. and Mrs. Frank Gianattassio. This painting of an old house in Pittsburgh, Pennsylvania, is reminiscent of the mood conveyed by the architecture of an earlier day. Today, amid the unkempt bushes and weeds, it seems somewhat heavy and oppressive. There was very little sponge technique used in this painting. I rendered most of the smaller textures in the house and shrubs with a No. 6 round brush, black India ink, and color.

Detail. Notice the simple handling of the windows. I created their reflective glasslike quality with a light and dark wet-into-wet wash. Pencil line alone carries the rendering of the upright mullion in the left-hand window.

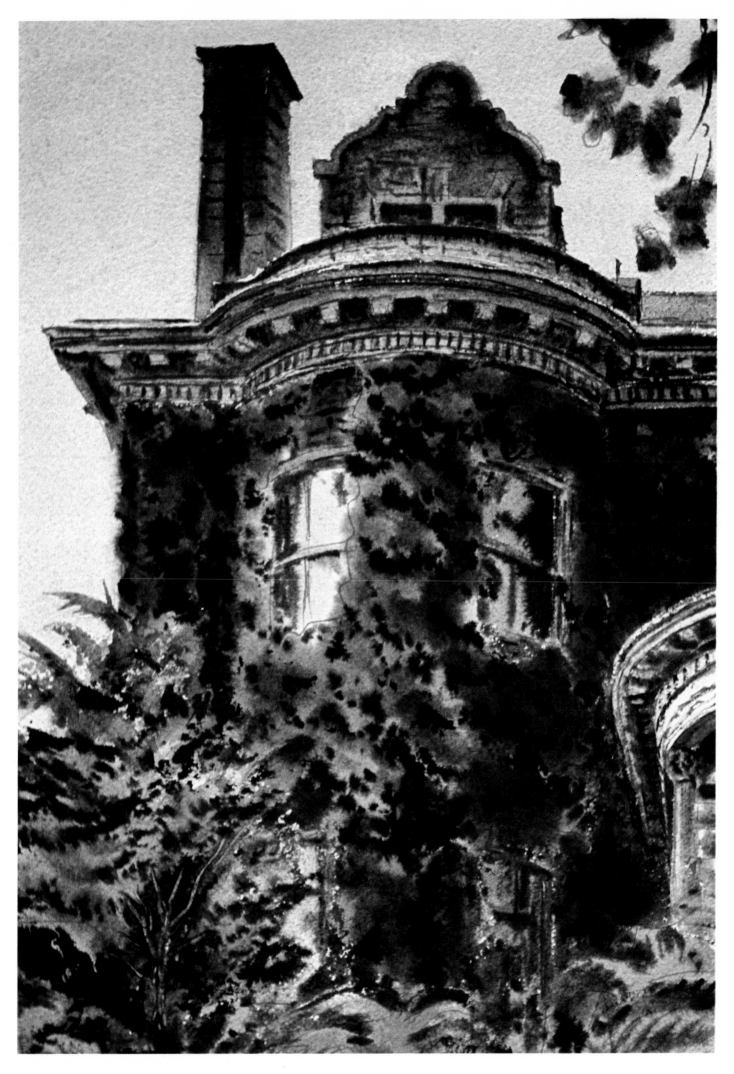

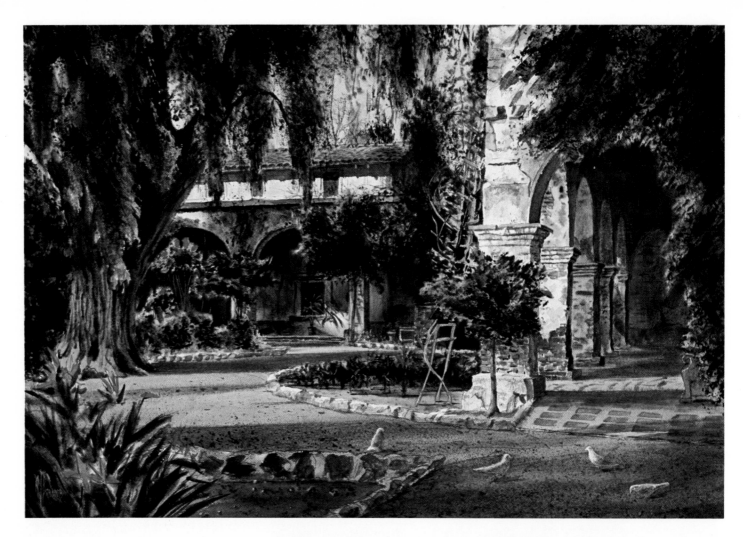

Capistrano. (Above) Watercolor on 300-lb Arches cold-pressed, stretched watercolor paper, 19 1/2″ x 29 1/2″ (49.5 x 74.9 cm). I have always found missions and ruins particularly attractive. The warm pervading sunlight spilling over the green growth, flickering up against old masonry walls was an open invitation for me to paint it. I applied color and ink with the usual techniques: brushes, sponges, stippling, spattering, and drybrush.

Detail. The loose handling of the flowers, bushes, and archways is controlled by varying the density of the black India ink that is sponged, stippled, and painted into the color.

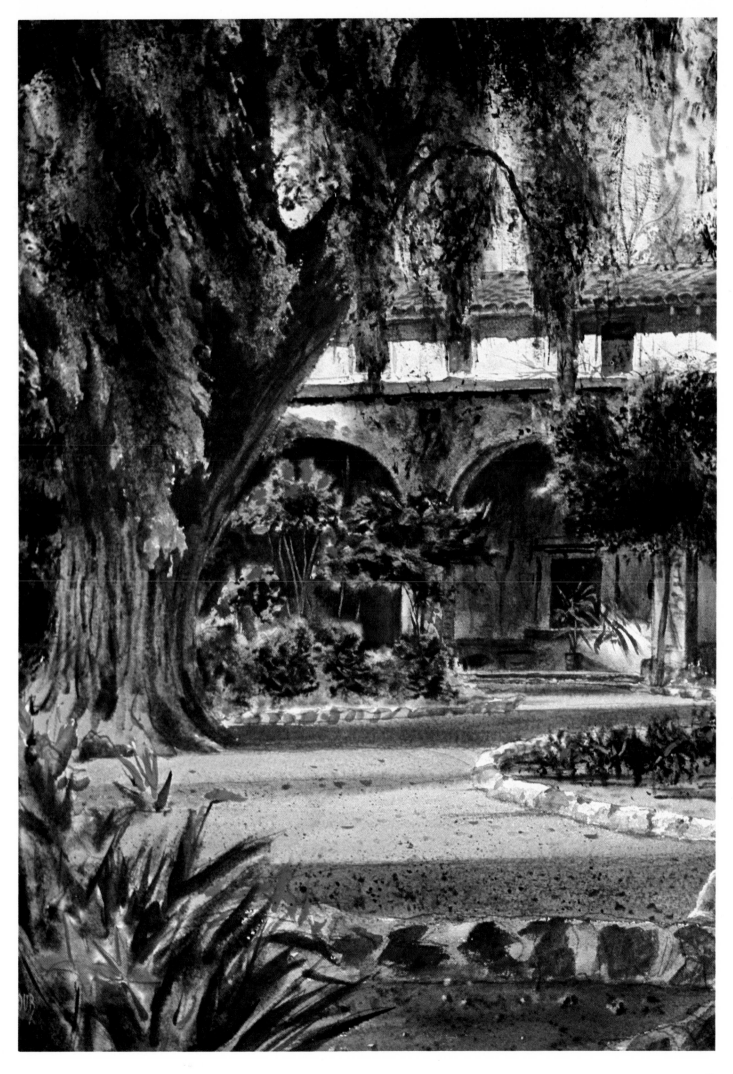

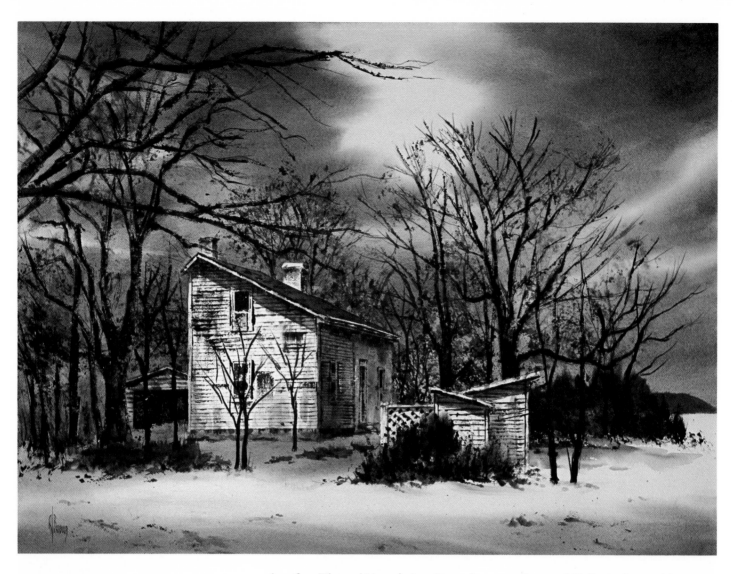

Another Time. (Above) Acrylic and watercolor on 300-lb Arches cold-pressed, stretched watercolor paper, 21 1/2″ x 29 1/2″ (54.6 x 74.9 cm). I executed this painting using the techniques shown in the black-and-white Demonstration 19, "Let Acrylic Color Dry and Wash Over." I put in the trees, house, and sheds with a razor blade and acrylic paint, and added the heavy growth wet-in-wet using acrylic paint and sponges. I put in the large wet washes, such as the sky and foreground snow, after the acrylic was dry, by rewetting the area with a sponge and clear water and flooding in bold washes of transparent watercolor.

Detail. Here you can see the razor blade technique I used for various sections of the old farmhouse.

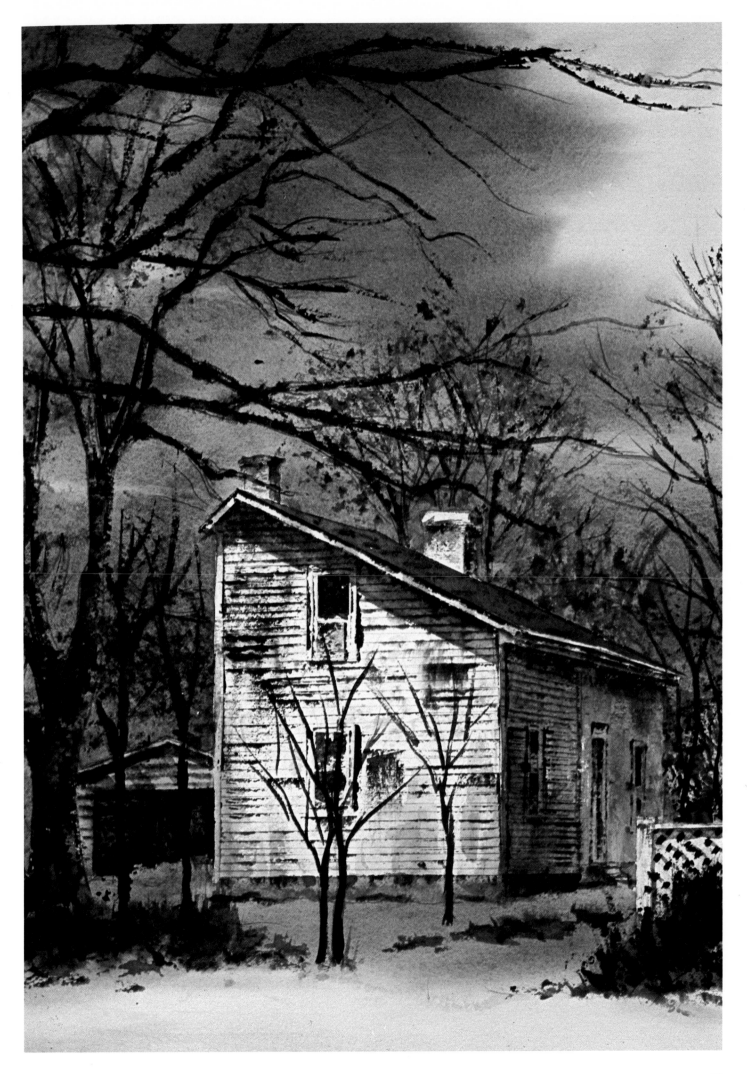

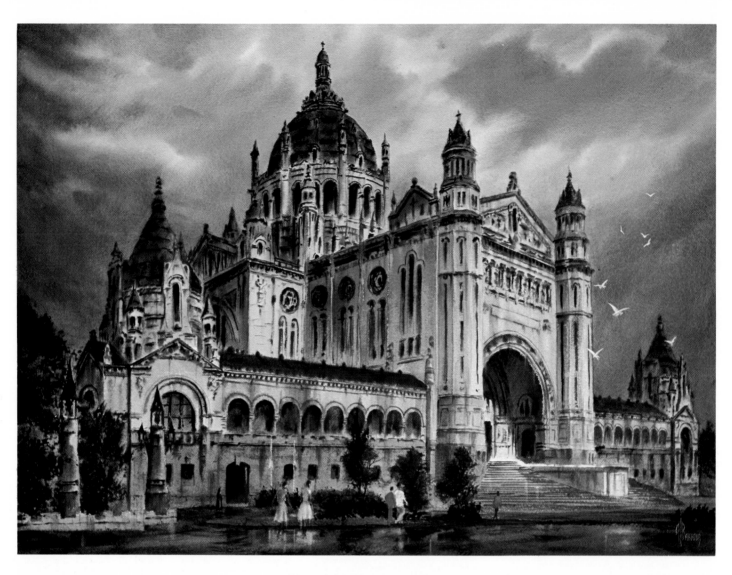

Basilica of St. Therese, Lisieux, France. (Above) Watercolor on 300-lb Arches cold-pressed, stretched watercolor paper, 29 1/2 x 21 1/2″ (74.9 x 54.6 cm), Collection of The Blue Army of Our Lady. This is the largest edifice ever built in the entire world to honor a single person. Second to this is the Basilica of St. Anthony of Padua and the Taj Mahal in Agra, India. I painted it with flat sable brushes, and accentuated and repeated the vertical lines of the architecture by dragging vertical shadows through portions of the building to better integrate the building masses.

Detail. The loose and suggestive wet-in-wet handling of the tower on the left was reinforced with wet-in-wet black India ink lines. The pencil lines also help suggest some of the structure's detail.

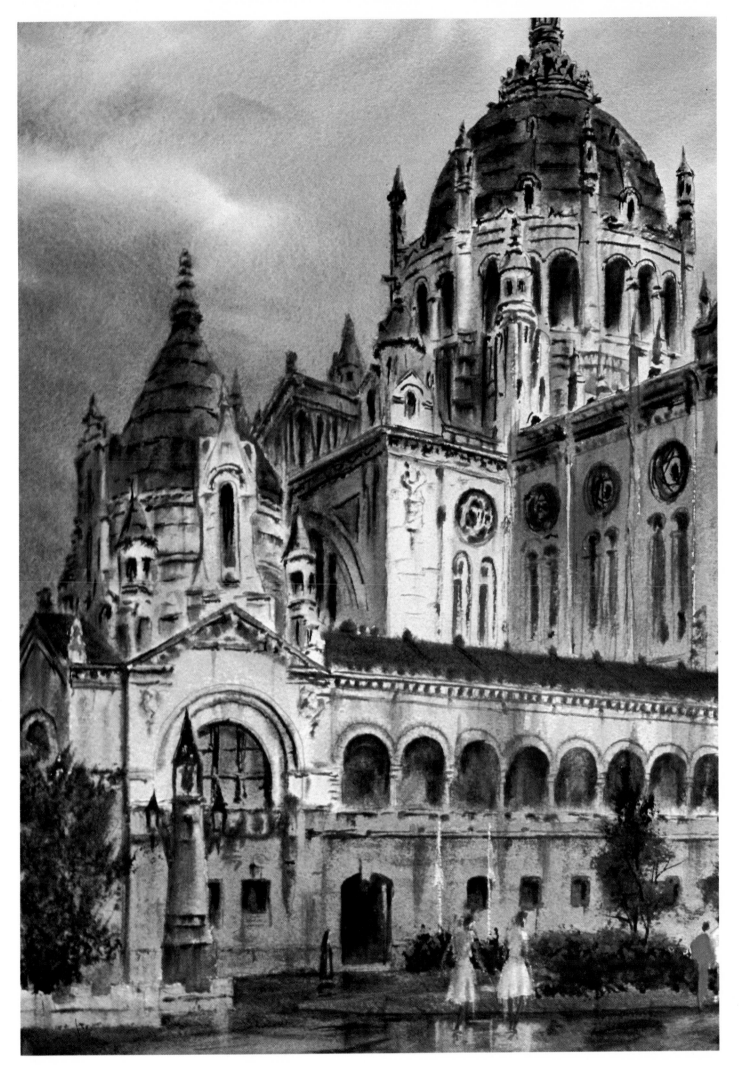

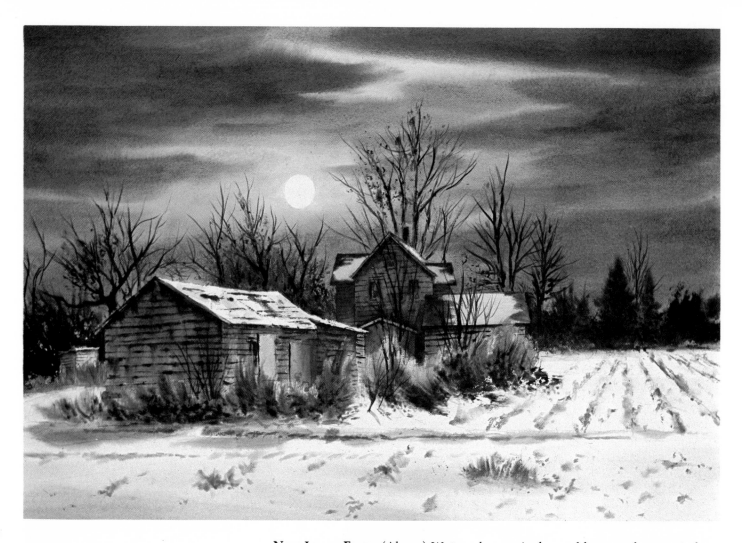

New Jersey Farm. (Above) Watercolor on Arches cold-pressed, mounted watercolor board, 21 1/2″ x 29 1/2″ (54.6 x 74.9 cm). For many years this farm scene caught my eye as I rode by it several times a month. But it wasn't until I caught the scene with the late afternoon sun breaking through the heavy atmosphere, that I decided to grab hold of it and paint it. The sky was painted wet-in-wet, except for the area containing the sun. I left that dry and painted around it with the first pale washes. The rest of the painting was done using my usual techniques.

Detail. In this detail, you can see how the deeper values of the old house and sheds define the light-filled top and side edges of the growth in this backlit painting.

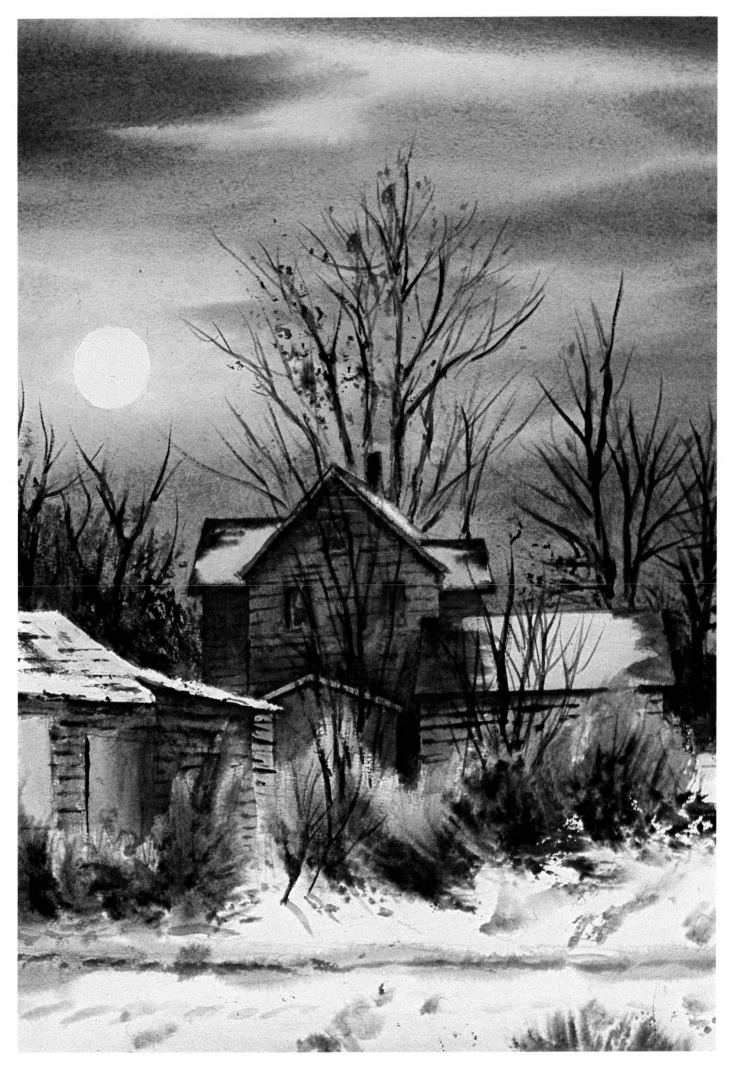

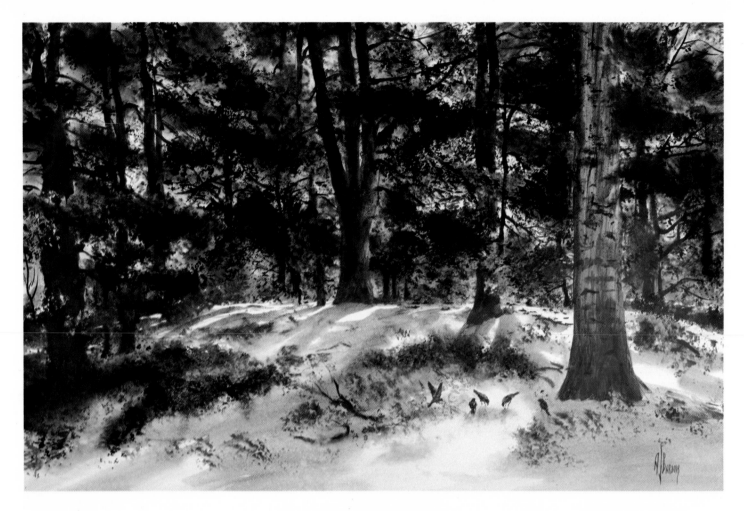

Dance of the Winter Sunlight. (Above) Acrylic watercolor on smooth Arches En-Tout-Cas paper, 24″ x 36″ (61 x 91.4 cm), Collection of Mr. and Mrs. Richard Fallon. Arches En-Tout-Cas paper comes in rolls of 52 1/2″ x 10 yds (133.3 cm x 9.2 m) or sheets, 27 1/2″ x 42′ 1/2″ (70 x 109 cm). It has two surfaces: one side is cold-pressed, and the other is smooth. I used the smooth side. This backlit painting has a shimmering light that casts shadows on a light groundcover of snow. For the main body of background foliage, I used a wet-in-wet treatment, sponging color on lightly when the washes were nearly dry and again when they were completely dry.

Detail. Here you can see where the black India ink was mixed with color and stippled in dry over the already dried washes.

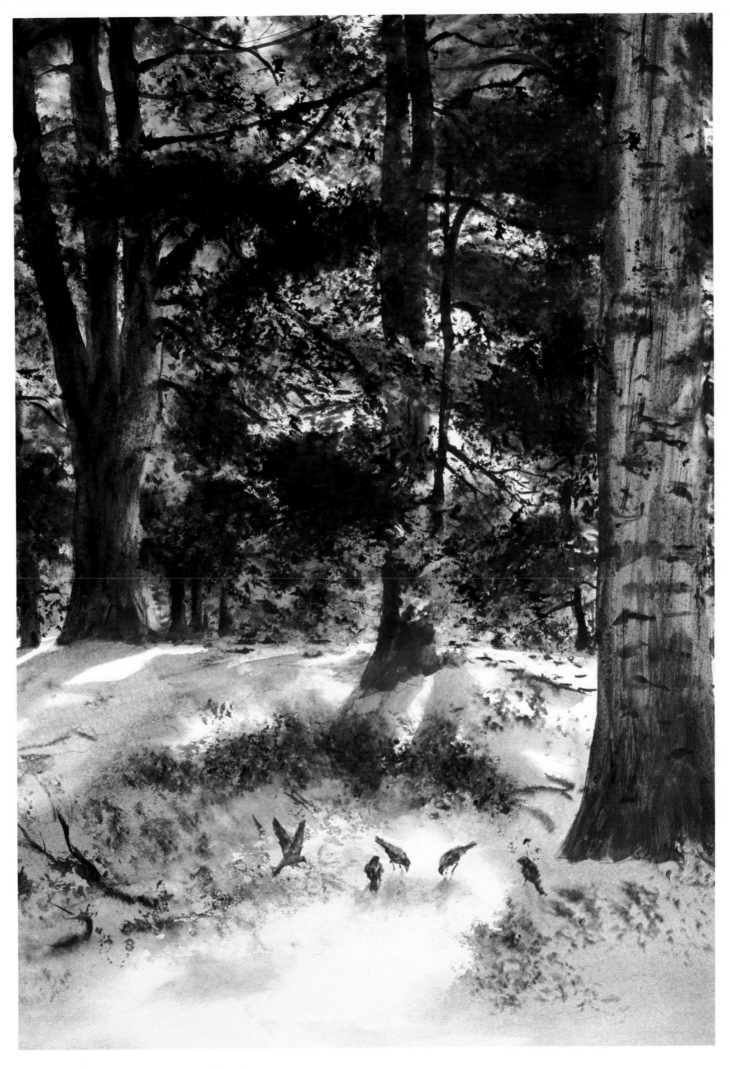

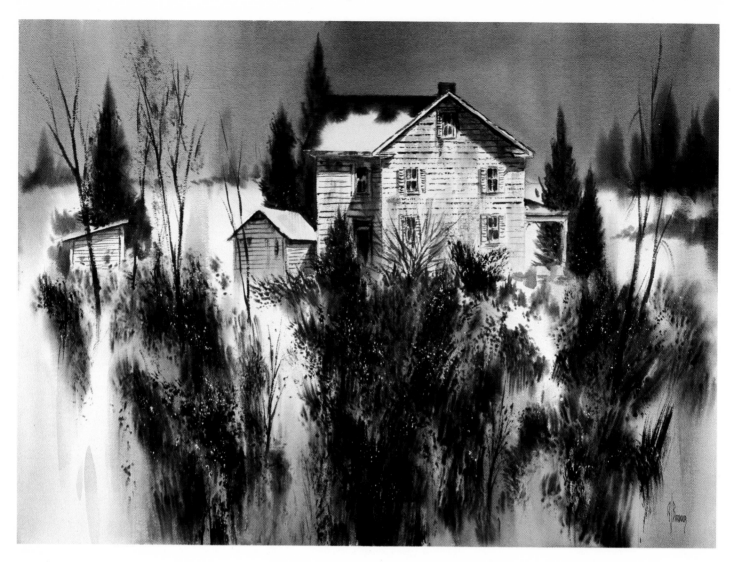

Winter on the Farm. (Above) Watercolor on commercially mounted, rough Arches board, 21 1/2″ x 29 1/2″ (54.6 x 74.9 cm). I stamped cobalt blue and burnt sienna on the clapboards of the house with a razor blade and put the cast shadows and windows in with a brush. Then I wet the entire board around the house and painted the sky by first washing in raw sienna, then adding vertical strokes of alizarin crimson, van Dyke brown, cobalt blue, and raw sienna with a 1″ (25 mm) flat brush. I then put the foreground bushes in with sponges and van Dyke brown, burnt sienna, and cobalt blue, and added the tones in the snow with vertical strokes of cobalt blue and burnt sienna, using the same brush. Next I put in the trees with raw sienna and a No. 6 round brush, and then added the little sheds. Finally, I spattered white tempera in the foreground for frost on the weeds.

Barbour, Arthur J. *Painting Buildings in Watercolor.* New York: Watson-Guptill; London: Pitman, 1973.

——. *Painting the Seasons in Watercolor.* New York: Watson-Guptill; London: Pitman, 1975.

Blake, Wendon. *Acrylic Watercolor Painting.* New York: Watson-Guptill, 1970.

Brandt, Rex. *The Winning Ways of Watercolor.* New York: Reinhold, 1973.

Cooper, Mario. *Painting with Watercolor.* New York: Reinhold, 1971.

Guptill, Arthur L. *Watercolor Painting Step-by-Step.* Edited by Susan E. Meyer. New York: Watson-Guptill; London: Pitman, 1967.

Kautzky, Ted. *Painting Trees and Landscapes in Watercolor.* New York and London: Reinhold, 1952.

——. *Ways with Water Color.* 2d ed. New York and London: Reinhold, 1963.

Kent, Norman. *100 Watercolor Techniques.* Edited by Susan E. Meyer. New York: Watson-Guptill, 1968.

O'Hara, Eliot. *Watercolor with O'Hara.* New York: Putnam, 1966.

Pellew, John C. *Painting in Watercolor.* New York: Watson-Guptill; London: Pitman, 1970.

Pike, John. *Watercolor.* 2d ed., rev. New York: Watson-Guptill; London: Pitman, 1973.

Richmond, Leonard, and Littlejohns, J. *Fundamentals of Watercolor Painting.* New York: Watson-Guptill, 1970.

Schmalz, Carl. *Watercolor Lessons from Eliot O'Hara.* New York: Watson-Guptill; London: Pitman, 1974.

Szabo, Zoltan. *Creative Watercolor Techniques.* New York: Watson-Guptill; London: Pitman; Toronto: General, 1974.

——. *Landscape Painting in Watercolor.* New York: Watson-Guptill; London: Pitman, 1971.

——. *Zoltan Szabo Paints Landscapes.* New York: Watson-Guptill; London: Pitman, 1977.

Whitney, Edgar A. *Complete Guide to Watercolor Painting.* 2d ed., rev. New York: Watson-Guptill; London: Pitman, 1974.

Wood, Robert E., and Nelson, Mary Carroll. *Watercolor Workshop.* New York: Watson-Guptill; London: Pitman, 1974.

INDEX

(*Note*: Names of paintings appear in *italics*)

Edited by Bonnie Silverstein
Designed by Bob Fillie
Set in 10-point Palatino